# FIRE

# FIRE

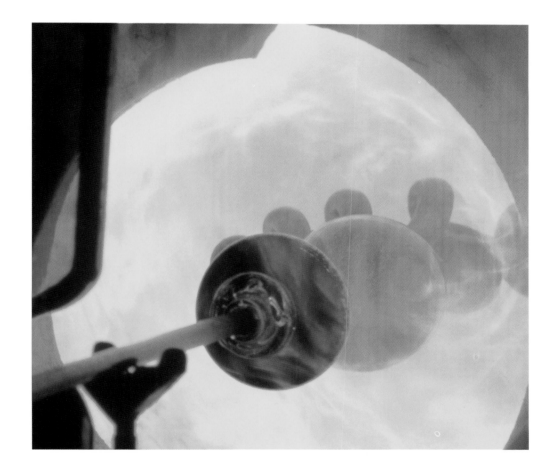

# DALE CHIHULY

Portland Press

for
Leslie & Jackson

I DALL MY OWN STUNTS

# CONTENTS

# SEISMIC SHIFTS:

# CHIHULY
# IN THE NORTHWEST

Margery Aronson

Surrounded by mountains and water, Seattle, Washington, the Emerald City of the Evergreen State, is heralded for its natural beauty and its vibrant cultural landscape, especially in the field of contemporary glass. This is no accident, as Seattle is also where Tacoma-born Dale Chihuly, described as the world's most successful glass artist, lives and works.

Seattle is a city of neighborhoods, each with distinctive characteristics. Fremont, north of the city's center, proudly honors its eccentric and nonconformist roots, most notably with a handcrafted signpost at a major intersection indicating the location of "The Center of the Universe." Coincidentally, this marker is sited midway between The Boathouse, Chihuly's home, hotshop, and studio on Lake Union, and the Chihuly Ballard Studio, the site of his large-scale fabrications.

Over the last thirty-five years, Seattle and the Northwest region have become the new "Center of the Universe" for the medium of glass, a shift in no small part due to Chihuly's decision to return to the Northwest to live, work, and continue with his early commitment to education. Chihuly had developed a visionary educational philosophy, epitomized by Pilchuck Glass School north of Seattle, which he cofounded in 1971 with art patrons John H. Hauberg and Anne Gould Hauberg. At Pilchuck, artists and students work alongside renowned international glass artists and with artists-in-residence from other disciplines in a creative cross-pollination process. Consequently, the Pacific Northwest has become the epicenter of American contemporary glassmaking, with more than 500 artists and over 100 hotshops and studios, more than on the island of Murano in Venice.

Chihuly came from working-class roots, Scandinavian on his mother's side and Eastern European on his father's side. George Chihuly was a butcher and a union organizer in Tacoma, who in 1958 suffered a fatal heart attack at the age of 51, only months after his son George, Dale's only sibling, was killed in a Naval Air Force training accident in Pensacola, Florida. Dale's mother, Viola, went to work to support herself and her remaining son, strongly encouraging him to continue his education. He agreed to enroll in Tacoma's

College of Puget Sound, and then transferred to the University of Washington to pursue his developing interests in interior design and architecture. In 1962, he took a leave of absence to visit Florence, Paris, and the Middle East, where he visited Jordan and worked on a *kibbutz* in Israel. Reenergized, he returned to the University of Washington in 1963 to study with design legends Hope Foote and Warren Hill. In Doris Brockway's weaving class, he utilized glass shards for the first time, incorporating them into a woven tapestry. Drawing upon a childhood fascination with beach glass, in 1965, Chihuly melted stained glass in a ceramic kiln in his basement and, using a metal pipe, blew his first glass bubble.

Just three years earlier, the modern glass movement had its beginnings in a modest workshop initiated by glass artist and scientist Dominic Labino and artist Harvey Littleton in Toledo, Ohio. Their pioneering work showed artists the way to build small furnaces and annealing ovens in individual studios and to experiment with the medium. Littleton went to the University of Wisconsin at Madison, where he attracted the best and brightest students to the first university art program in glass.

Armed with a B.A. in Interior Design from the University of Washington and intrigued by the potential of glass as a sculptural material, Chihuly entered graduate school at Wisconsin in 1966 with a full scholarship, receiving his M.S. in Sculpture in 1967. He continued his education at the Rhode Island School of Design in Providence, where he explored neon, argon, and blown-glass forms. At RISD, he met artist Italo Scanga, who became his lifelong friend and "brother."

In 1968, Chihuly received an M.F.A. in Ceramics from RISD and was awarded a prestigious Fulbright Fellowship, which enabled him to return to Europe. After meeting Ludovico de Santillana, director of the venerable Venini glass house and factory on Murano, Chihuly became the first American glass artist to work at Venini. He received a Louis Comfort Tiffany Foundation Grant and, upon returning to the U.S., began teaching at the Haystack Mountain School of Crafts in Deer Isle, Maine.

After another European excursion in 1969, during which Chihuly met the German artist Erwin Eisch and the formidable Czech artists Stanislav Libenský and Jaroslava Brychtová, he was invited to start a glass program at RISD, an association that would last fifteen years. Chihuly also began to work with James Carpenter and John Landon, developing ideas for the creation of an experimental school somewhat similar to Haystack and North Carolina's Penland, but focused only on glass.

With a $2,000 grant from the Union of Independent Colleges of Art and a commitment for land and patronage from the Haubergs, Chihuly returned to the Northwest in 1971 to realize his vision of an alternative educational environment on the Haubergs' tree farm near Stanwood, Washington. Departing from Viola Chihuly's house in Tacoma on June 1, he was joined by Landon, Carpenter, and eighteen students from various art colleges. Despite continual rainy weather, the hotshop was up and running in two weeks. Chihuly described the first summer in a grant proposal: "Pilchuck was a total educational experience, functioning on the premise that the way people live, learn, cook, eat, and relate to each other is all part of how they express themselves—their art . . . " (*Pilchuck: A Glass School*, p. 76).

In the fall of 1971, Chihuly returned to RISD and, with James Carpenter, he made *Glass Forest #1*, an installation in glass, neon, and argon with over 100 freestanding forms that ranged from six to nine feet tall, for the American Craft Museum in New York. Another collaborative project, *20,000 Pounds of Ice and Neon*, followed. The next year, Chihuly and Carpenter began work on a series of doors, made at Pilchuck, and in 1974, created their final installation, *Corning Wall*, for the Corning Museum of Glass. Also in 1974, Chihuly helped to establish a glass program at the Institute of American Indian Arts in Santa Fe, New Mexico.

With Carpenter, Flora Mace, Kate Elliott, and RISD students, Chihuly developed a technique of picking up glass thread drawings, essentially weaving the drawings into the molten glass matrix, which evolved during 1975 into his highly acclaimed series of *Navajo Blanket Cylinders*. Chihuly

received his first Individual Artist grant from the National Endowment for the Arts, and along with Seaver Leslie, another RISD colleague, he was an artist-in-residence at Artpark in New York State. He also collaborated in 1975 with Leslie and Flora Mace on the *Irish Cylinder* and *Ulysses Cylinder* series, inspired by scenes from James Joyce.

While traveling in England in 1976, Chihuly had a serious automobile accident and lost sight in his left eye, covered ever since with his signature black eye patch. Upon his return to Providence, he became head of the Department of Sculpture and the Program in Glass at RISD. He continued to blow glass, but with diminished depth perception, he experienced increasing difficulty in managing the molten material. Undaunted, Chihuly turned to the team approach he had observed in Venice, and he began to utilize gaffers and assistants to create work under his direction, expanding upon the collaborative efforts already used to make the *Cylinder* series. Henry Geldzahler, curator of contemporary art at New York's Metropolitan Museum of Art, acquired three *Navajo Blanket Cylinders* for the museum's permanent collection, thereby validating and honoring Chihuly's early work.

In 1977, Chihuly visited the Washington State Historical Society in Tacoma and was enthralled by its collection of Native American baskets. At Pilchuck that summer, he explored basket forms in translucent glass, using gravity and centrifugal force to shape asymmetrical vessels, with their edges typically defined by a thin thread of applied glass of a contrasting color. Chihuly's RISD student Benjamin Moore became the gaffer for this series, beginning a relationship that has endured for thirty years. Charles Cowles, then curator of modern art at the Seattle Art Museum, exhibited Chihuly's early *Baskets* and *Cylinders* along with mixed-media works by James Carpenter and Italo Scanga. Several art galleries began to exhibit and sell Chihuly's work.

Chihuly's encouragement of Pilchuck truck driver William Morris's early efforts to work in glass in 1978 initiated an eight-year association and an escalation in scale of the glass forms Chihuly envisioned. A one-person

exhibition, *Baskets and Cylinders: Recent Glass by Dale Chihuly*, was curated by Michael W. Monroe for the Smithsonian Institution's Renwick Gallery in Washington, D.C., swiftly followed in 1979 by the inclusion of Chihuly's work in the Corning Museum's seminal exhibition, *New Glass: A Worldwide Survey*, which traveled to New York's Metropolitan Museum and Europe.

During a trip to Southern California in 1979, Chihuly dislocated his shoulder and could no longer be the gaffer of his own work. Of necessity, he began to make drawings to direct and assist the gaffers and teams as they worked in the hotshop, and often he would step in and take the paddles to add a finishing touch to the molten sculptures. 1979 was also the year that Benjamin Moore brought the great Italian glass maestro Lino Tagliapietra to Pilchuck as a visiting artist to teach intermediate glassblowing. For years, American glass artists had essentially been self-taught, learning from experimentation and trial and error. A peerless master of Venetian glass techniques, Lino willingly and freely shared his knowledge, even of the most basic skills like gathering glass properly or knocking a finished piece off the blowpipe. For this generosity, he was censured by the glassmakers on Murano for having revealed their traditional secrets. In fact, he had left Murano because it no longer inspired him, and he gained new energy for his own work from the freedom of expression he saw at Pilchuck. And, of course, he met Dale Chihuly.

Chihuly resigned his position at RISD in 1980, although he continued as artist-in-residence there for several years. During the summer of 1980 at Pilchuck, working with William Morris on the *Basket* series, Chihuly discovered that using ribbed molds strengthened the glass, making an increase in the scale of the blown forms possible, even as they became thinner. Glass threads in contrasting colors were applied to the transparent forms in an endless embedded spiral body wrap, resulting in a series he named *Seaforms*, abstractions that evoked memories for Chihuly of his walks along the beach. Larger vessel forms frequently contained groupings of smaller shapes nestled together in an arrangement that was fluid and variable.

By 1981, Chihuly had modified the *Seaforms*, and again with Morris as his gaffer, began work on a series of colorful fluted vessel forms spotted with multicolored glass "jimmies." Chihuly's goal in making these vessels was to use all 300 colors available from the European manufacturers of color rods. With the help of his friend Italo Scanga, he named the series *Macchia*, the Italian word for "spotted." Many of the first *Macchia* were transparent and small in scale, but the *Macchia* later evolved into increasingly larger forms, luscious singular objects with the interior color separated from the exterior color by "clouds"—a layer of opaque white color—and a lip wrap of a contrasting color.

*Chihuly Glass*, an exhibition of *Seaforms*, opened at the Tacoma Art Museum in 1982 and traveled until 1984 to five other American museums. Also in 1984, with gaffers William Morris and Richard Royal, and with Flora Mace and Joey Kirkpatrick making glass thread and shard drawings for pickup, Chihuly revisited his *Cylinders*, first by increasing the scale of the straight-sided *Cylinders* and including the "clouds" and lip wraps developed for the *Macchia* series, and then by expanding the forms and letting gravity affect the *Cylinders*, making them "soft" rather than rigid. The thread drawings still referenced Chihuly's passion for Navajo weavings and blankets. In 1985, Chihuly invited Martin Blank to come from RISD to Seattle as gaffer for a new experimental series, the *Persians*. Blank began making riotously colored and patterned eccentric shapes finished with lip wraps of a contrasting color, fashioned after drawings made by Chihuly. Over the next several years, these odd and exotic objects were assembled into groupings and sets, becoming *Persian Installations*. Ultimately, the *Persians* grew in scale, intensity, and complexity of color, and with the addition of artist Parks Anderson to the Chihuly team, ways were devised for the glass to inhabit walls, windows, and ceilings in dynamic, grandiose installations.

Also in 1985, anchoring his presence in the Northwest, Chihuly purchased the Buffalo Shoe Building in Seattle's South Lake Union neighborhood, which served as his studio until 1987, when he acquired space in a former

bakery, the Van De Kamp Building, for his own hotshop. By 1990, he was able to buy the former Pocock Building on Lake Union, a 45,000-square-foot warehouse where racing shells had been manufactured. He renamed the building The Boathouse and transformed it into a fully functioning studio with a state-of-the-art hotshop, an upstairs apartment with spectacular views of the lake and city skyline, and a dock. Flora Mace and Joey Kirkpatrick leased Chihuly's hotshop in the Van De Kamp Building, where Martin Blank also leased space for his studio. Artists who initially had been attracted to Pilchuck by its innovative programs and by Chihuly's missionary zeal were beginning to settle in the Seattle area, creating the nexus of a core community of glass artists.

*Dale Chihuly objets de verre*, Chihuly's one-person exhibition at the Musée des Arts Décoratifs at the Louvre in Paris, opened in 1986. He was only the fourth American artist to be so honored. In 1987, the Met's Henry Geldzahler recommended Chihuly for a commission of a glass installation for the Rainbow Room in New York's Rockefeller Center, and he worked with Parks Anderson on the realization of this project, the *Rainbow Room Frieze*.

While in Venice in 1988, Chihuly had seen a private collection of exceptional Art Deco objects made by great Italian glass masters. Chihuly then invited maestro Lino Tagliapietra to work in Seattle with him for the first time as gaffer to create a new series inspired by the Deco works from Venice. Using charcoals and pastels and rapidly departing from the formality of the Deco pieces themselves, Chihuly drew increasingly flamboyant and original forms whose execution required a great deal of spontaneity and improvisation from Lino and the fifteen-person team. The result was the *Venetians*, extravagant sculptures masquerading as vessels, exploding with energy, brilliant color, applied gold and silver leaf, fantastical flowers and leaves, coils and tendrils, prunts and knots. In a subsequent historic blow at Pilchuck in 1989, Chihuly added maestro Pino Signoretto, whose forte is hot sculpted glass, to a team in which both Lino and Pino served as gaffers for a new series of *Venetians*, many of which were embellished with gold-leafed cherubic *Putti*.

After traveling in Japan, where he became interested in the traditional art of flower arranging, Chihuly also worked with Lino on his first *Ikebana* sculptures, a more radical realization of the *Venetian* forms, in which large-scale, stemmed, plantlike forms were added to or placed inside vessels. Chihuly's Japanese experiences rekindled memories of the fishing floats he had admired and collected as a young man as they washed up along the Pacific shore. In 1991, with Richard Royal as gaffer, his team produced the *Niijima Floats*, extraordinary colored spheres up to four feet in diameter with applied gold and silver leaf and jimmies—among the largest glass forms ever blown by hand.

Having a hotshop at The Boathouse allowed Chihuly to produce artworks with his team for his rapidly expanding exhibition commitments and, simultaneously, to experiment with new forms and inventive ways to present and install his work. For the exhibition *Dale Chihuly: Installations 1964–1992* at the newly designed downtown Seattle Art Museum, Chihuly eschewed the notion of a retrospective presentation and focused on creating new work and utilizing his glass sculptures in architectural environments. Chihuly's first *Chandelier* was shown at SAM, as well as installations of *Persians, Macchia, Ikebana, Floats*, and a set design commissioned by the Seattle Opera for *Pelléas et Mélisande* by Claude Debussy. For the exhibition's opening, he re-created an installation of the 1971 work *20,000 Pounds of Ice and Neon*, and, in 1993, in his hometown of Tacoma, he covered the ice rink at the Tacoma Dome with *100,000 Pounds of Ice and Neon*.

Since the 1980s, Chihuly had owned studio buildings in Tacoma where he archived his work and stored many of the collections he had amassed during years of international travel. He also returned frequently to Tacoma to visit his mother, who maintained the home and gardens where he had grown up. In 1994, he made five installations for the new Federal Courthouse in the renovated Union Station in Tacoma, and with his good friend Kathy Kaperick and Team Chihuly member Charles Parriott, Chihuly started the Hilltop Artists-in-Residence program to teach at-risk teenagers to blow

glass. A model program, Hilltop has since partnered with the Tacoma Public Schools, and Chihuly continues as an adviser and supporter.

In 1995, Chihuly developed plans for his team to create *Chandeliers* in several of the world's glass centers—The Boathouse in Seattle, Nuutajärvi in Finland, Waterford in Ireland, Monterrey in Mexico, and Murano in Italy—with the ultimate goal of installing the completed works over the canals in Venice during September 1996 to coincide with the first contemporary glass biennale, the *Venezia Aperto Vetro*. Chihuly selected Leslie Jackson as international project director, and for a year, Dale and Team Chihuly traveled the world, producing over 10,000 *Chandelier* components and creating temporary installations at each glassmaking venue. Finally, in August of 1996, the glass, the armatures for the *Chandeliers,* and essential equipment and supplies (along with Chihuly's canoe) were shipped to Venice. Fourteen spectacular *Chandeliers*, brilliantly lit at night, were mounted on steel tripods along the Grand Canal and in *palazzi* and *campi* throughout the city, in addition to Chihuly's contribution to the biennale itself, the *Palazzo Ducale Chandelier*. The entire project was filmed by the Seattle PBS station.

The following year, Chihuly acquired and renovated a warehouse in Seattle's Ballard neighborhood, where full-scale mock-ups of commissions and installation works could be created with appropriate lighting, and with in-house shops for metal fabrication and experimental work with Polyvitro, a plastic material. Ballard also houses his extensive photographic archives. While continuing to make "set pieces" for museum and gallery exhibitions, Chihuly also accepted site-specific commissions, including two *Chandeliers* for the new home of the Seattle Symphony, Benaroya Hall, and his largest installation to date, *Fiori di Como*, for the lobby ceiling at the Bellagio Hotel in Las Vegas in 1998. On February 12, 1998, Chihuly and Leslie Jackson's son, Jackson Viola Chihuly, was born in Seattle.

Approaching the millennium, Chihuly began work on a project even more ambitious than *Chihuly Over Venice*, which would take him back to the Middle

East: *Chihuly in the Light of Jerusalem 2000*, at the Tower of David Museum of the History of Jerusalem. Among the works created for the site were a forty-four-foot-tall *Crystal Mountain* fabricated in Polyvitro, a forty-eight-foot-tall *Blue Tower* with over 2,000 glass components, installations of *Red Spears* and *Yellow Spears* made in Finland and France, *Green Grass* made in the Czech Republic, *Hebron Vessels* made in Israel, and a *Persian Ceiling*. Chihuly also shipped sixty-four tons of Arctic Diamond clear ice from Alaska for a temporary installation, the *Jerusalem Wall of Ice*, which melted in three days in the intense October heat.

For Chihuly, the new century has been filled with major installation projects and a multitude of exhibitions at museums and galleries. The year 2001 brought both triumph and heartbreak to the artist. Chihuly exhibited with Marlborough Gallery in Monte Carlo, New York, and London and also at the Victoria and Albert Museum in London. To great critical acclaim, he presented *Chihuly in the Park: A Garden of Glass*, his first exhibition in a classic garden conservatory, in Chicago's Garfield Park. But in July of 2001, Chihuly's dearest friend, colleague, and mentor since 1967 and a beloved and irreverent creative force in the world of contemporary glass and sculpture, Italo Scanga, died unexpectedly in his studio in San Diego.

Chihuly created installations for the 2002 Olympic Winter Games in Salt Lake City and also completed the Chihuly Bridge of Glass in Tacoma, which connects the new Museum of Glass with Pacific Avenue and the Washington State Historical Society. Chihuly's first *Fiori* sculptures were exhibited in an installation created especially for the 2003 opening of the new Tacoma Art Museum. He did several garden installations, including *Chihuly at the Conservatory* in Franklin Park Conservatory in Columbus, Ohio (2003); the Atlanta Botanical Garden (2004); *Gardens of Glass: Chihuly at Kew* in London (2005); the Fairchild Tropical Botanic Garden in Coral Gables, Florida (2005); the Bowman Garden in Medina, Washington (2006); the Missouri Botanical Garden in St. Louis, Missouri (2006), and the New York Botanical Garden (2006).

Life and art have always been indivisible in Chihuly's world. With his distinctive eye patch, his wildly coiled hair, and his painted shoes, he is recognized everywhere he goes, and he is unfailingly gracious to all who approach him. A true original and visionary with boundless energy and limitless ideas, he is constantly orchestrating and conducting the creation of his work. He continually coaxes and cajoles his team to surpass their previous achievements and to improvise in new and different ways, often engaging them in a Socratic discourse about the processes they are using and the choices they are making. Charismatic, passionate, and mercurial, Chihuly attracts and inspires people with his energy and intellect to participate and share in his dreams and projects.

In founding, developing, and sustaining the vision of Pilchuck Glass School for more than three decades, he has provided the archetype and sown the seeds for innovative glass programs throughout the world. He has been a mentor and role model for numerous artists, and, in establishing programs such as the Hilltop Artists-in-Residence Program in Tacoma and Seniors Making Art in the Seattle area, Chihuly has become the "Pied Piper of Glass," extending his support to deserving individuals outside of mainstream art programs.

As a master of a medium that he has pushed to its limits, Chihuly has proclaimed with each new series that the whole is indeed greater than the sum of its parts. In choosing to make his artworks, his home, and Pilchuck here, he has created a new "Center of the Universe" in Washington State for the world of glass and all who have fallen under the spell of this ancient art form.

# Ice & Neon

In the early 1970s, Chihuly was making environmental works in glass, neon, argon, and ice. These were large installations, as the titles suggest: *Glass Forest* and *20,000 Pounds of Ice and Neon* (which covered 600 square feet). These were serious attempts at the start of his career to engage with site specificity and performance, mediated by the opportunities and challenges of working with new materials. The materials were challenged and challenging, and the art demanded action and reaction. The ice melted, the glass was stretched, the audience was expected to enter the arena and experience the stridently artificial light. And as he became more intensely involved and skilled in the use of the medium, it was the glass that became all-important.

<div align="right">Jennifer Hawkins Opie, 2001</div>

Several times I've done big ice projects. The most noted one was . . . 1993 . . . when I froze neon into 100,000 pounds of ice at the Tacoma Dome, in my hometown, on the ice-skating rink. So we made 300 blocks of ice that weighed about 300 pounds apiece. And they're sort of like human scale. And then we put them on the ice-skating rink, and we froze them to the floor, where they froze automatically. And in them we had frozen neon. You can imagine what neon, one of the brightest—talk about a form of light. I mean, neon is light itself. But of course . . . neon couldn't exist without glass. And so you could say that neon is another light; neon, ice, glass, plastic—they're all very similar.

<div align="right">Dale Chihuly, 1998</div>

Alaska is about as far away as you can be from Israel . . . But the ice is unbelievably clear and perfect for this project.

I've always liked the idea of ice in the desert . . . The wall's form is still undecided, but some portions will probably be collapsed. The big blocks will be fused together using dry ice. Everything changes—color, form—as the ice melts. The wall will initially be transparent, but over time the sun will make it more textured, more milky as the blocks melt, with water running between them . . . Shooting color through it will be as dramatic as neon, in some ways more dramatic. The light will sear through the ice in beams, no movement. Just—boom!

<div align="right">Dale Chihuly, 1999</div>

<div align="center">20</div>

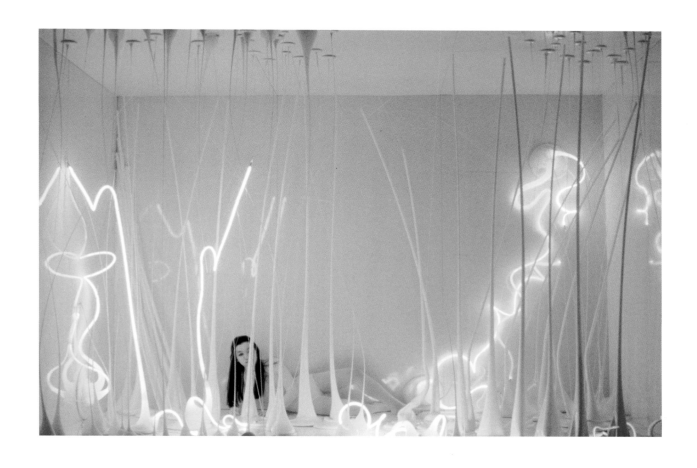

Pages 21 to 27

**Glass Forest #2,** Collaboration with James Carpenter, Rhode Island School of Design, Providence, RI, 1971–72

**100,000 Pounds of Ice and Neon,** Tacoma, WA, 1993

**Jerusalem Wall of Ice,** Jerusalem, Israel, 1999

**Orange and Aquamarine Tumbleweeds,** Medina, WA, 2006

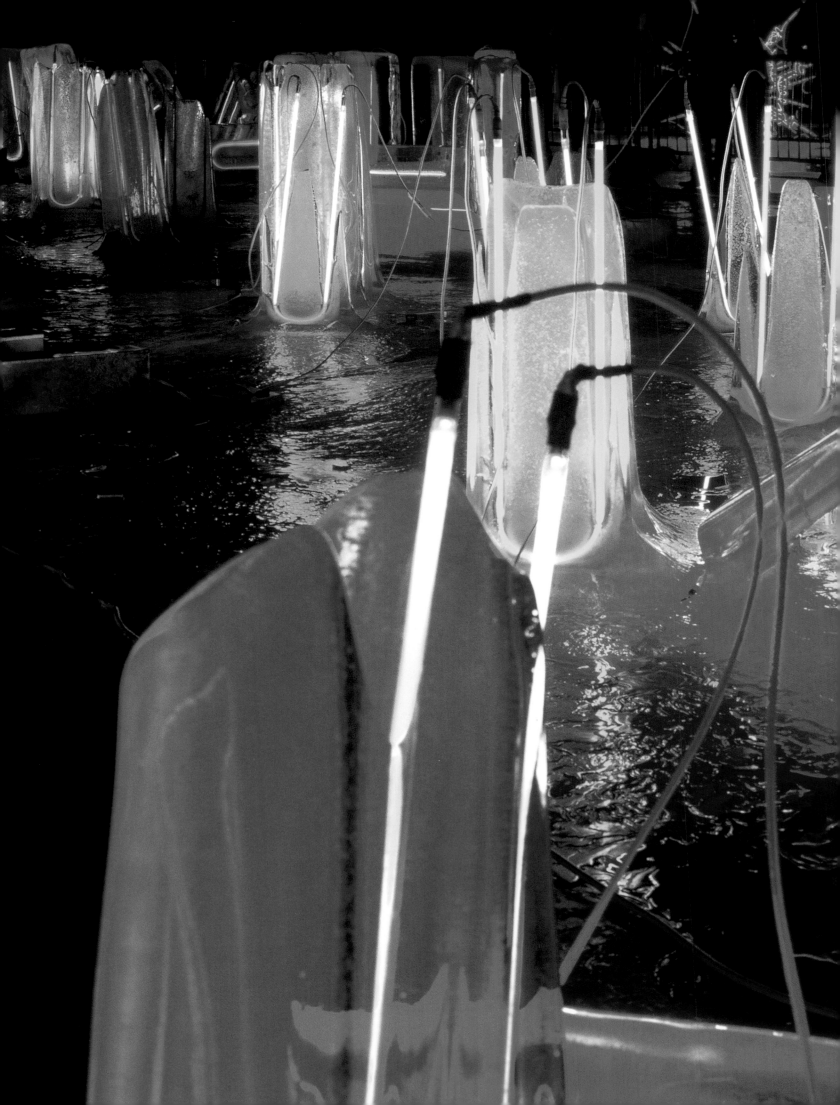

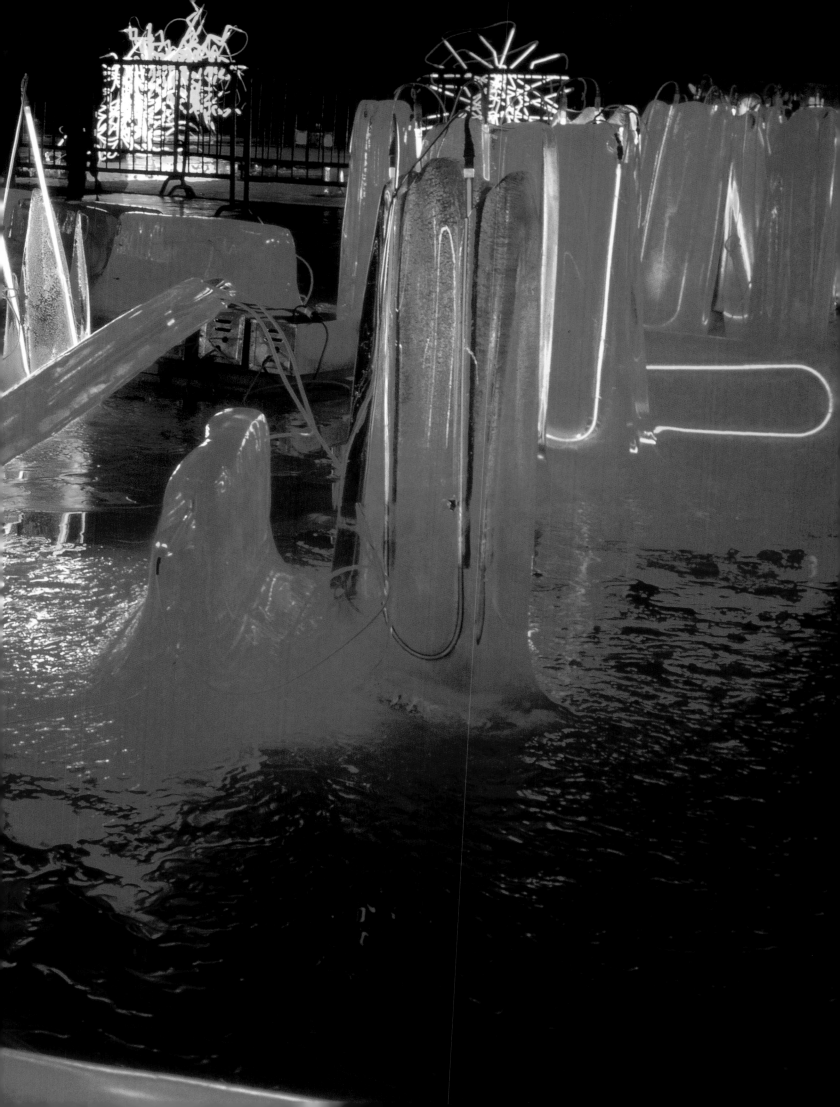

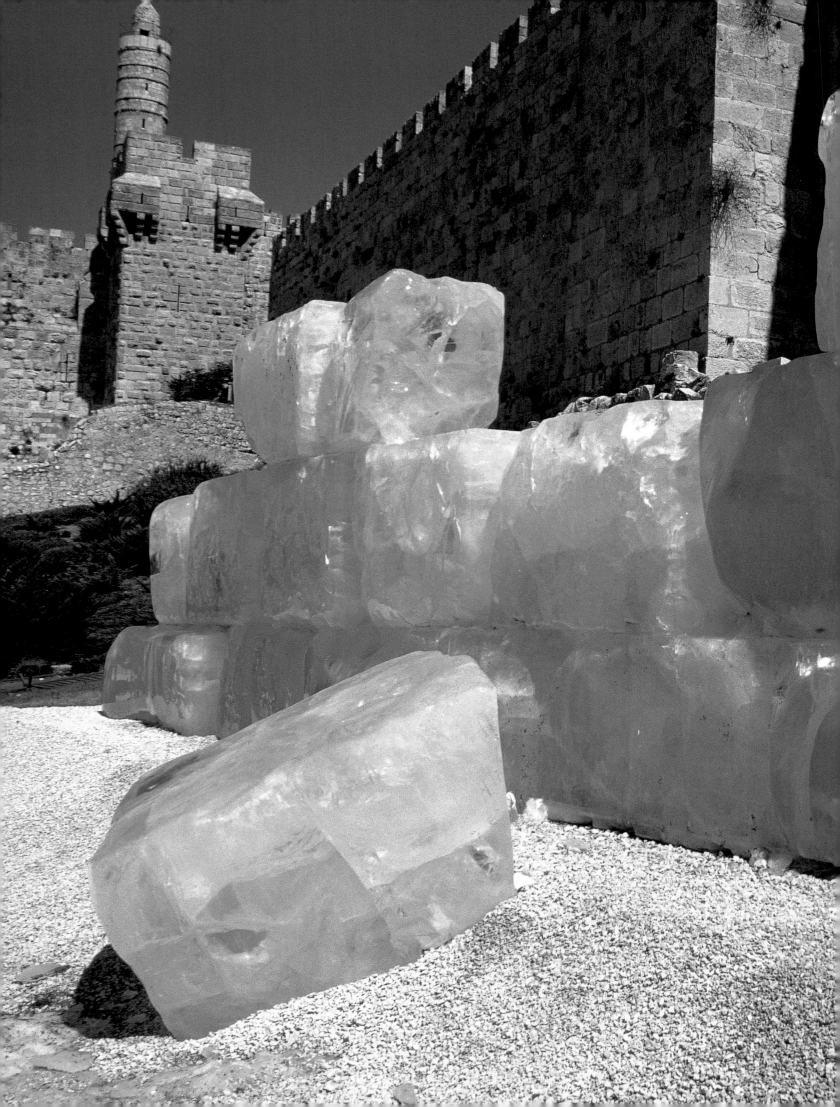

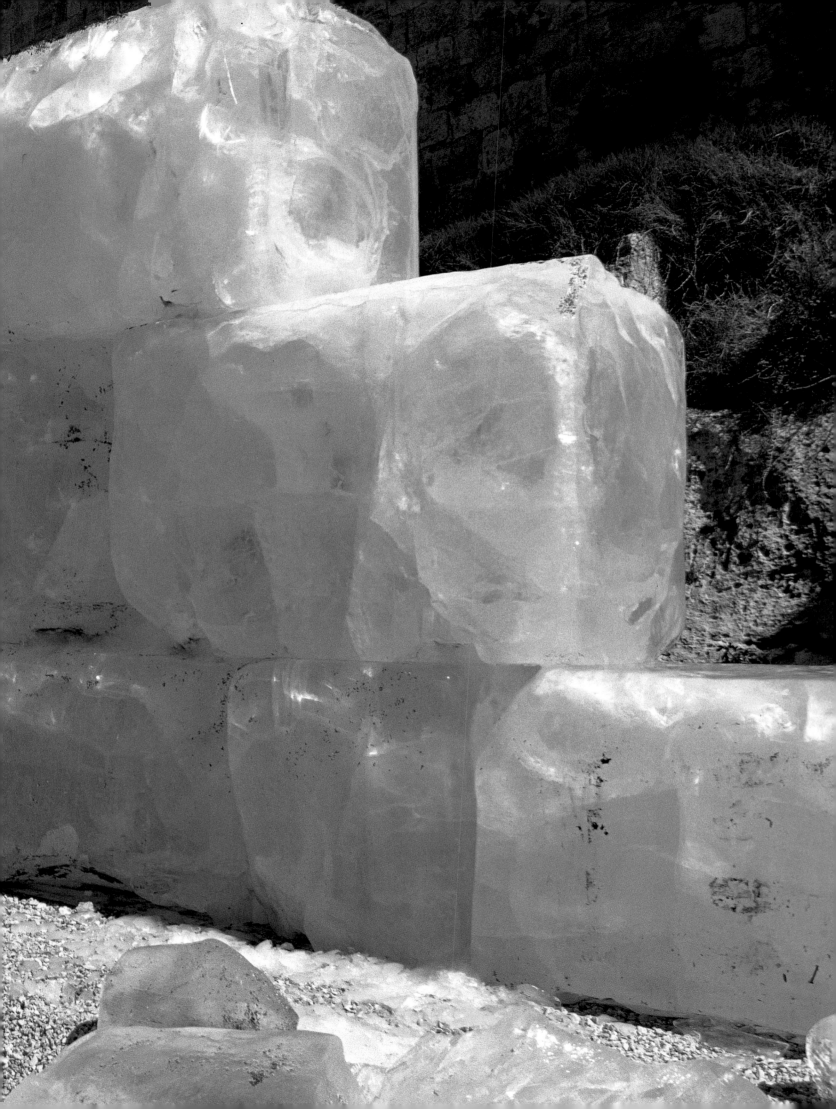

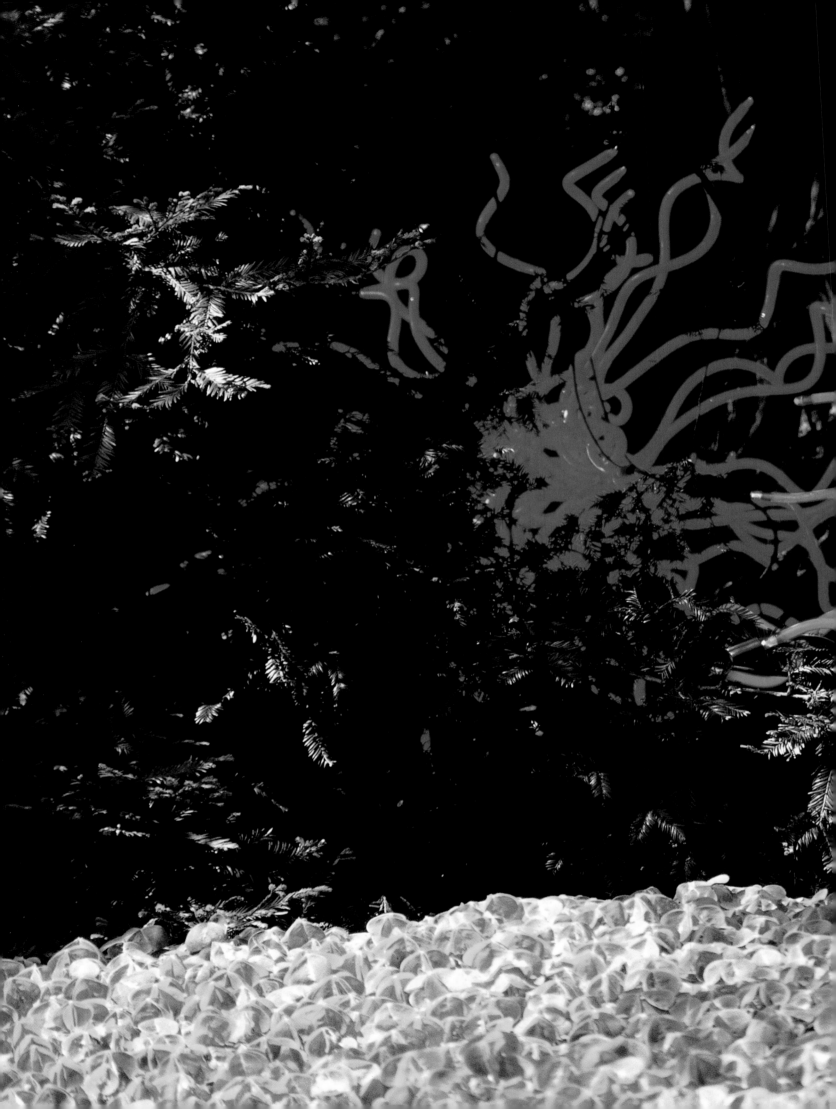

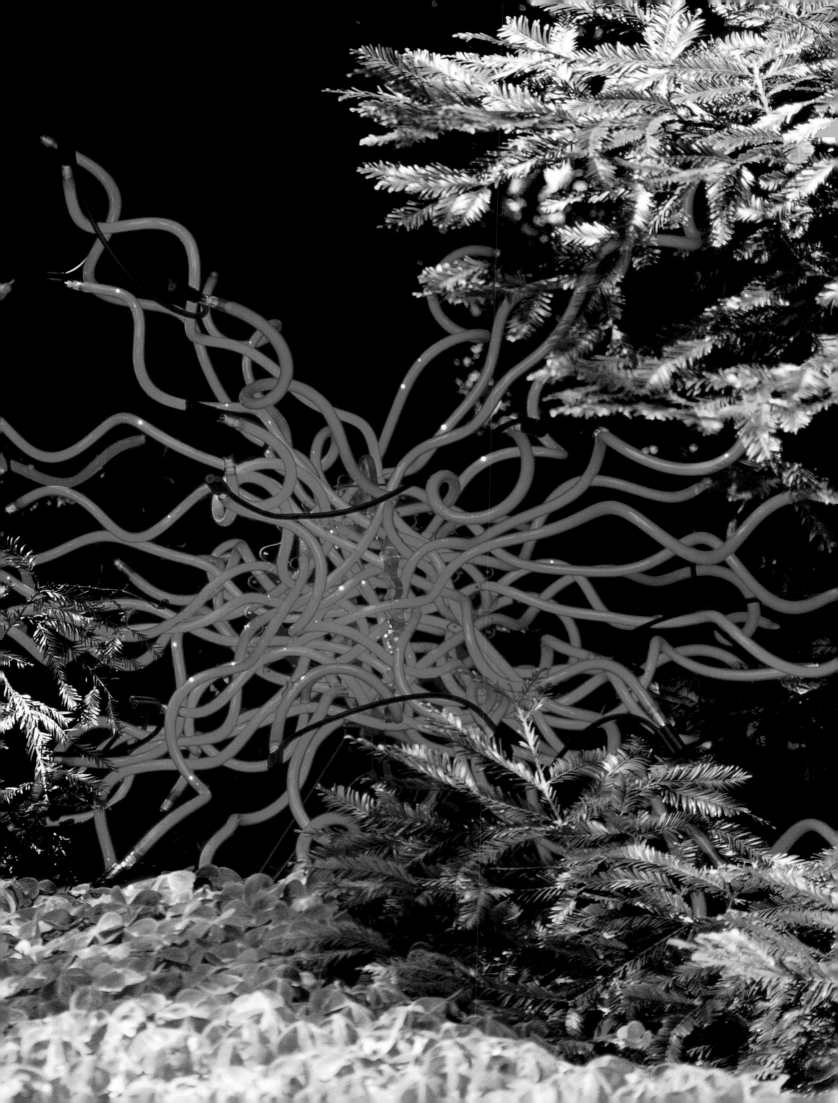

# Cylinders

I guess it was 1974 and I was up at Pilchuck, and Jamie Carpenter was there and Italo Scanga and Kate Elliott. We came up with this technique that we could make little bits of glass, lay them down on the steel table, and then pick them up with molten glass and then blow those into a form. It was a technique that we truly felt was original and new. I decided to take this concept and see what I could do with it. I started by making some fabrics to pick up, and I made them into *Cylinders*. Then I started to think about Navajo blankets—so I started a series called the *Navajo Blanket Cylinders*. A lot of them were just straight lines and beads. Kate really got it going with the torch. Then, when I went to Snowbird that summer with Seaver Leslie and there were a lot of RISD people who came out with me, Flora Mace was one of my students. So I told her about the torch and about how to make the drawings. She was real excited about it, and she started taking the torch, bending and manipulating the glass threads. And she became really extraordinary with this technique. In fact, no one ever was as good with manipulating these drawings as Flora. Probably no one ever will be, because she is just miraculous with this torch.

Dale Chihuly, 2002

I would do boxes of drawings and send them off to Dale. Then he would blow with people and take little parts. Because I would send a box of horses, and I would do a bunch of blankets. He would add and subtract those things from whatever. It was like a pencil box. He could take either the whole drawing or part of the drawing, or some of them got broken in the mail and he would start combining them.

Flora Mace, 2002

The glass shard is carefully placed on a hot plate with hundreds of pieces of glass threads all around the drawing. About halfway through the blowing process, right after the last gather of glass has been dipped from the furnace, the gaffer comes down on it with glass and fuses it to the surface. This is the most exciting moment of making the *Soft Cylinder*. The shard may crack at this point, and the glass threads go flying everywhere.

Dale Chihuly, 1998

Pages 29 to 39

Wax pencil, berry juice, and watercolor on paper, 1980, 8 x 13"

**Full Wrap Pueblo Cylinder,** 1975, 10 x 8 x 8"

**Navajo Blanket Cylinders,** 1976, tallest 14 x 8"

**Pilchuck Cylinder,** 1984, 13 x 9"

**Serape Blanket,** 1995, 18 x 10 x 10"

**Rose Doré Soft Cylinder with Chartreuse Drawing,** 1986, 17 x 14 x 13"

**Delta Yellow Soft Cylinder with Red Ochre Drawing,** 1986, 14 x 12 x 10"

**Black Cylinder #42,** 2006, 13 x 11 x 11"

Black Cylinder grouping, 2006

**Clear Cylinder #2,** 2006, 21 x 7 x 7"

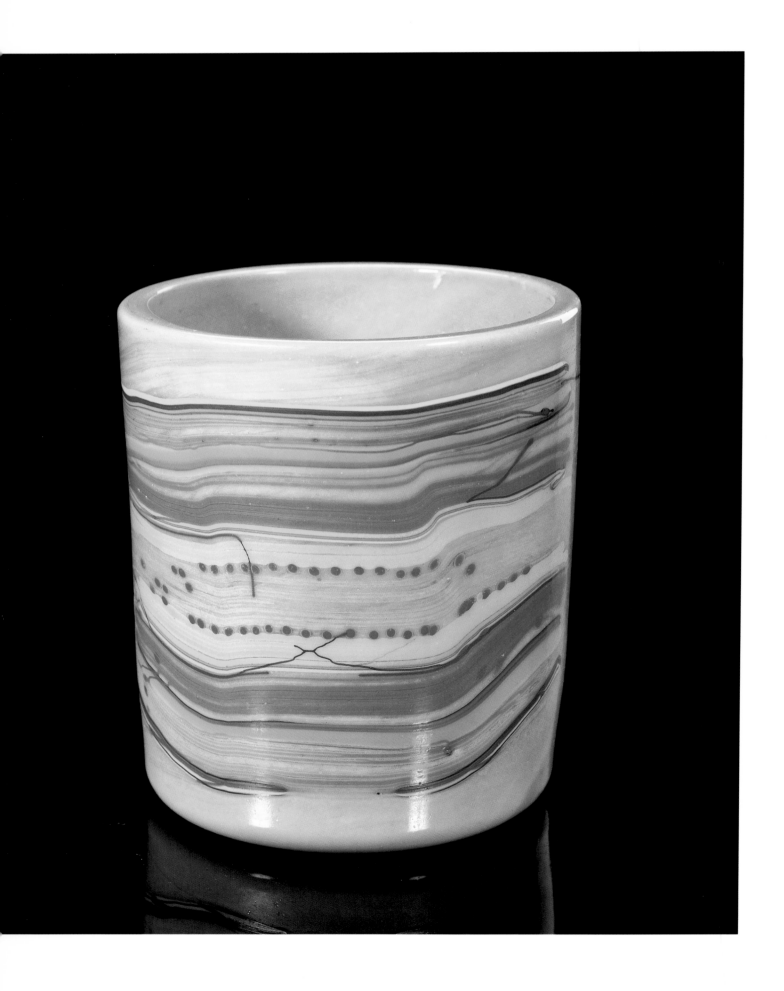

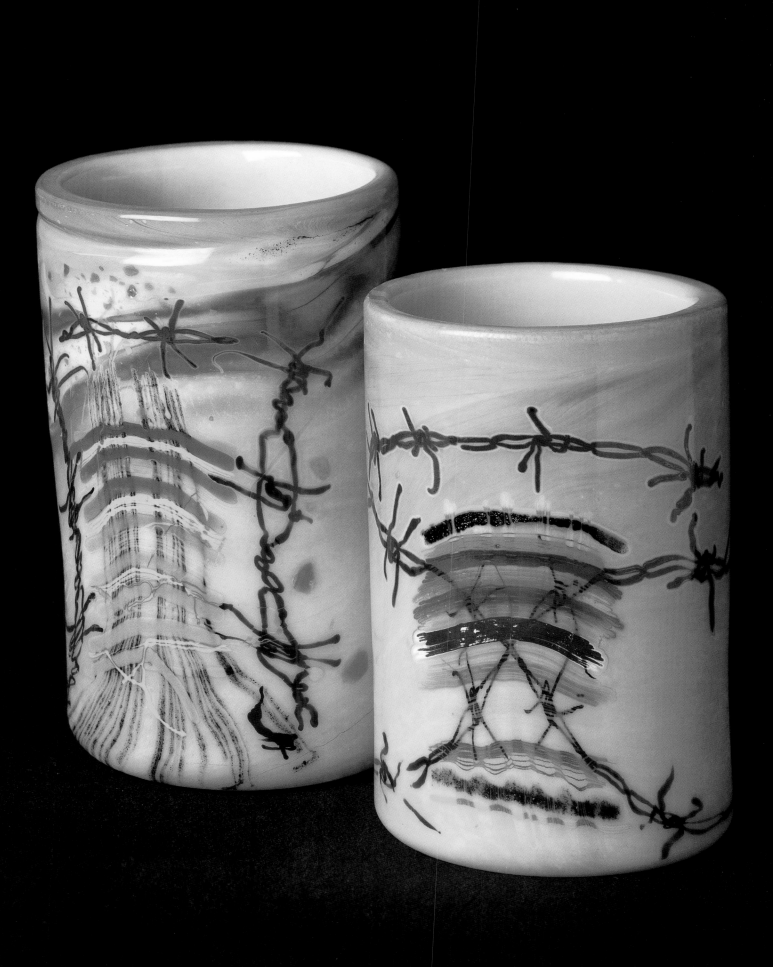

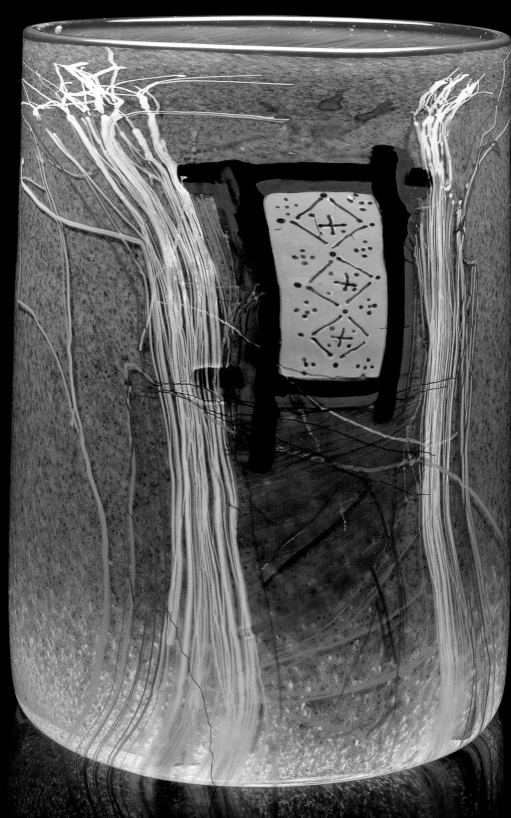

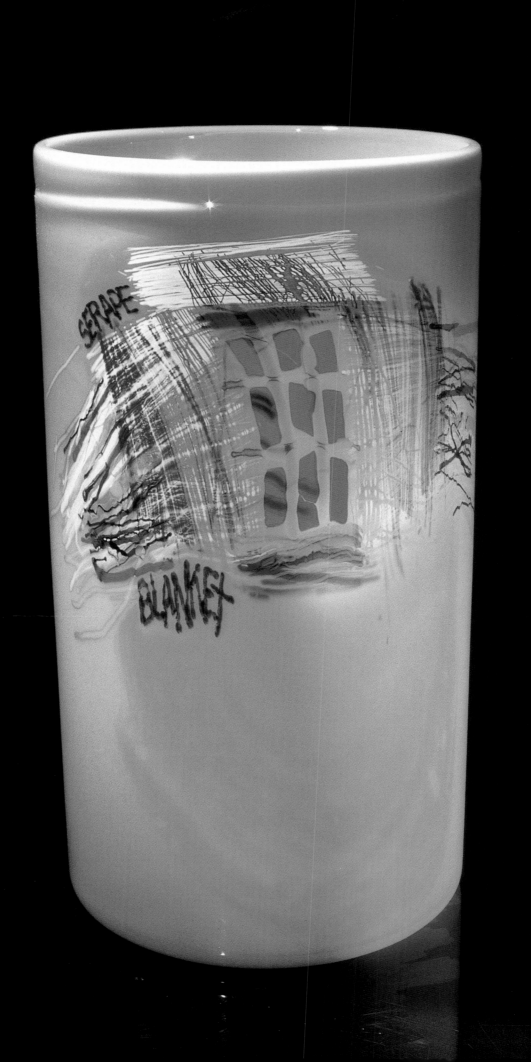

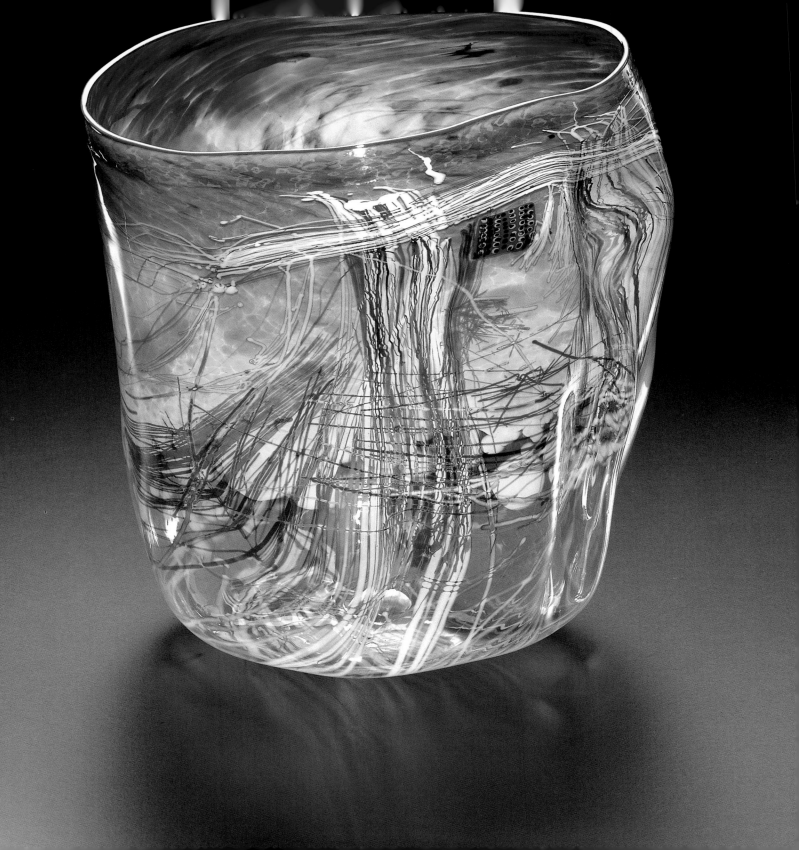

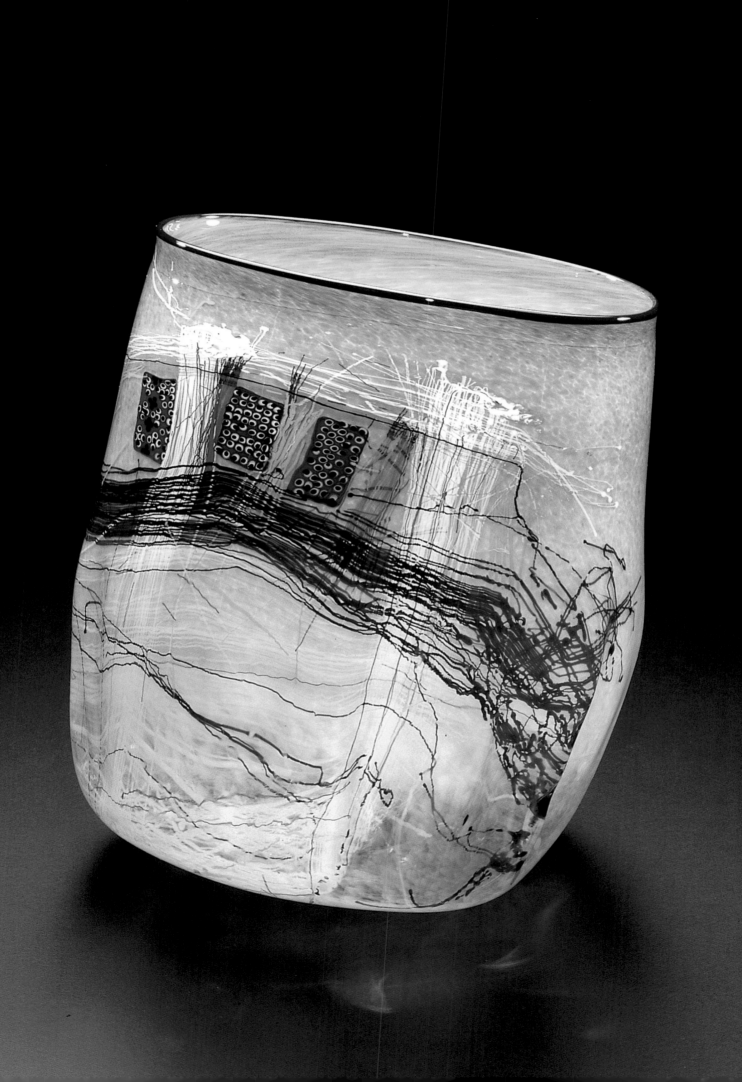

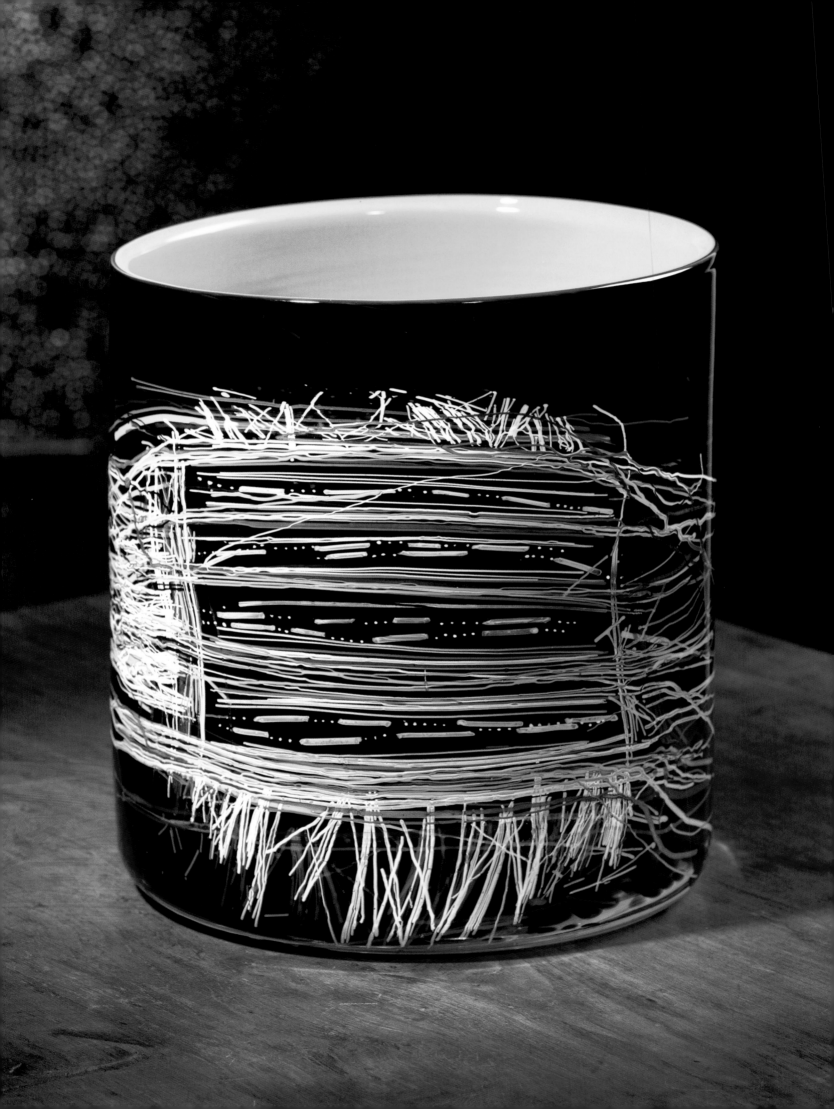

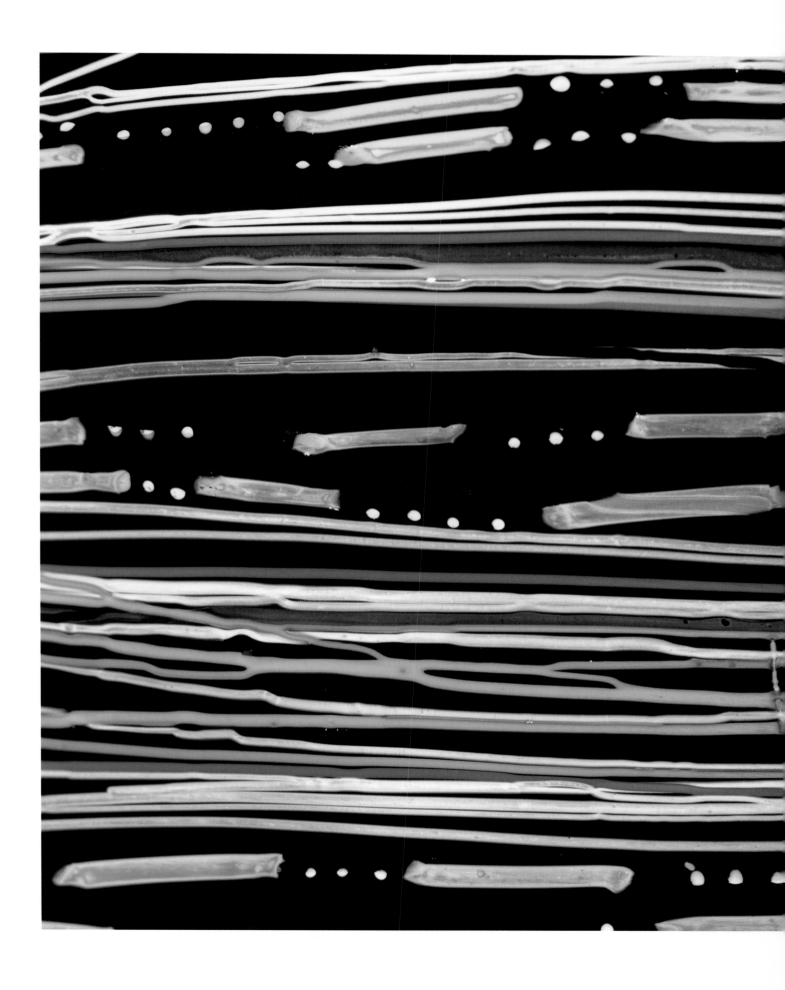

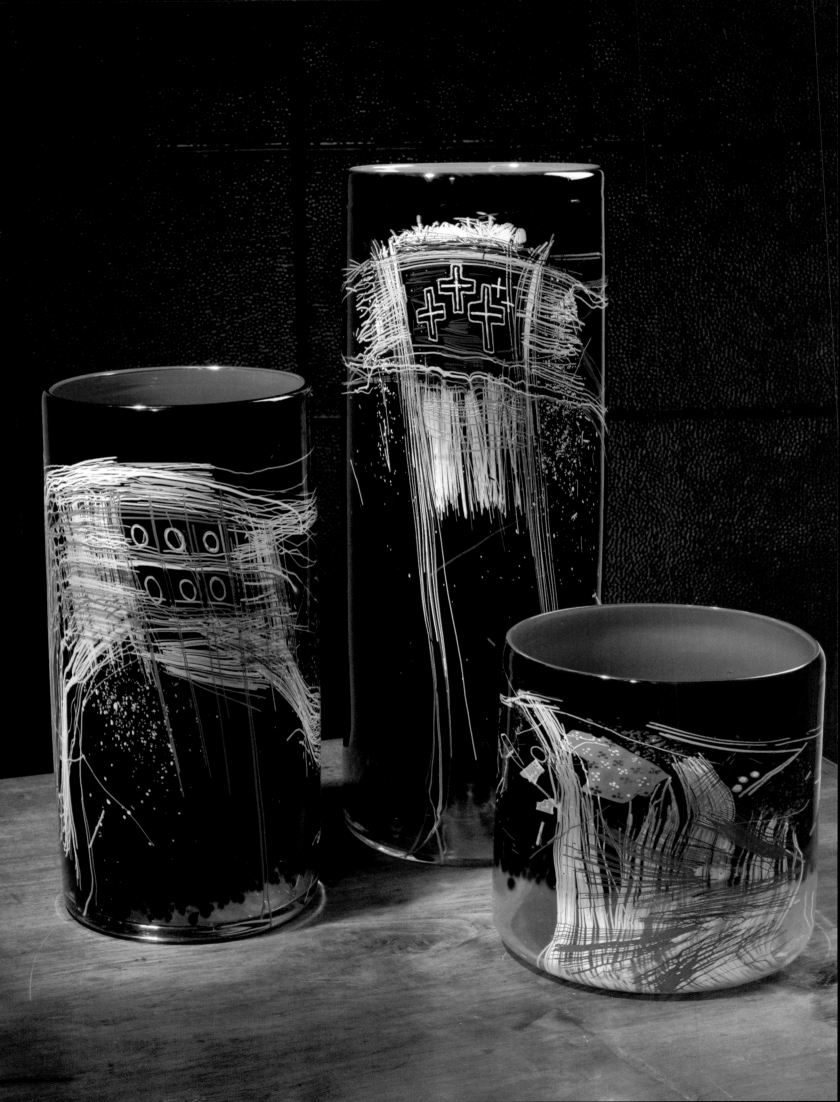

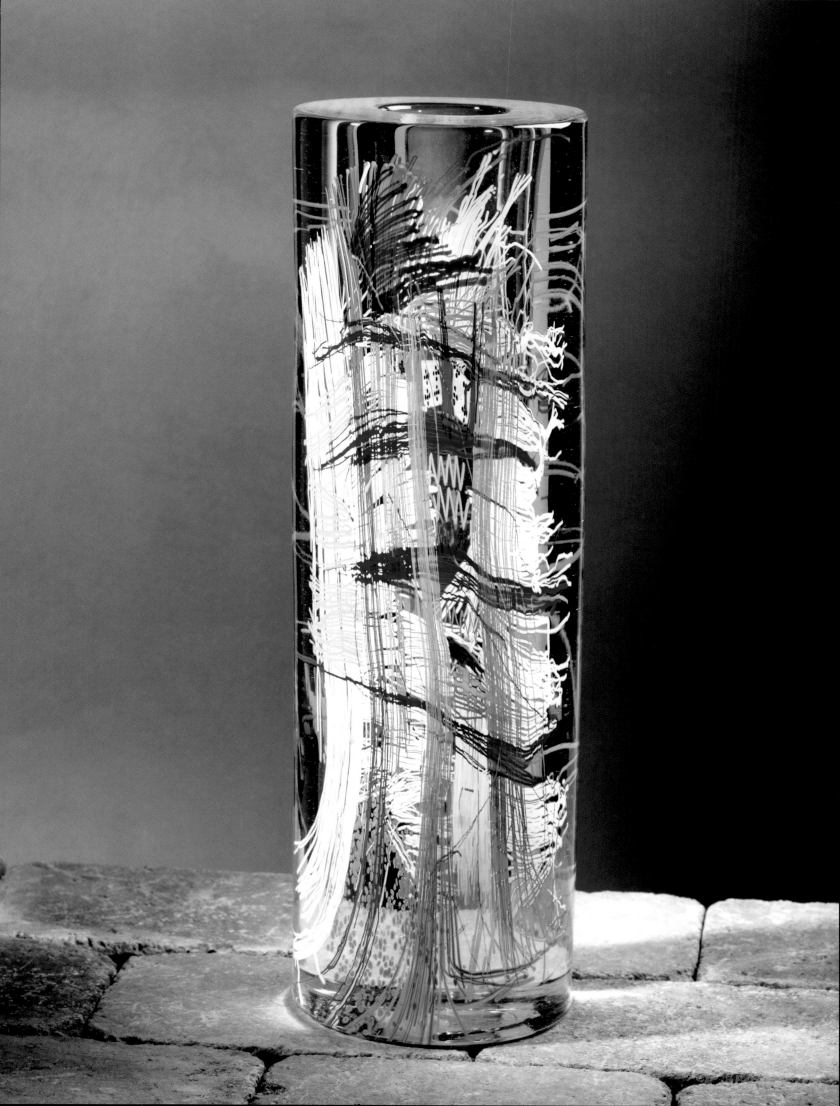

# Baskets

These pure forms in sheer shades, originally tabac or the red of embers and later honeyed yellows and the blues of dusk, translated woven fiber into a less flexible but more mercurial material—glass. The *Baskets* enabled Chihuly to combine his early interest in weaving with his passion for glassblowing.

<div align="right">Karen S. Chambers, 1992</div>

Dale Chihuly is representative of the artist who chooses to confront the demanding, paradoxical medium with his own vitality, passion, intellect, and skill. Acting and reacting, acting and reacting, he is in daily pursuit of the essence of his medium, attempting not only to probe and question the definitions and standards of the past, but to open himself to the improvisational possibilities of glass . . . His *Basket* series is an exploration of forms rather than surface. It was inspired by examples of Indian baskets from the Northwest Coast . . . Many of these artifacts, he observed with fascination, seemed to be collapsing under their own weight. This tension, pressure, or force is reflected in his glass baskets, which appear malleable and very light . . . They seem to be moving under a stress more sensed than seen.

<div align="right">Michael W. Monroe, "Baskets and Cylinders: Recent Glass by Dale Chihuly," Renwick Gallery,<br>National Collection of Fine Arts, 1978</div>

The *Baskets* turned out to be one of the best ideas I have ever had. I had seen some beautiful Indian baskets at the Washington State Historical Society and I was struck by the grace of their slumped, sagging forms. I wanted to capture this grace in glass. The breakthrough for me was recognizing that heat was the tool to be used with gravity to make these forms.

<div align="right">Dale Chihuly, 1992</div>

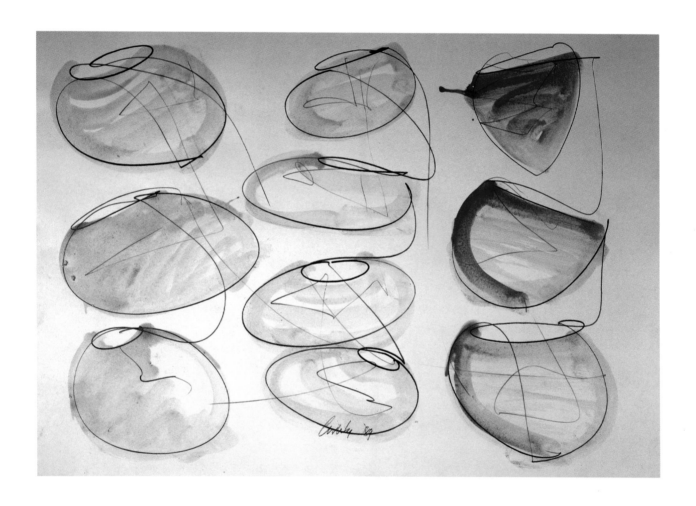

Pages 41 to 49

Pencil and acrylic wash with dry pigment on paper, 1989, 22 x 30"

Early Basket grouping, Stanwood, WA, 1978

**Spotted Melon Basket with Black Lip Wrap,** 1993, 16 x 16 x 15"

**Tobacco Basket Set with Chocolate Lip Wraps,** 1988, 6 x 17 x 17"

**Sun Yellow Basket Set with Terra Cotta Lip Wraps,** 2002, 14 x 14 x 12"

**Sky Blue Basket Set with Cobalt Lip Wraps,** 1992, 17 x 15 x 16"

Gray Wrapped Basket grouping, 1978, 10 x 40 x 24"

Brick Red Basket grouping, 1993

41

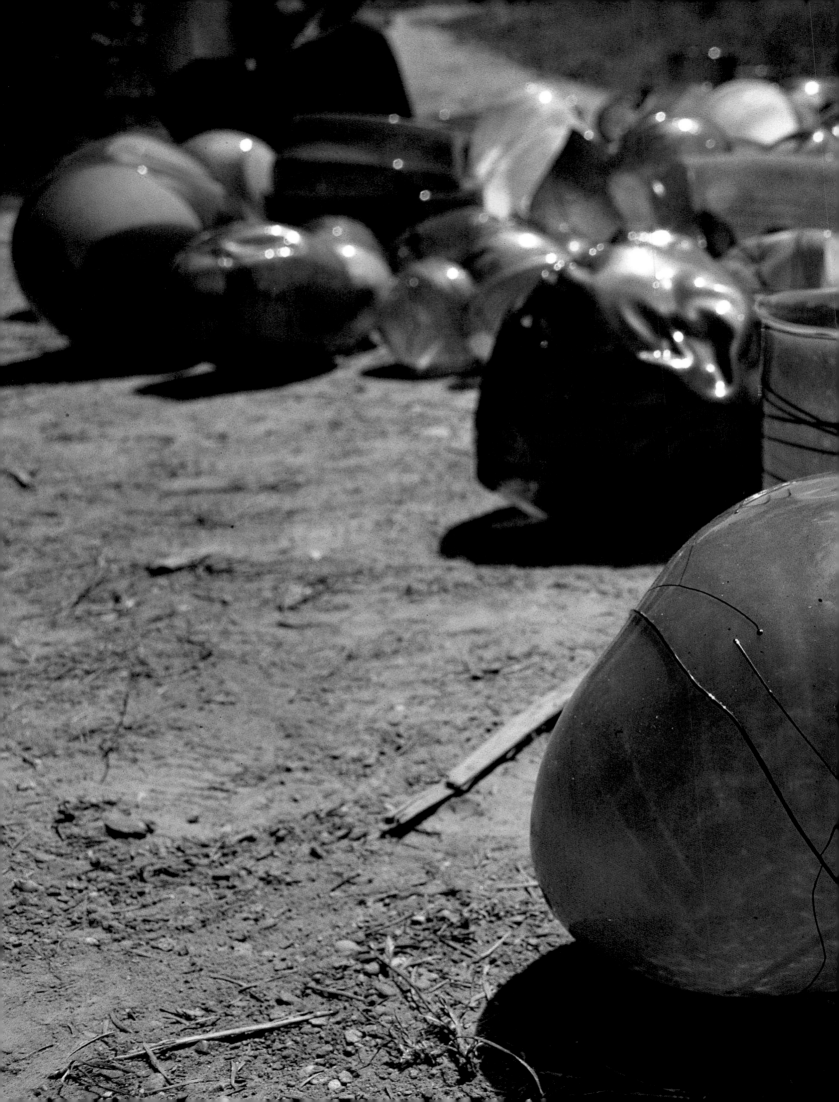

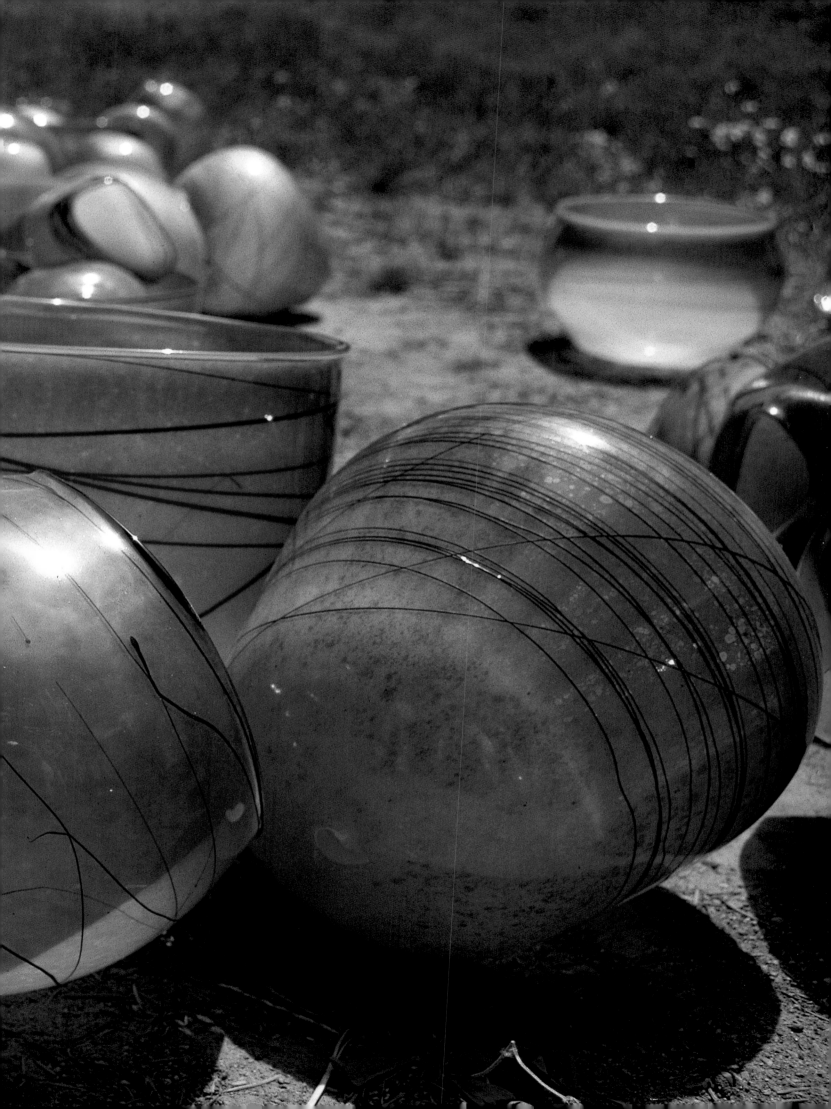

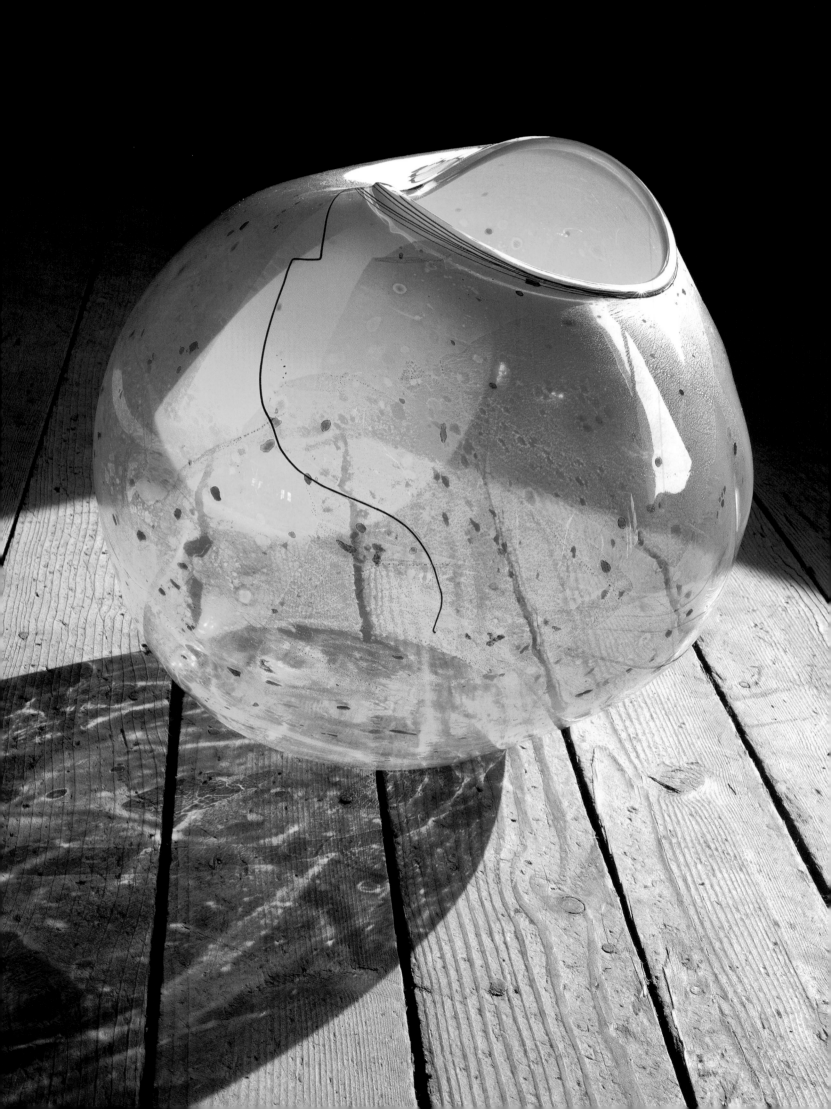

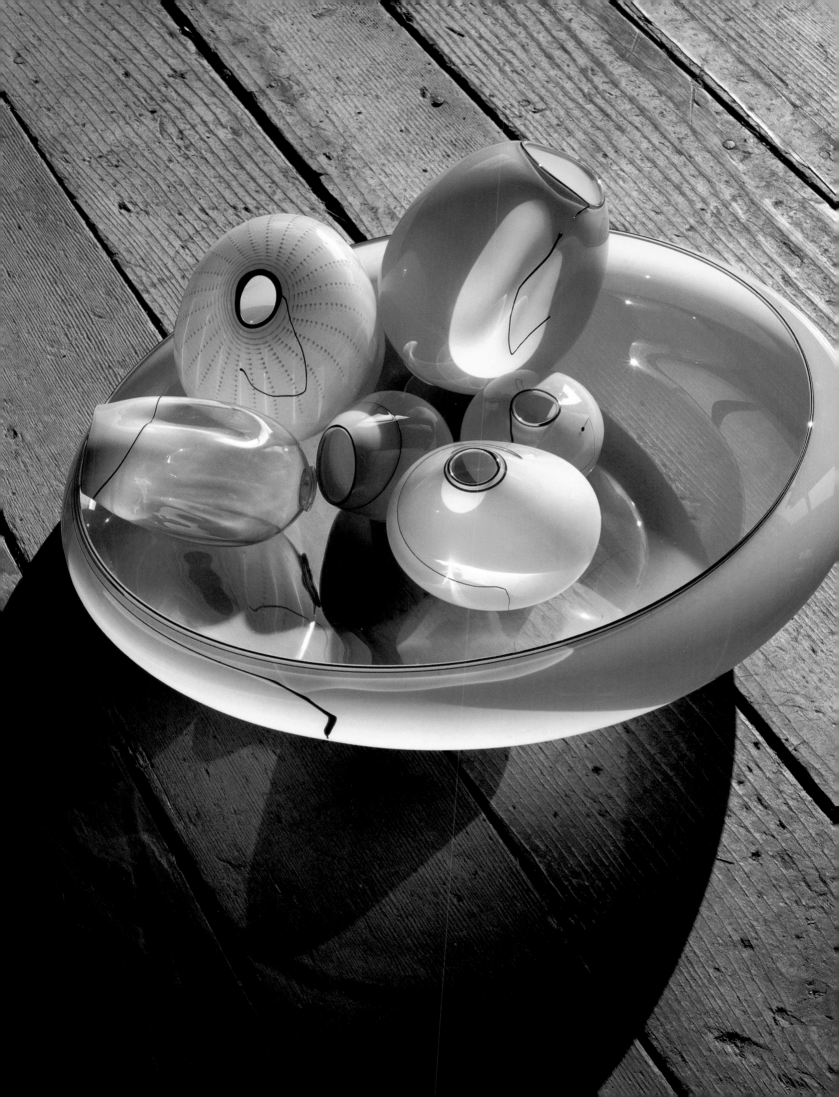

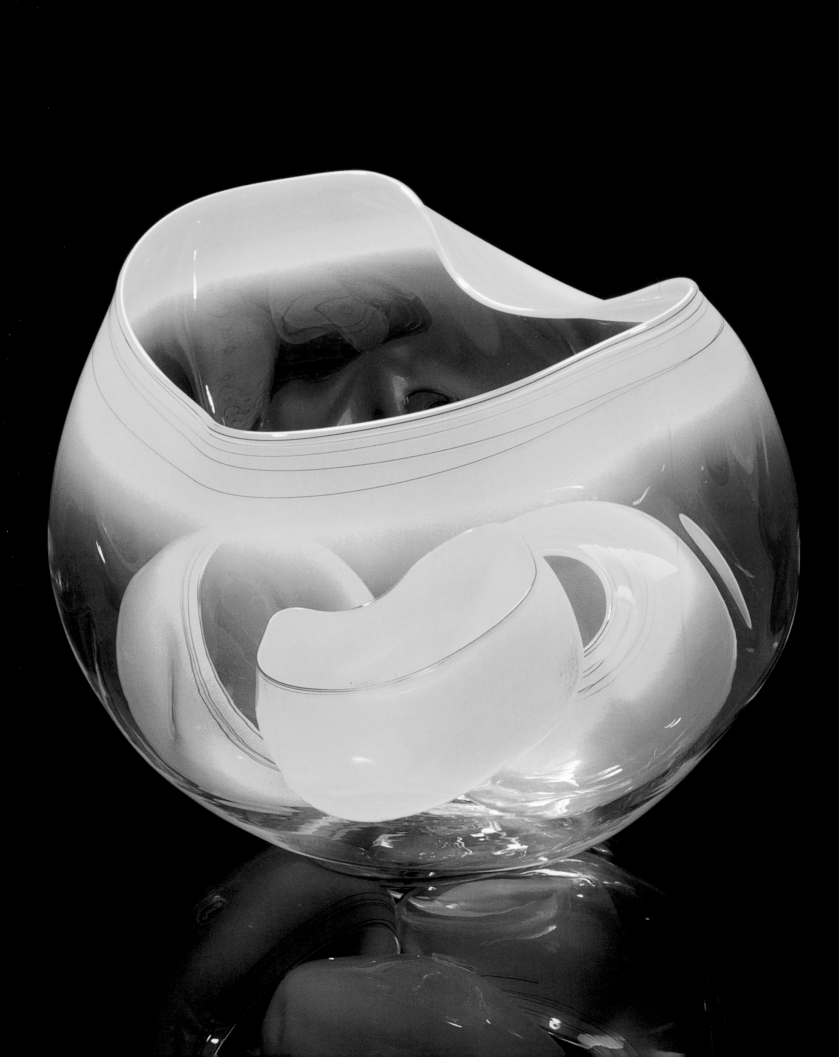

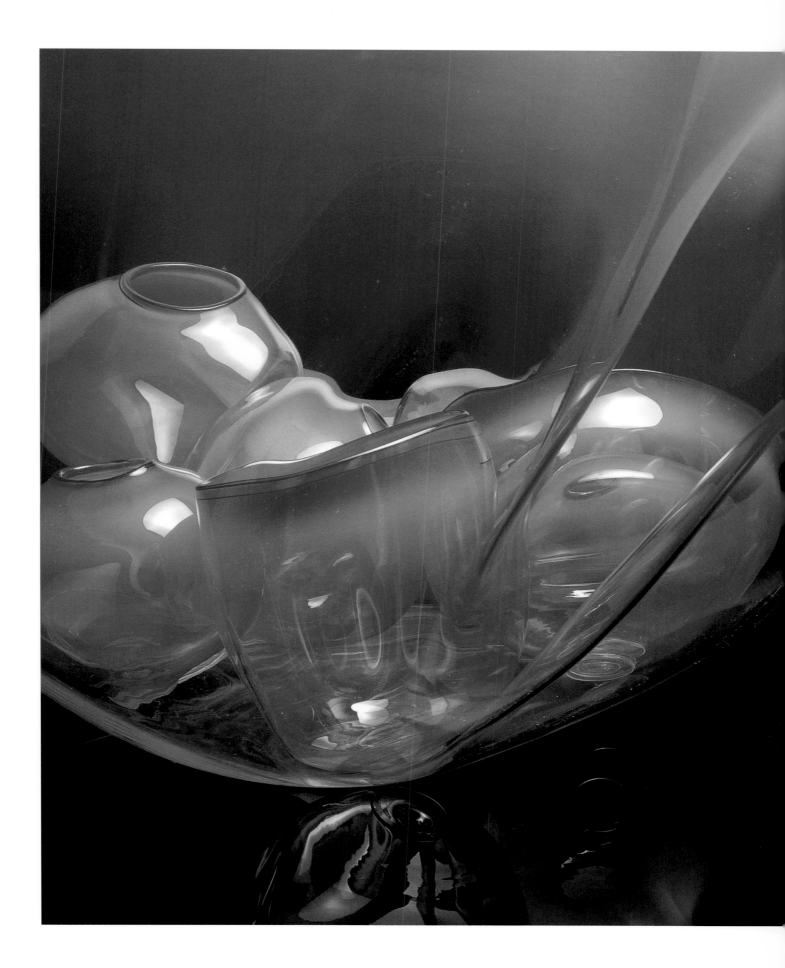

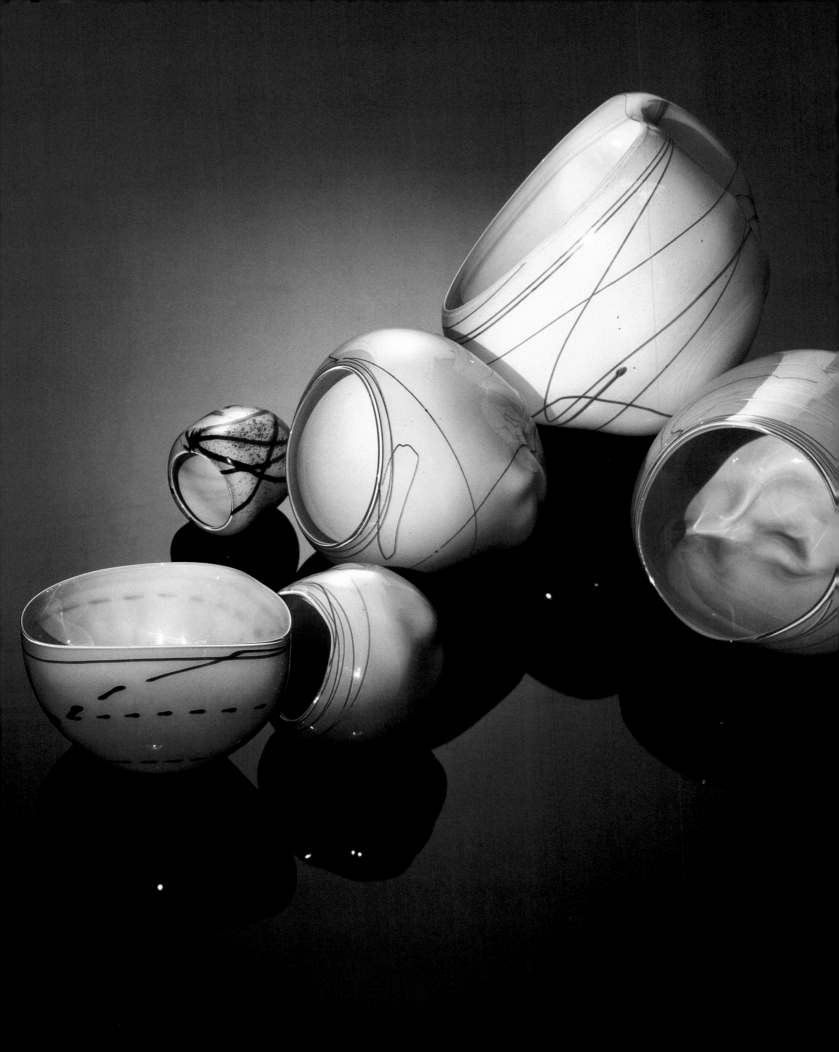

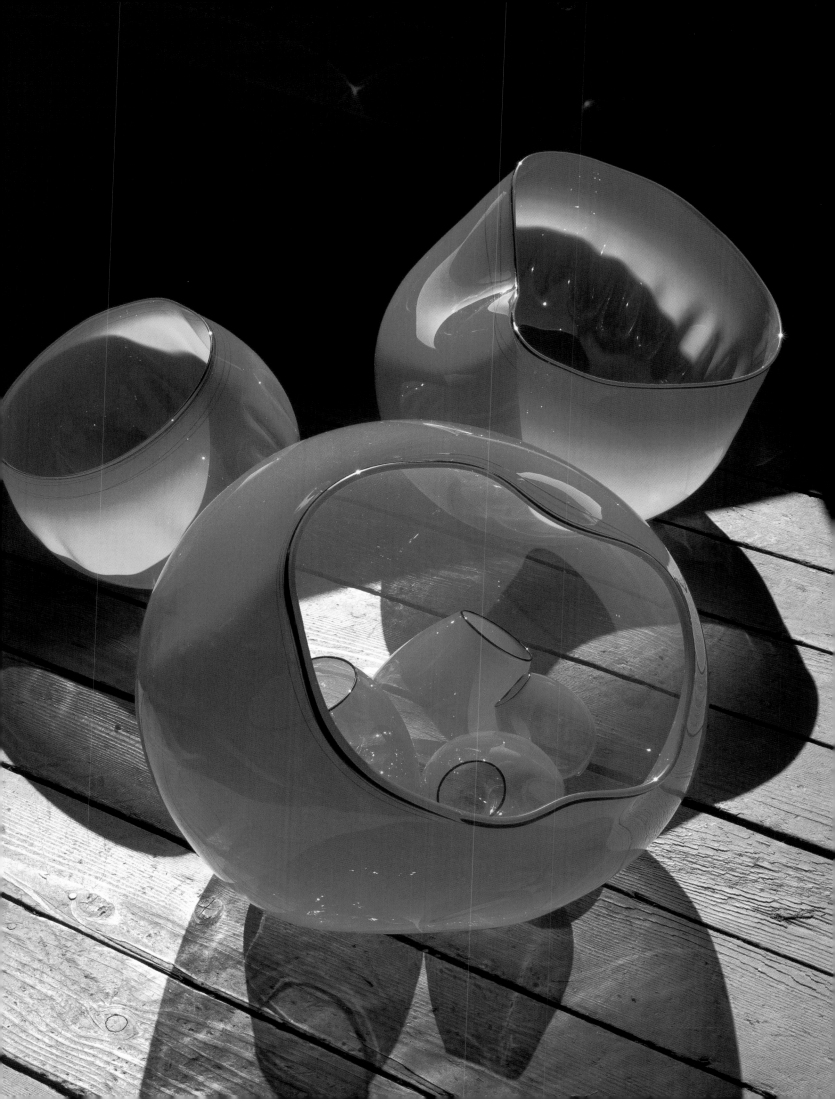

# Seaforms

When thin glass threads are trailed over the ridges in a continuous motion, they adapt to the unique contours of each form so that a fusion of form and decoration occurs, differing markedly from the applied patches of drawing on many of the earlier *Baskets* . . . The new forms resemble sea urchins, distended sacks with small openings covered in pinpoints of white that spiral out from their opening. Other forms are more elegantly abstract.

Linda Norden, Arts Magazine, 1981

Chihuly's best pieces imply pure movement. It's as if his forms will surface to the top of the gallery room as soon as night comes. The pieces seem to float, one inside another, delicately tangential, each existing on its own.

Susan Zwinger, Santa Fe Reporter, 1981

The *Seaforms* seemed to come about by accident, as much of my work does—by chance. We were experimenting with some ribbed molds when I was doing the *Basket* series. By blowing the pieces into ribbed molds, it gave them more strength. It's sort of like corrugated cardboard or, actually, like seashells themselves, which are very often ribbed. Then the *Baskets* started looking like sea forms, so I changed the name of the series to *Seaforms*, which suited me just fine in that I love to walk along the beach and go to the ocean. And glass itself, of course, is so much like water. If you let it go on its own, it almost ends up looking like something that came from the sea.

Dale Chihuly, 1992

**Pages 51 to 59**

Pencil, watercolor, and colored pencil on paper, 1989, 22 x 30"

**White Seaform Set with White Lip Wraps,** 1984, 5 x 18 x 12"

**White and Oxblood Seaform Set,** 1983, 11 x 19 x 9"

**Honeysuckle Blue Seaform Set with Yellow Lip Wraps,** 1993, 13 x 26 x 16"

**Pink and White Seaform Set,** 1990, 9 x 16 x 8"

**Misty Pink Persian Seaform Set,** 1983

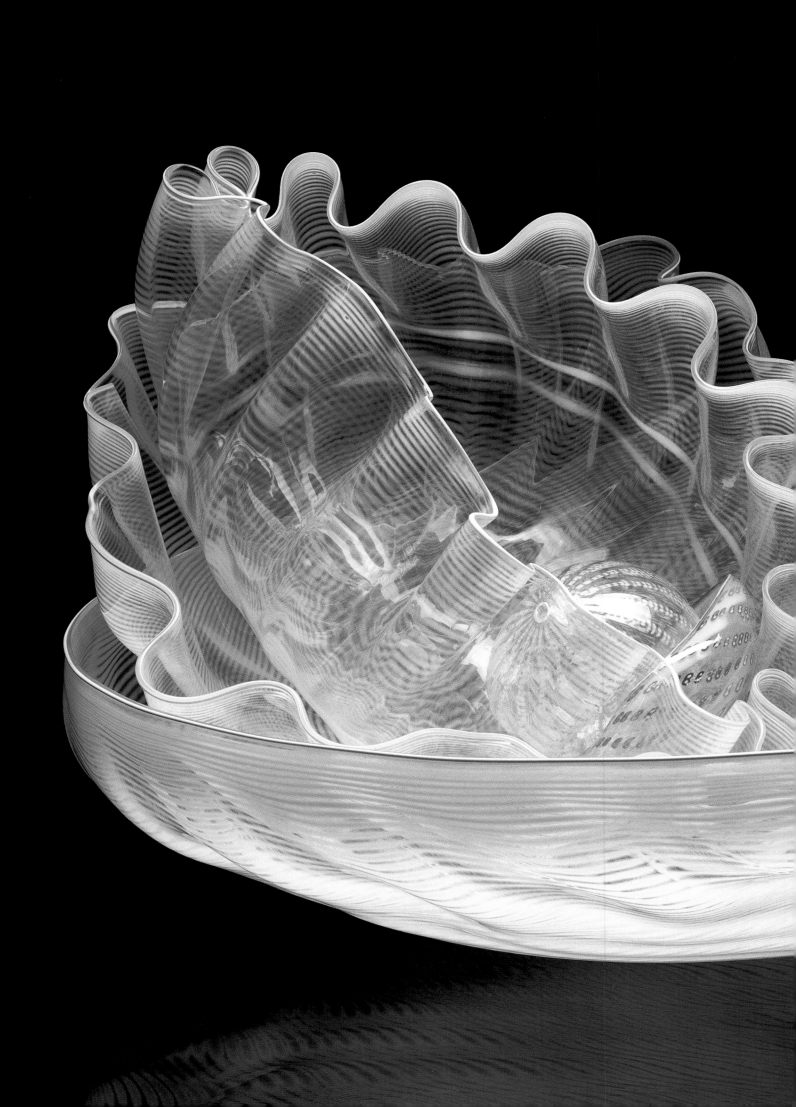

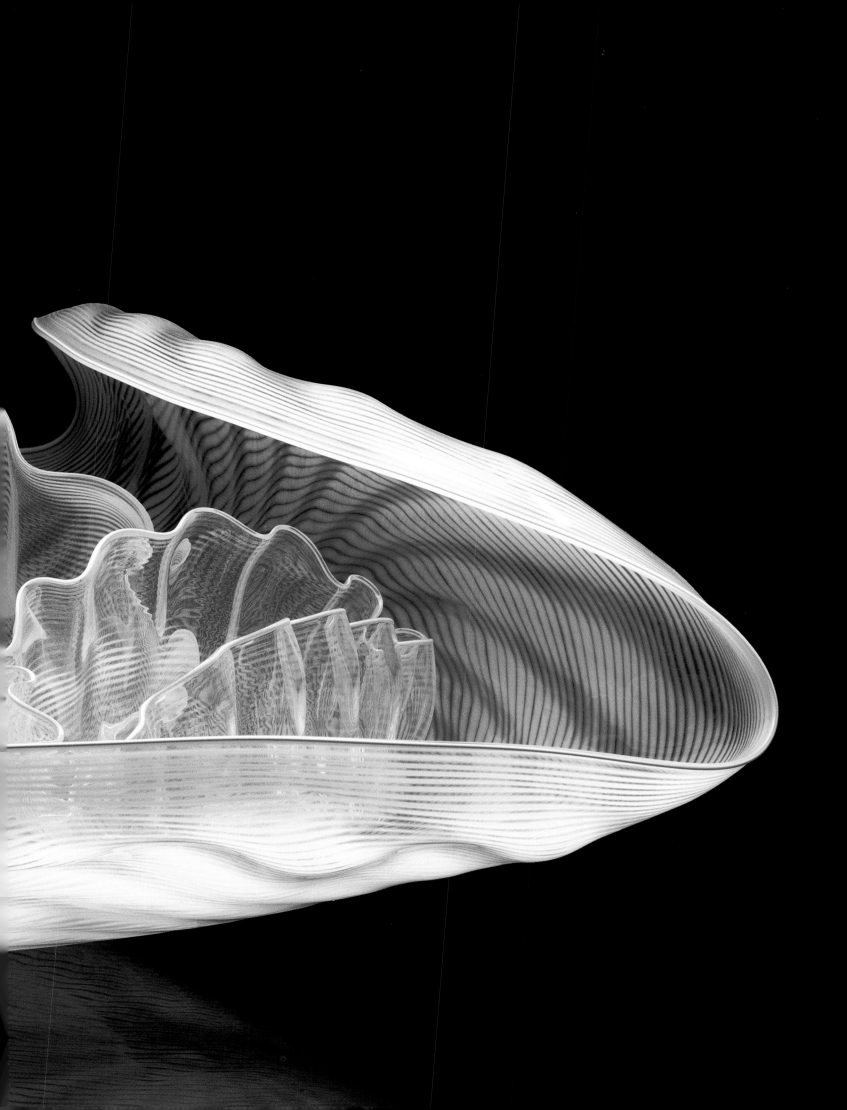

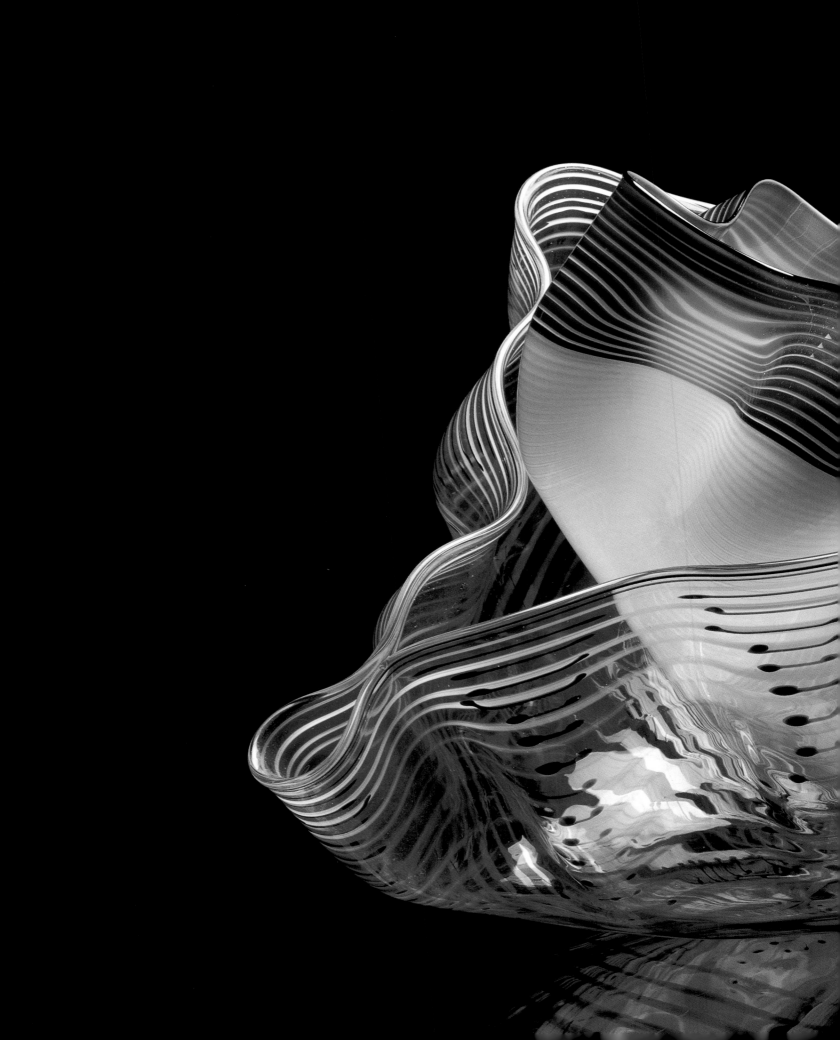

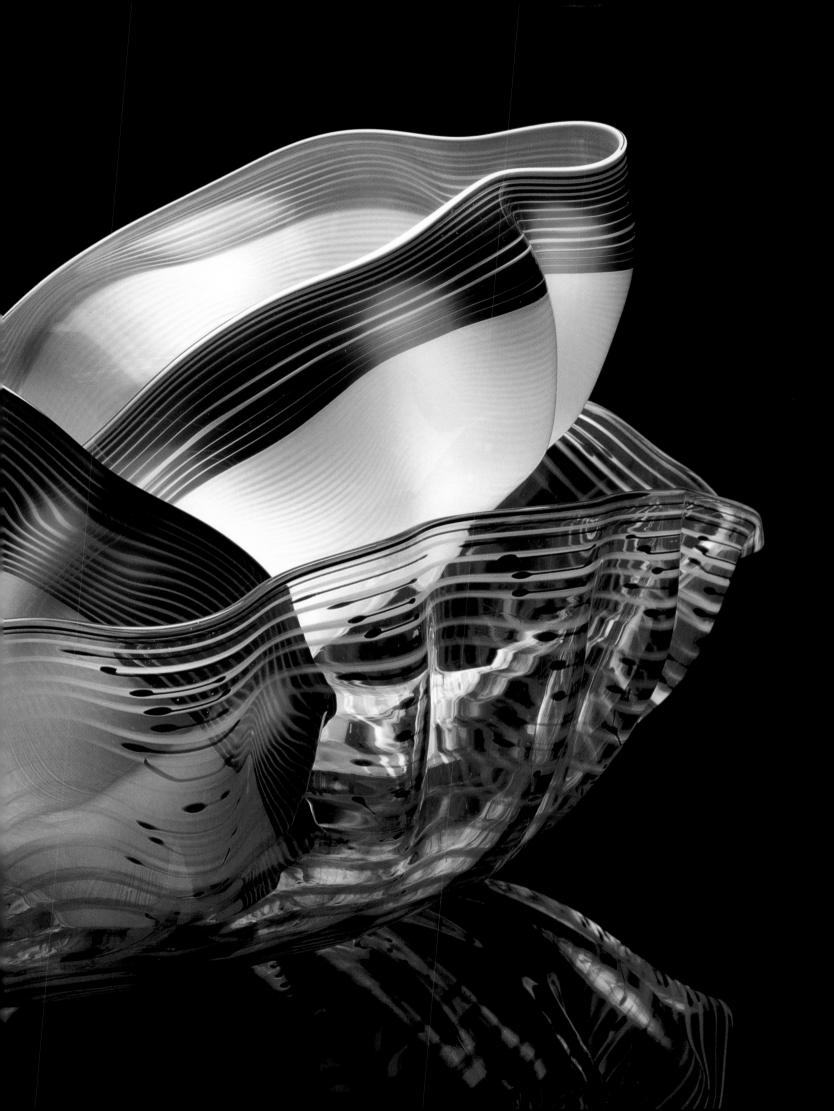

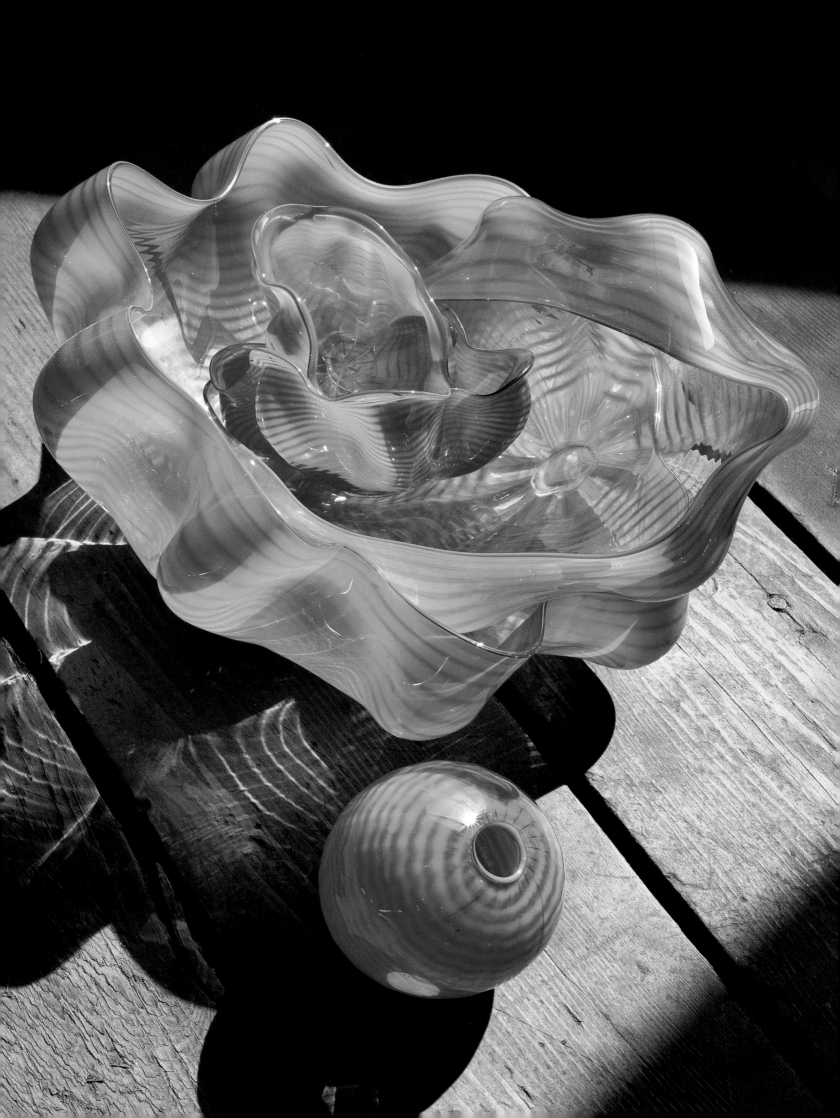

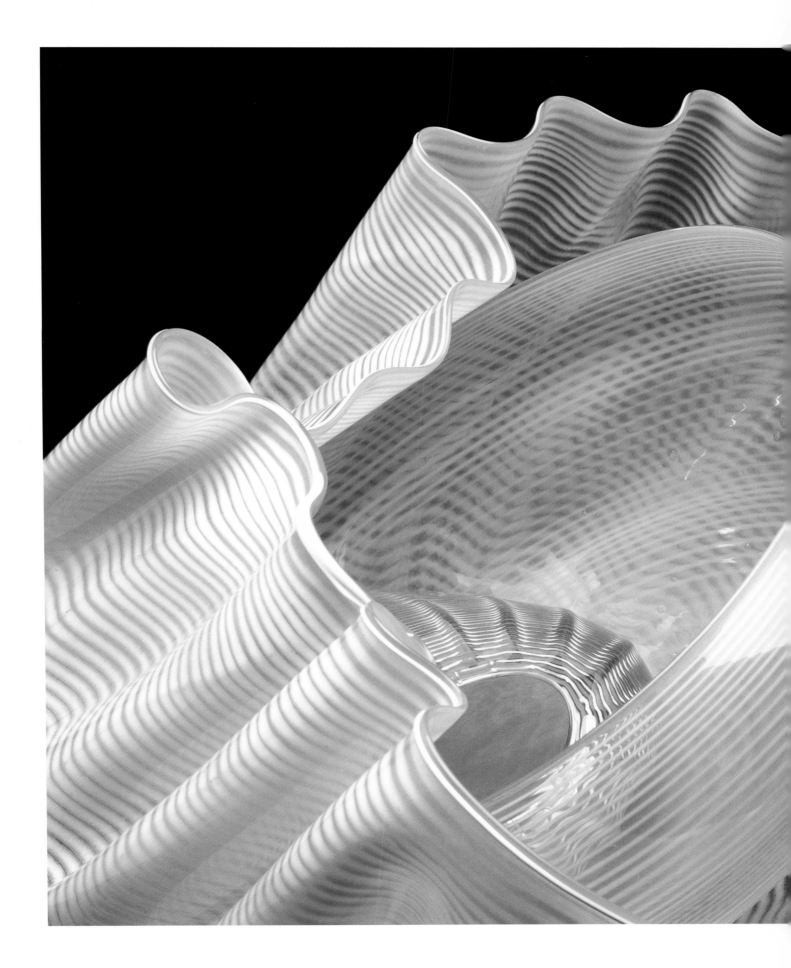

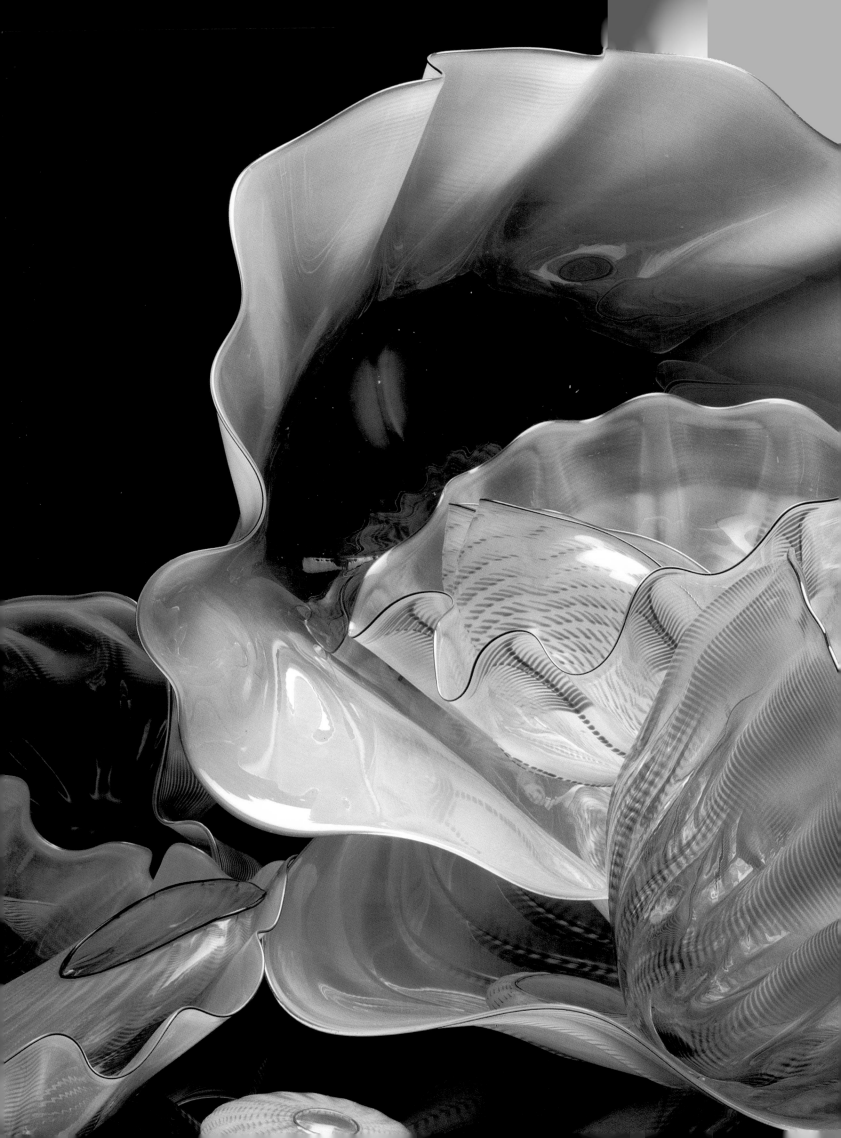

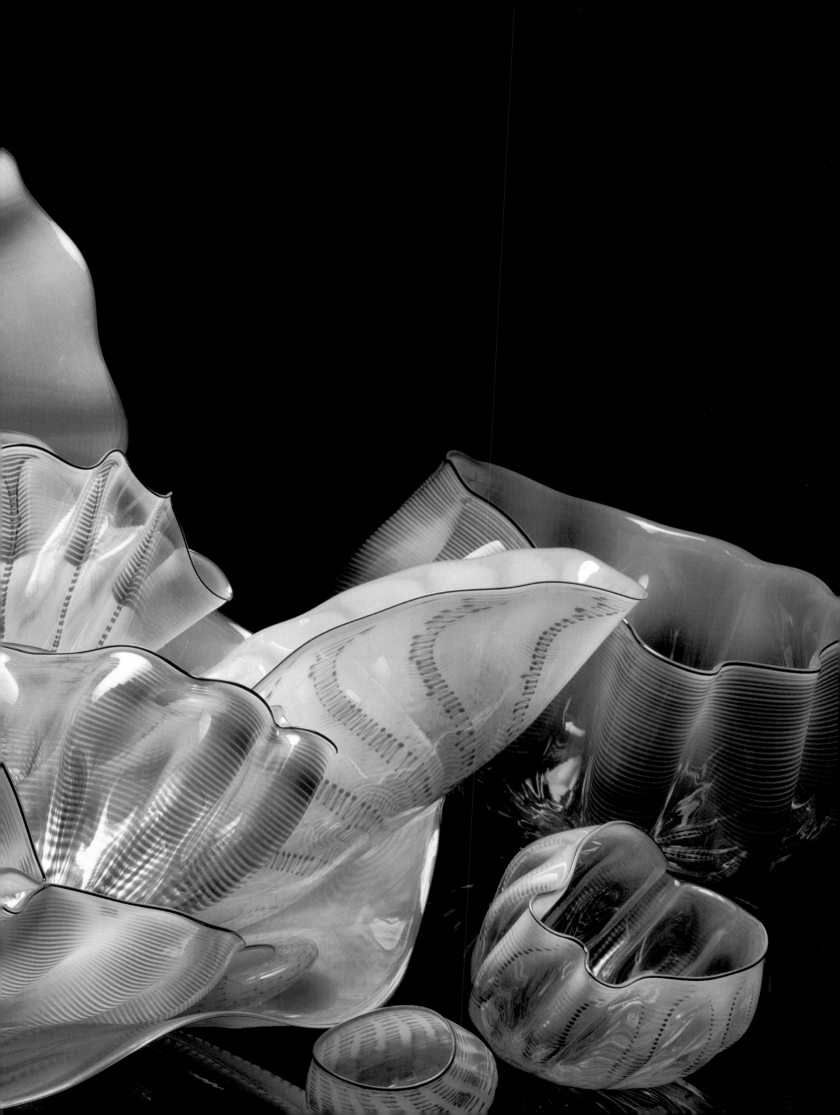

# Macchia

I was always looking at all these 300 different color rods that make up our palette. They come from Europe, mostly from Germany. I think it was in 1981 that I woke up one morning and said, "I'm going to use all 300 colors in as many possible variations and combinations as I can." I began making a series of pieces with one color inside and another color outside, and I discovered a way to put opaque white "clouds" between the two layers to clarify the colors, to keep the colors separate.

<div align="right">Dale Chihuly, 1992</div>

When glass objects reach the scale of Chihuly's *Macchia* series, a new identity is achieved. Glass no longer has to pretend to be unassuming, undemanding, and fragile, even though it continues to play on ephemerality. In the *Macchia*, the strength of the glass is suggested with references to geological formations. The colors in the *Macchia* are related to the colors of stones. Seen under bright light they look like nature caught on fire, nature in molten flux, nature in the process of being created.

<div align="right">Robert Hobbs, "Chihuly's Macchia," Dale Chihuly objets de verre, Musée des Arts Décoratifs, Palais du Louvre, 1986</div>

I had to come up with a name for the series, and I called my friend Italo Scanga and said, "Italo, what's the word for 'spotted' in Italian?" And he said, "Spotted in Italian is *macchia*, and *macchia* comes from immaculate, meaning unspotted." It also means "patina" and "to sketch," and there are artistic roots to it as well. I really like all of the meanings.

<div align="right">Dale Chihuly, 1992</div>

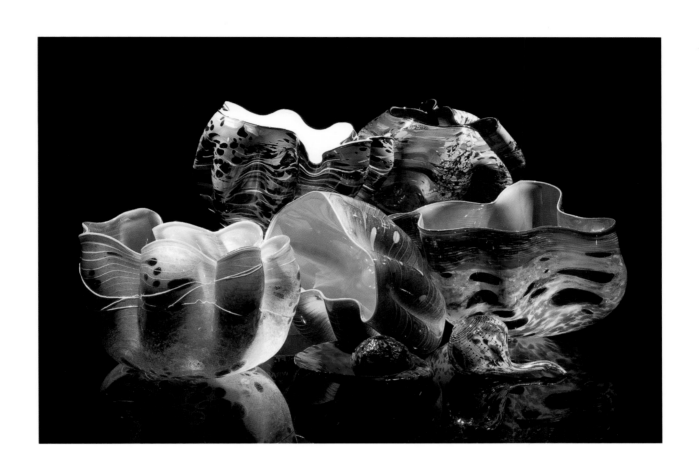

Pages 61 to 69

Macchia grouping, 1993

**Macchia Forest,** Seattle Art Museum, Seattle, WA, 1992

**Valencia Rose Macchia with Carmine Lip Wrap,** 2000, 19 x 24 x 23"

**Cerise Pink Macchia with Vermillion Lip Wrap,** 1992, 32 x 22 x 33"

**Macchia Forest,** Atlanta Botanical Garden, Atlanta, GA, 2004

**Macchia Forest,** Atlanta Botanical Garden, Atlanta, GA, 2004

**Kinau Court,** Honolulu Academy of Arts, Honolulu, HI, 1992

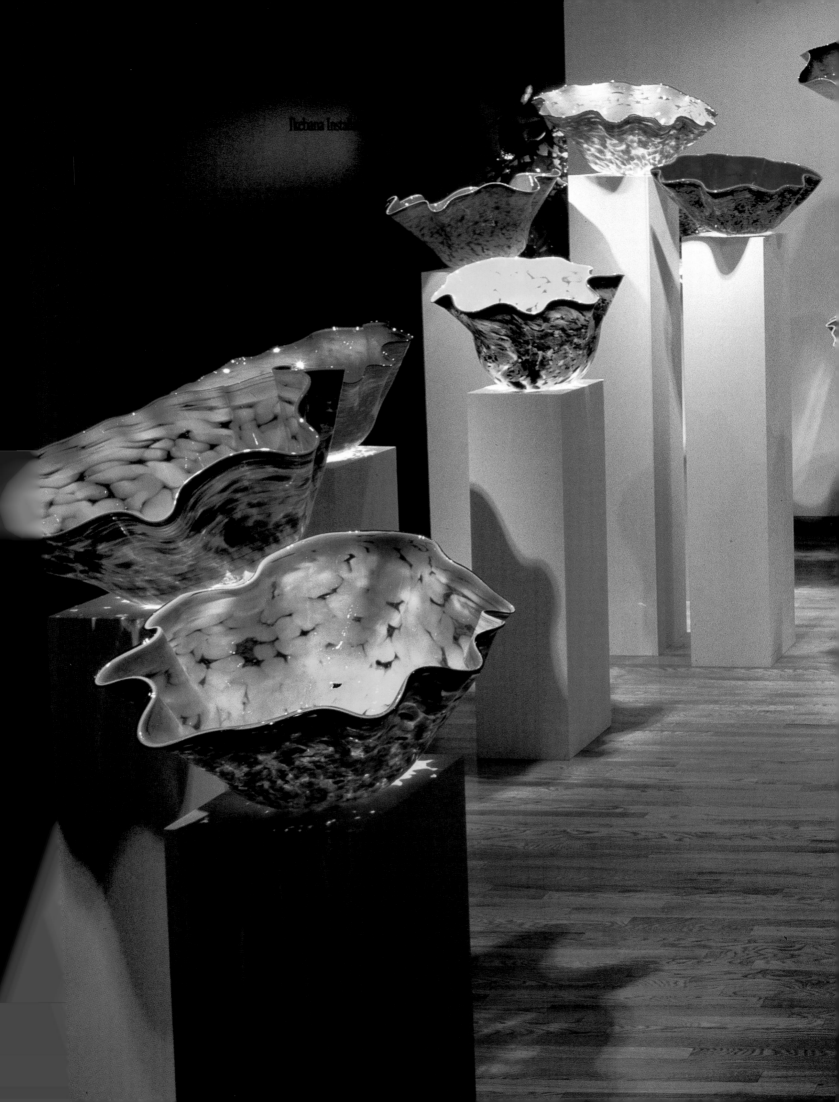

Ikebana Installation

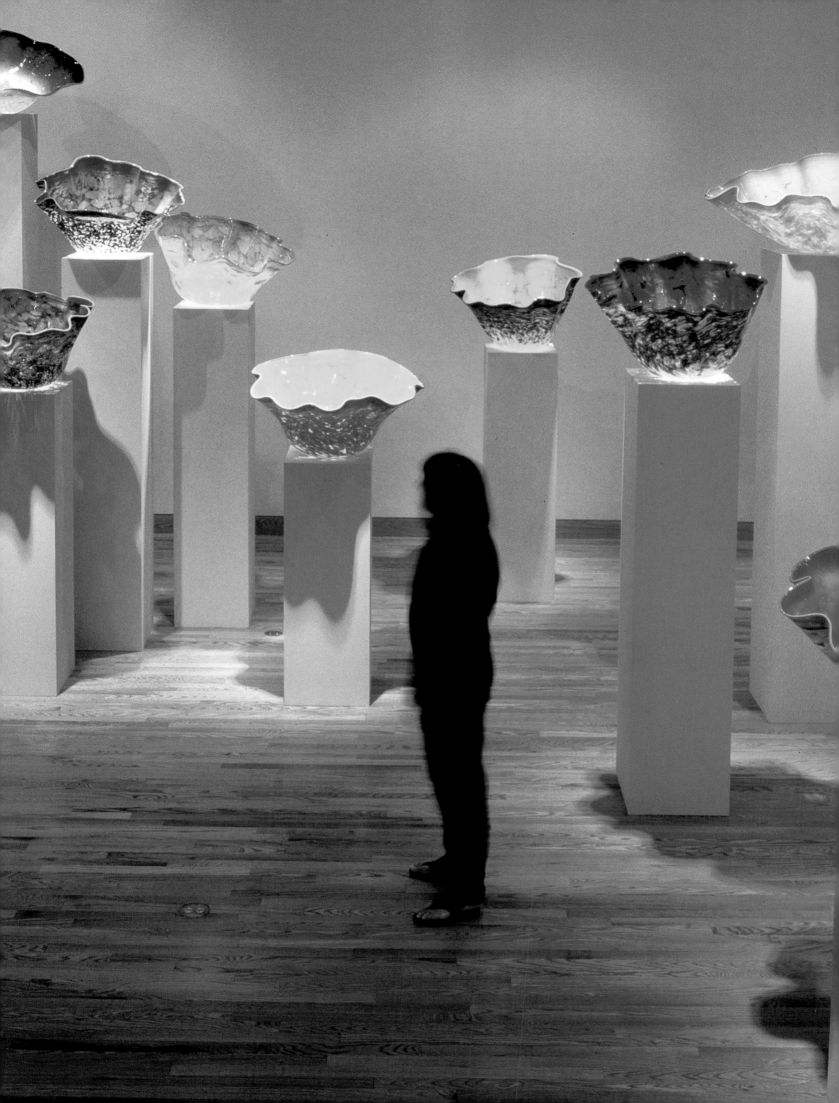

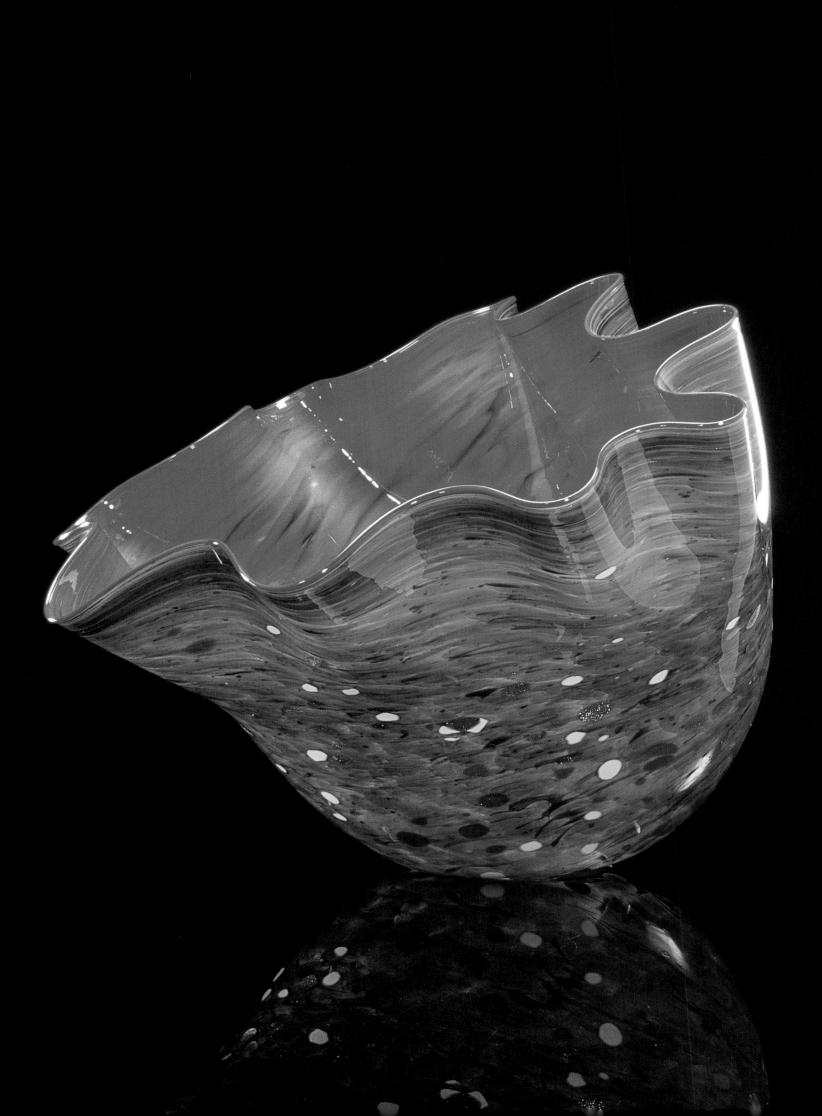

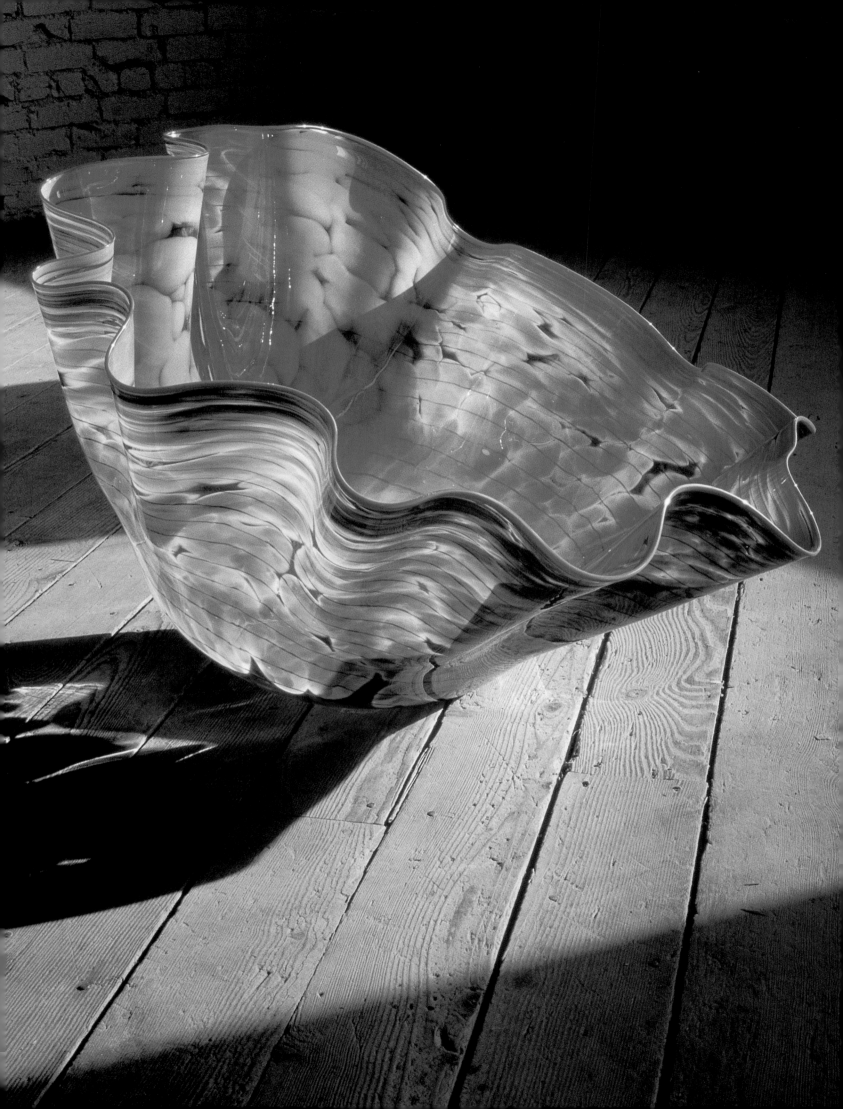

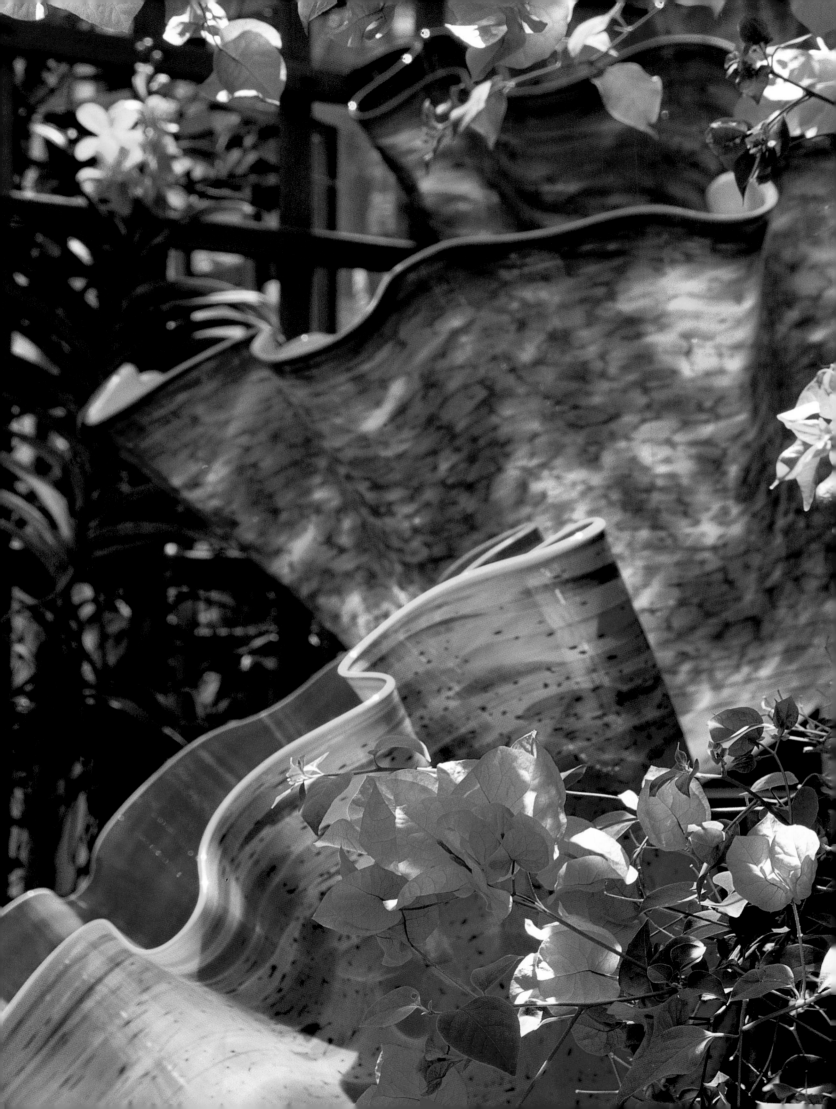

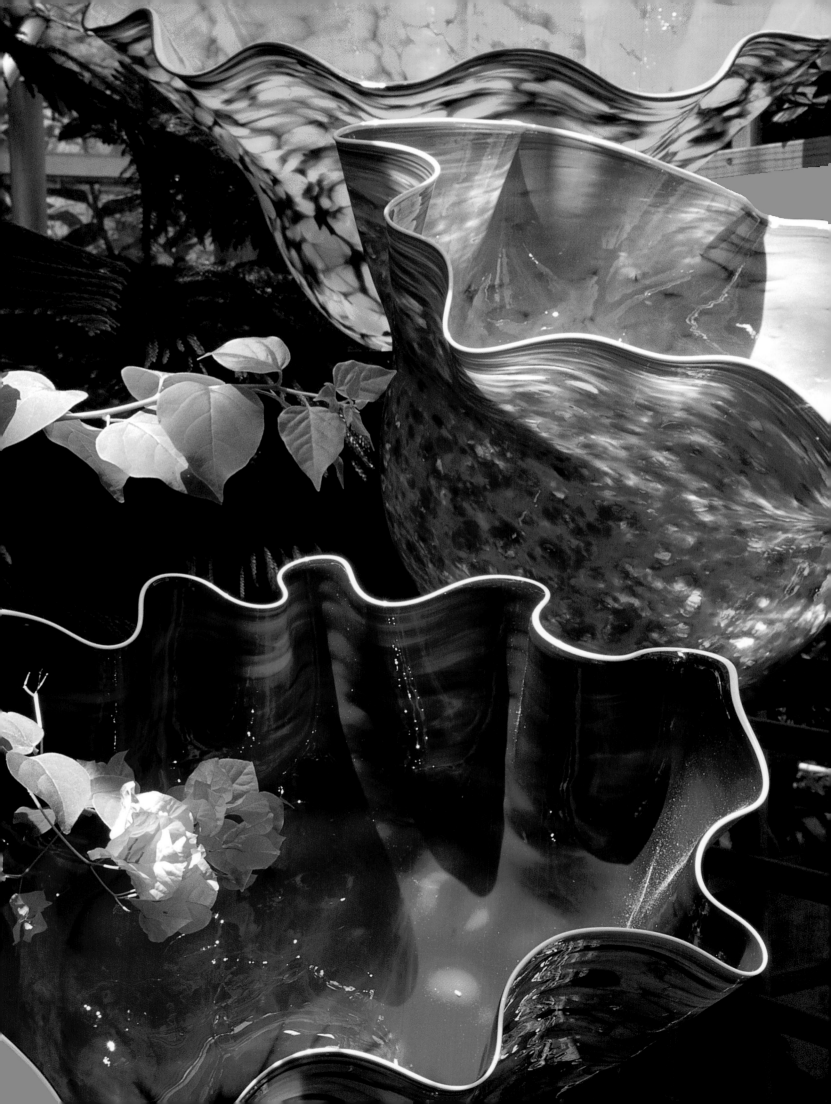

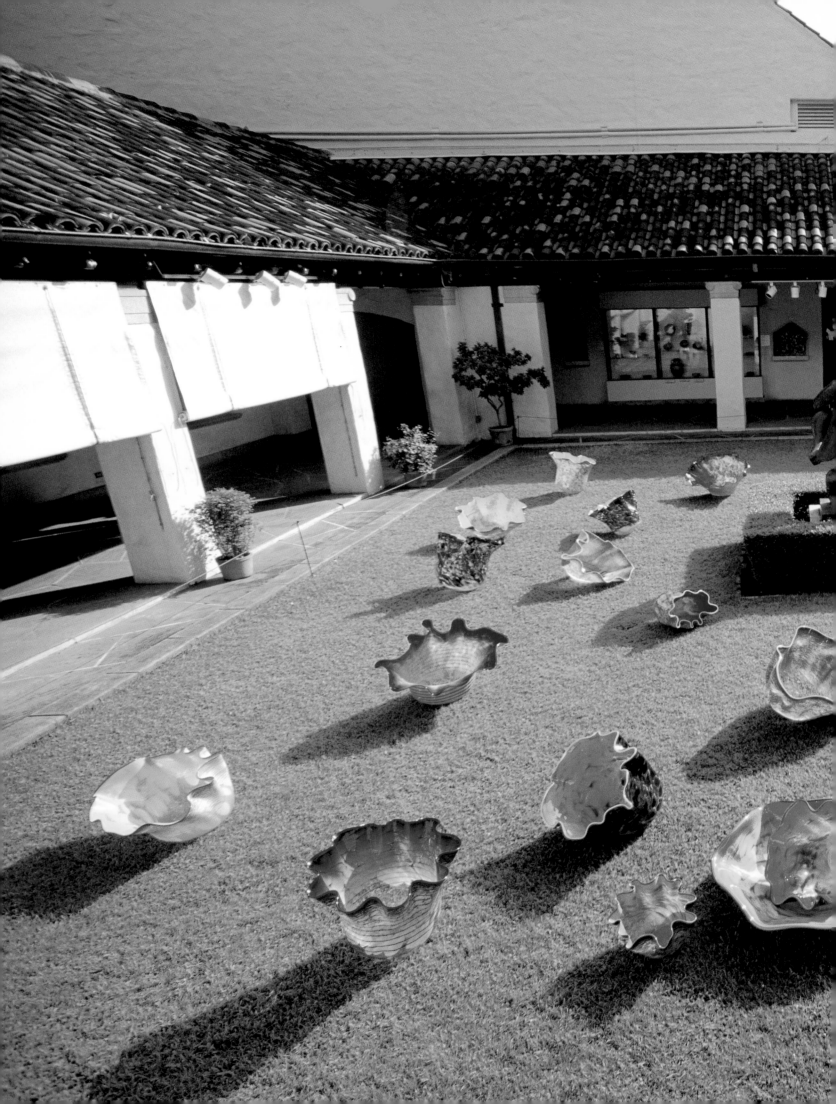

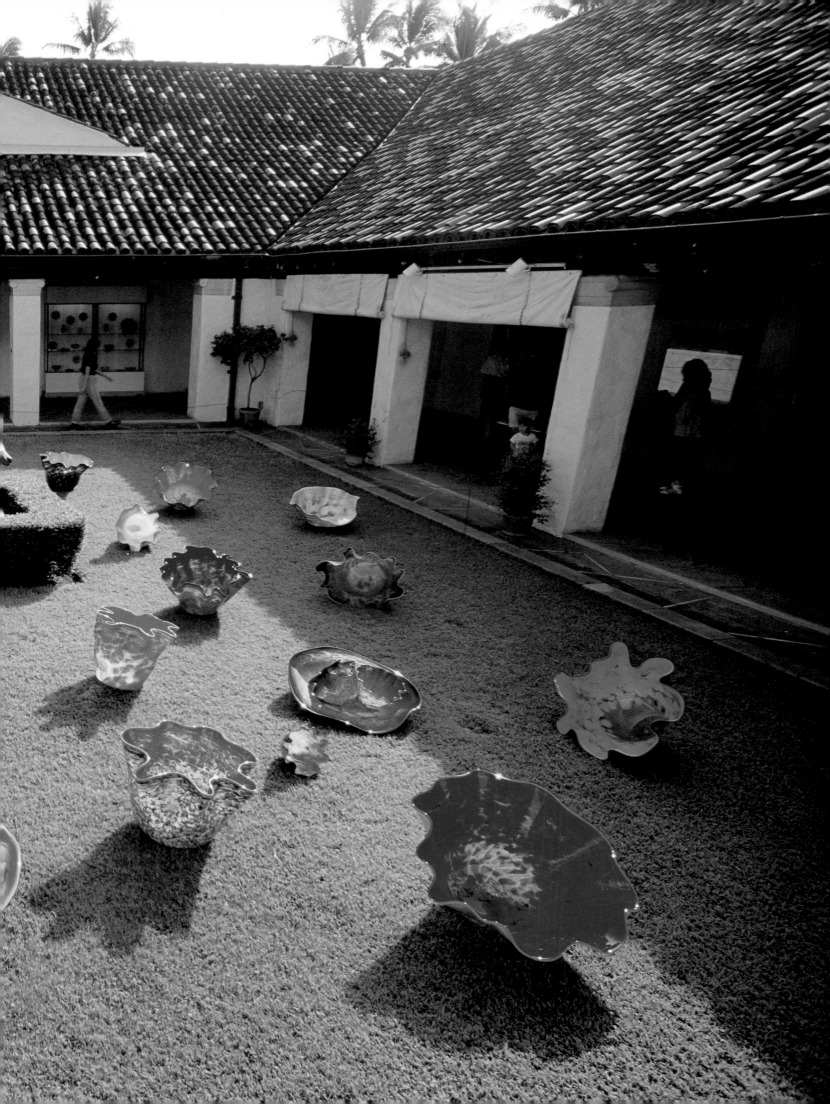

# Persians

The *Persians* started out as a search for forms. I had hired Martin Blank in 1985, just out of RISD, and I saw right away that he was very talented and creative. He wasn't concerned as much with craftsmanship as he was with experimenting, so I immediately set him and Robbie Miller up in a corner of the hotshop at Pilchuck while the big team, headed by Billy Morris, was working on large *Macchia*. I would make large pencil drawings for Martin and Robbie with a couple dozen small forms, and then I would put an X under the ones I wanted them to go for. Over the next year, we made more than 1,000 miniature experimental forms.

<div align="right">Dale Chihuly, 1992</div>

The individual elements in the *Persians* still exude life. The elasticity of each form manifests glass's real character as a frozen liquid, as molecules held in suspension . . . The individual elements composing the *Persians* simulate the rhythms and forces of life . . . The delicacy and fragility of Chihuly's glass as well as its tentative placement is an impression of this world: the series is like some wonderful perfume blown across the great central Iranian desert. The pieces allude to romance, mystery, an ancient world and its survival in the present . . . Existence, as the *Persians* suggest, is always tentative and precarious, always something to be fought and won.

Robert Hobbs, "Dale Chihuly's Persians: Acts of Survival," Chihuly/Persians, Dia Art Foundation, 1988

The move from the object to the environment was inevitable for Chihuly, given his early experiments in site-specific installations. The tension of the contradiction between the fragile material and the exigencies of the public project became a dramatic encounter. His glass installations began to have a life of their own, like radiating tropical foliage or exotic flowers. Chihuly made dizzying varieties of *Persians*. Gradually they became room-size installations. Their shaded and expansive lips suggested vulval and erotic shell forms enhanced by the psychedelic rippling effects implicit in Murano techniques of striation. The 1994 window piece in Tacoma's Union Station, titled *Monarch Window*, acknowledges this inspiration.

<div align="right">Barbara Rose, 2000</div>

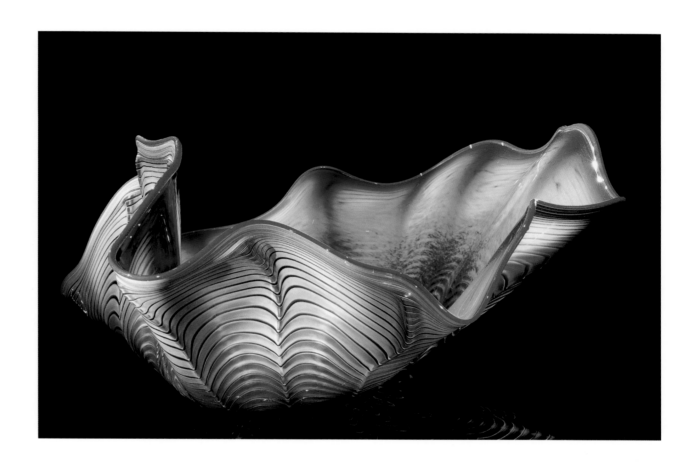

Pages 71 to 81

**Prussian Blue Persian with Ruby Lip Wrap,** 1990, 18 x 32 x 36"

**Chrome Green and Orange Persian Set,** 1988, 16 x 22 x 27"

**Dusky Violet Persian with Claret Red Lip Wrap,** 1994, 24 x 29 x 22"

**Festival Persian Set,** 1998, 9 x 42 x 39"

**Fiori di Como,** Bellagio, Las Vegas, NV, 1998

**Persian Pergola,** The Detroit Institute of Arts, Detroit, MI, 1993

**Monarch Window,** Union Station, Tacoma, WA, 1994

**Venturi Window,** Seattle Art Museum, Seattle, WA, 1992

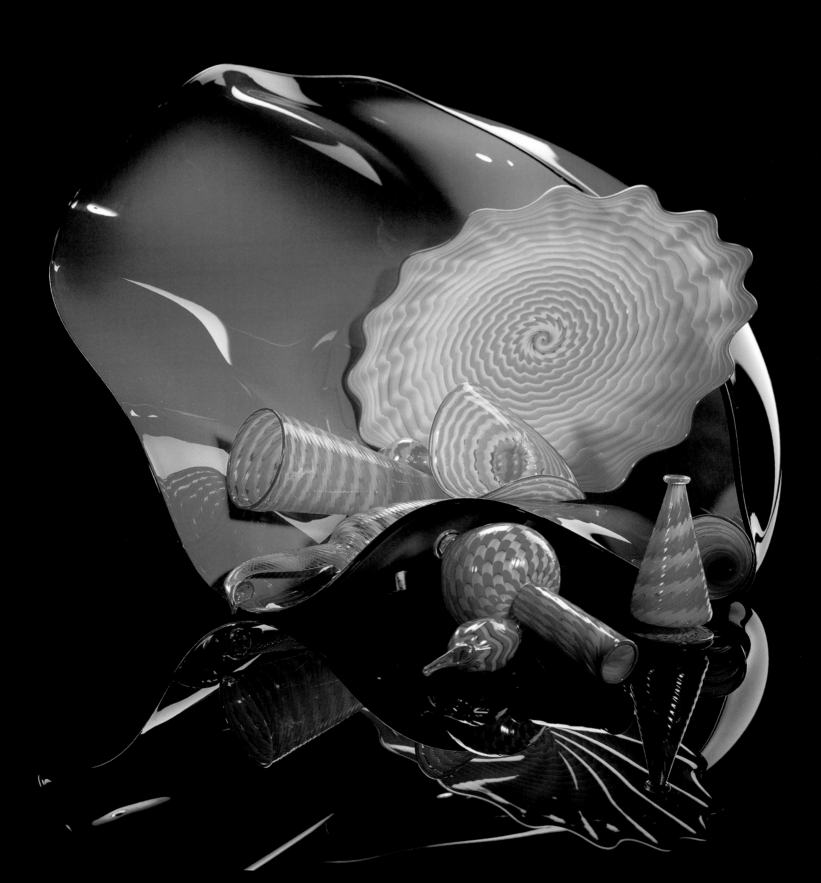

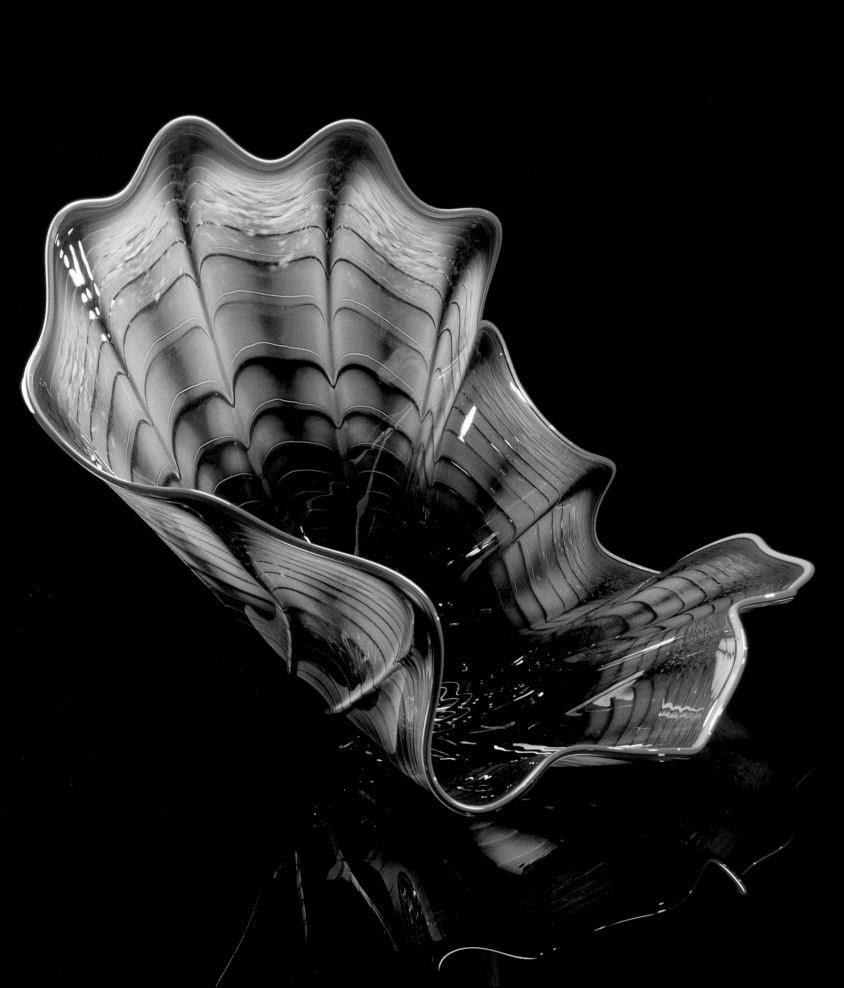

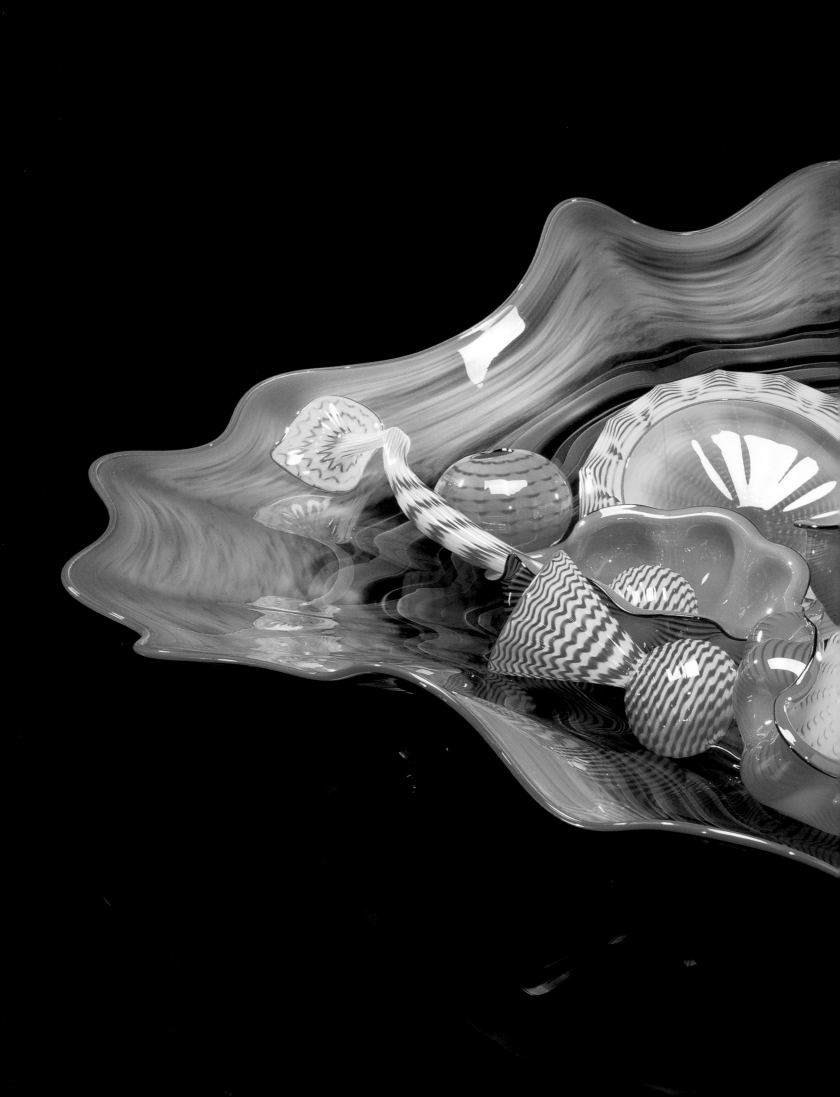

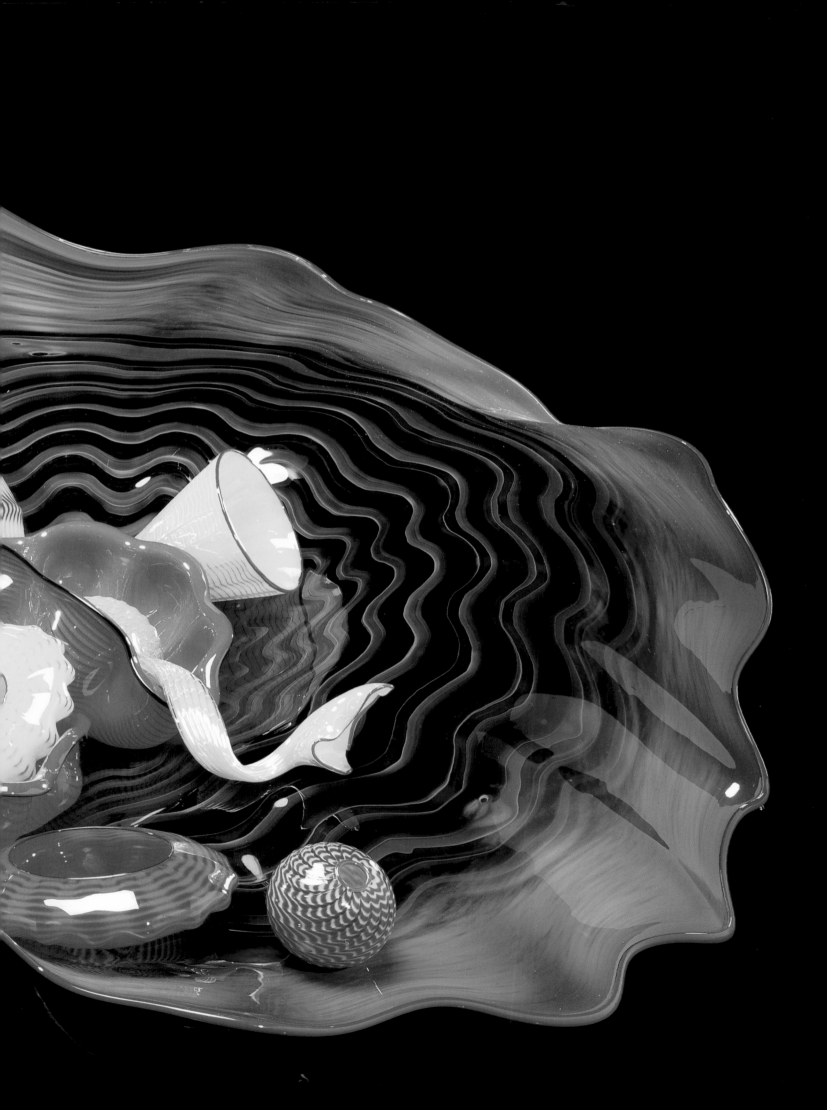

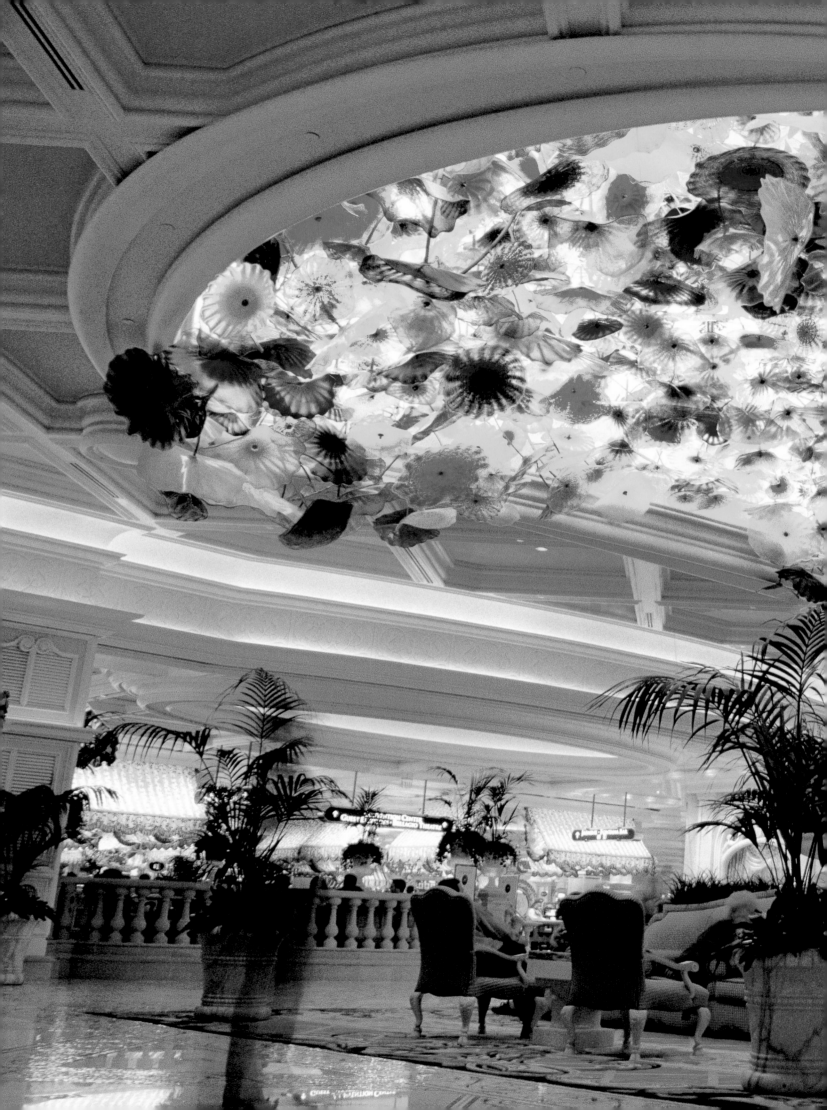

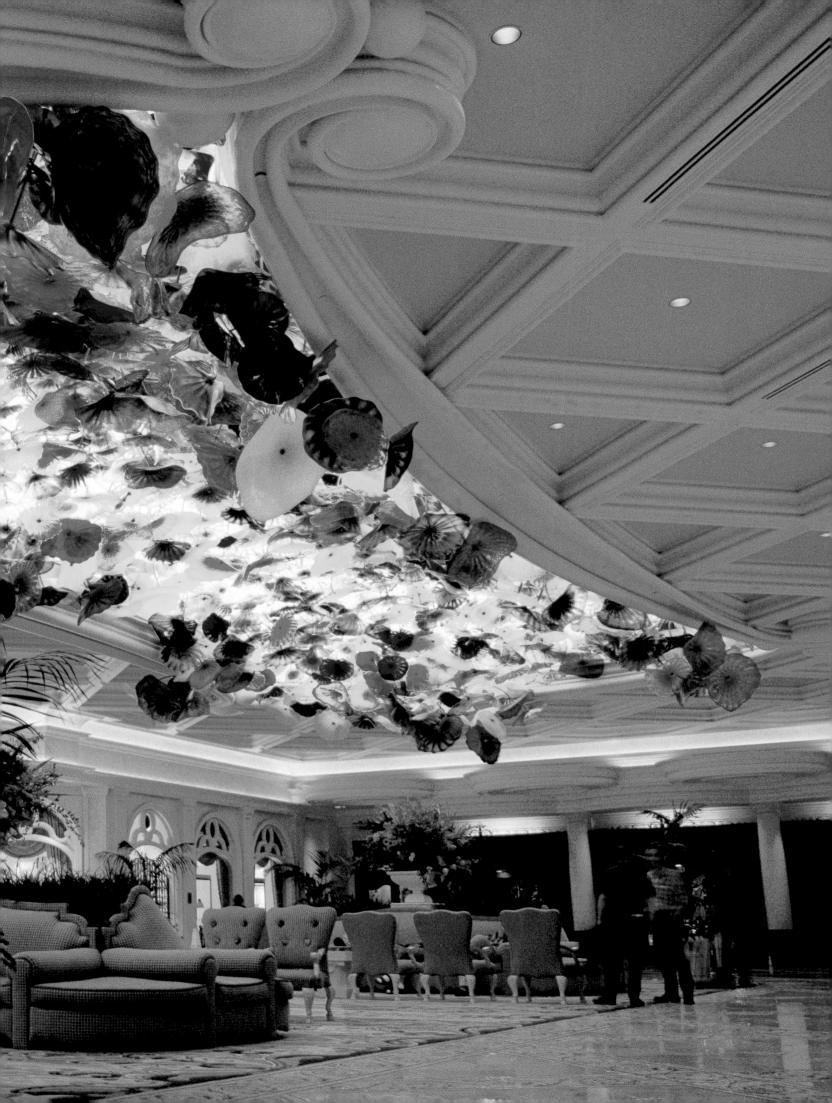

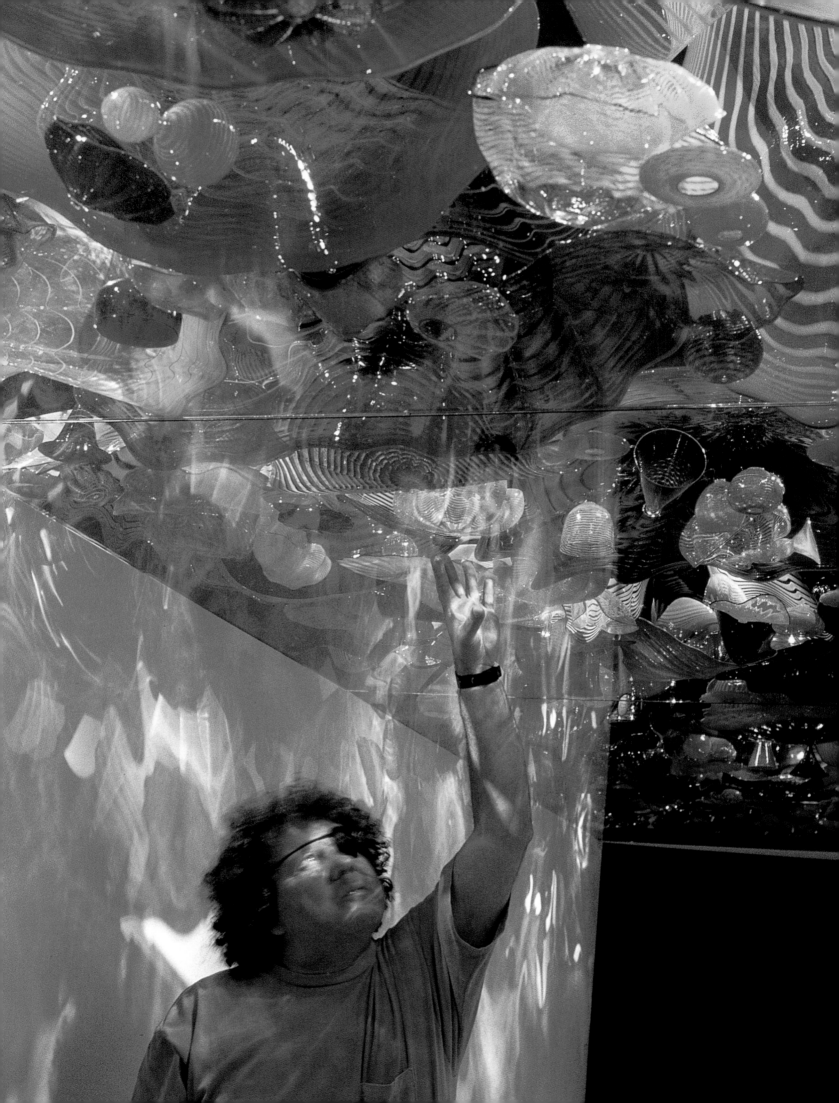

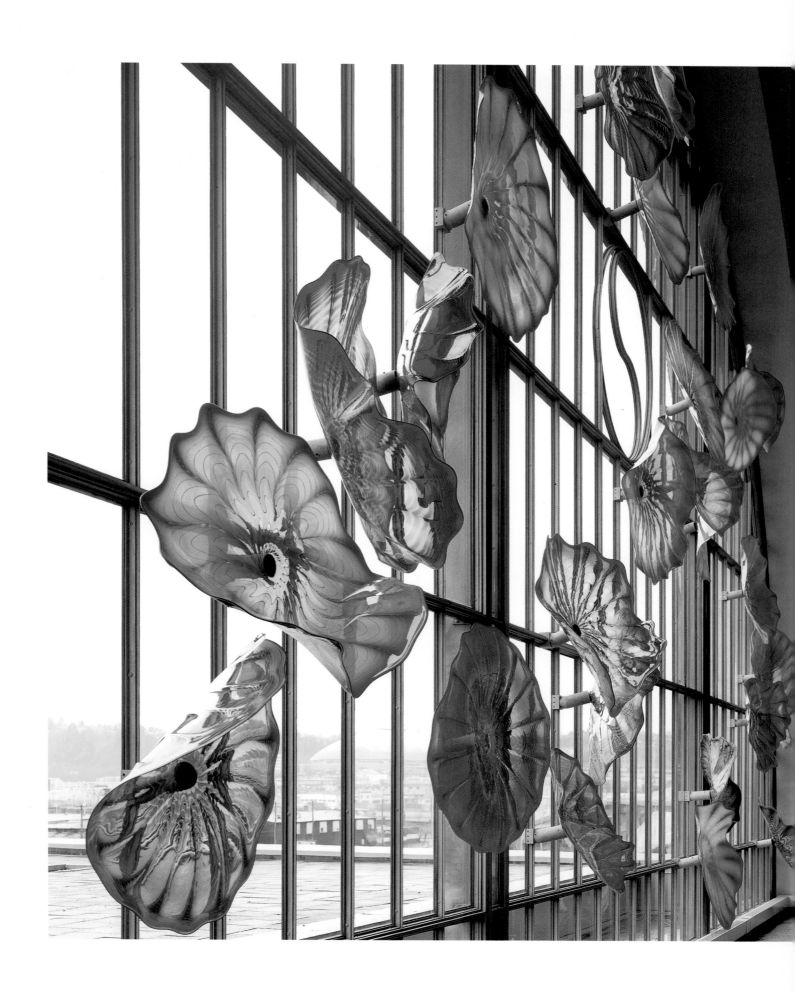

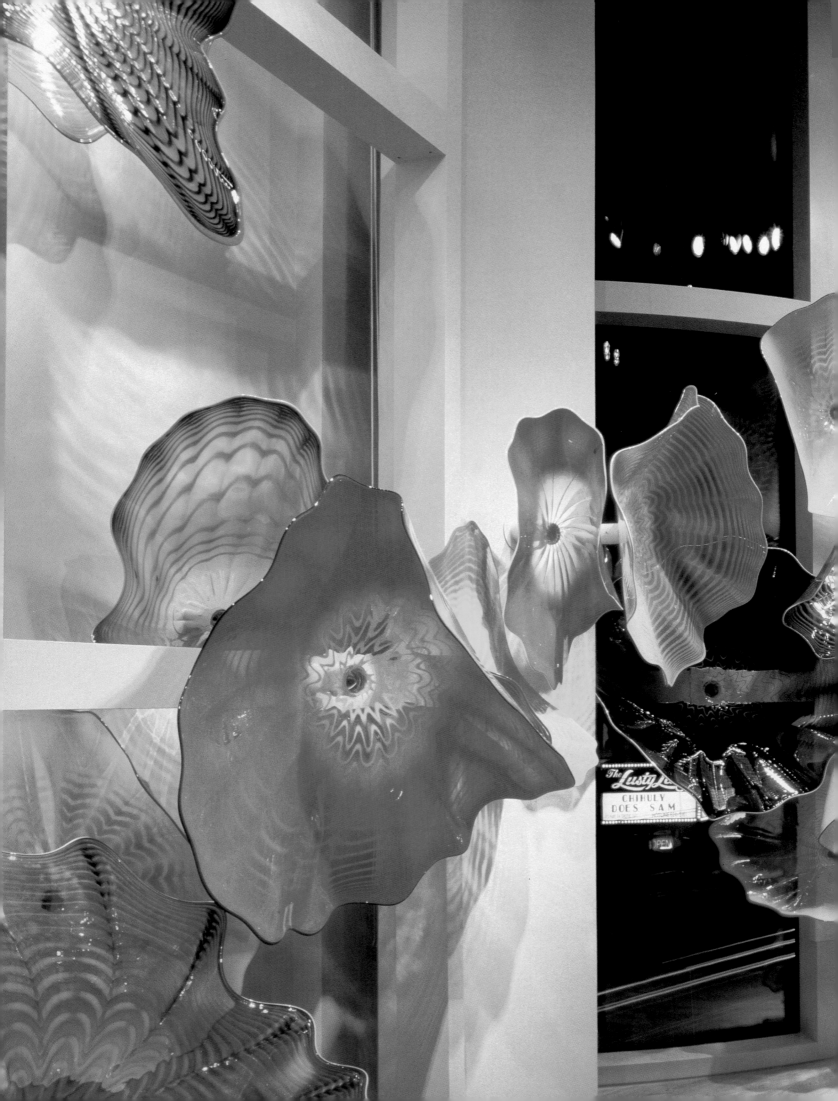

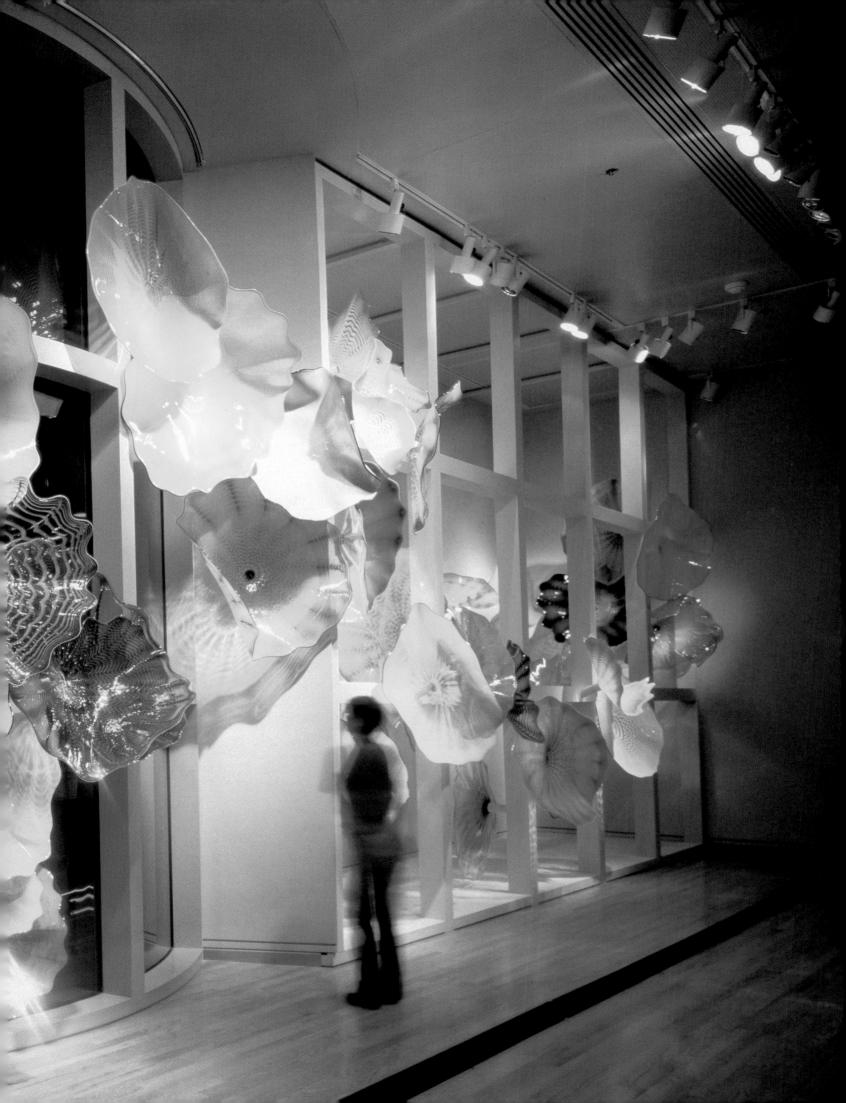

# Venetians

Tensions abound in the *Venetians*. Every attachment seems to indicate flux, a relentless, organic force impinging on the physical integrity of the classic form. Hot glass simulates or is affected by natural properties and realities—its fluidity and the spontaneity of working equate to the mysterious metamorphoses of living organisms, while physical forces of gravity can be utilized or challenged to suggest an independent vitalism. The vegetative and biomorphic decoration and ornamentation of the *Venetians* seem to both confirm and contradict the laws of nature. The works expand aggressively into space like a living and growing thing. And like living things, each work of the *Venetians* has an individual character, a personality if you will, much more so than Chihuly's other series.

Ron Glowen, 1989

Lino Tagliapietra had been coming to Pilchuck for years, but because my work had always been unorthodox and asymmetrical, I had never worked with him. Anyhow, Lino and I decided to try to do something together. I began by designing a series that was a takeoff on Venetian Art Deco pieces from the 1920s. I was able to sketch them, and from these images Lino began to blow. We had a great time putting these together—always going further, pushing beyond what we had done in each previous piece. Handles changed to knots, prunts became claws, colors went from subtle to bright and forms from symmetrical to asymmetrical.

Dale Chihuly, 1992

I began the blow [with Lino Tagliapietra] with the idea of replicating the Italian Art Deco vases I had spotted that evening in Venice. I started with a simple drawing of a classical Etruscan form with several handles. After Lino finished the first piece, I quickly made another drawing that was a little more complicated, involving more bit work . . . After a couple of days the pieces became much more involved. It wasn't long before something started to happen. It opened first in the drawings . . . around the fourth or fifth day I started to make bold drawings in charcoal. The series started a drastic change from rather refined classical shapes to very bizarre pieces: handles changed to knots, prunts became claws, colors went from subtle to bright, big leaves and feathers appeared.

Dale Chihuly, 1989

Pages 83 to 89

Charcoal and acrylic on paper, 1988, 22 x 30"

**Blue Venetian with Green Calla Lily,** 1989, 17 x 14 x 19"

**Rose Pink Venetian,** 1990, 13 x 16 x 16"

**Cobalt Blue Venetian,** 1989

**Indian Red Venetian,** 1988

**Gold over Carmine Venetian with Wrapped Leaves,** 1990, 18 x 14 x 17"

**Gold over Cobalt Venetian,** 1989, 22 x 12 x 11"

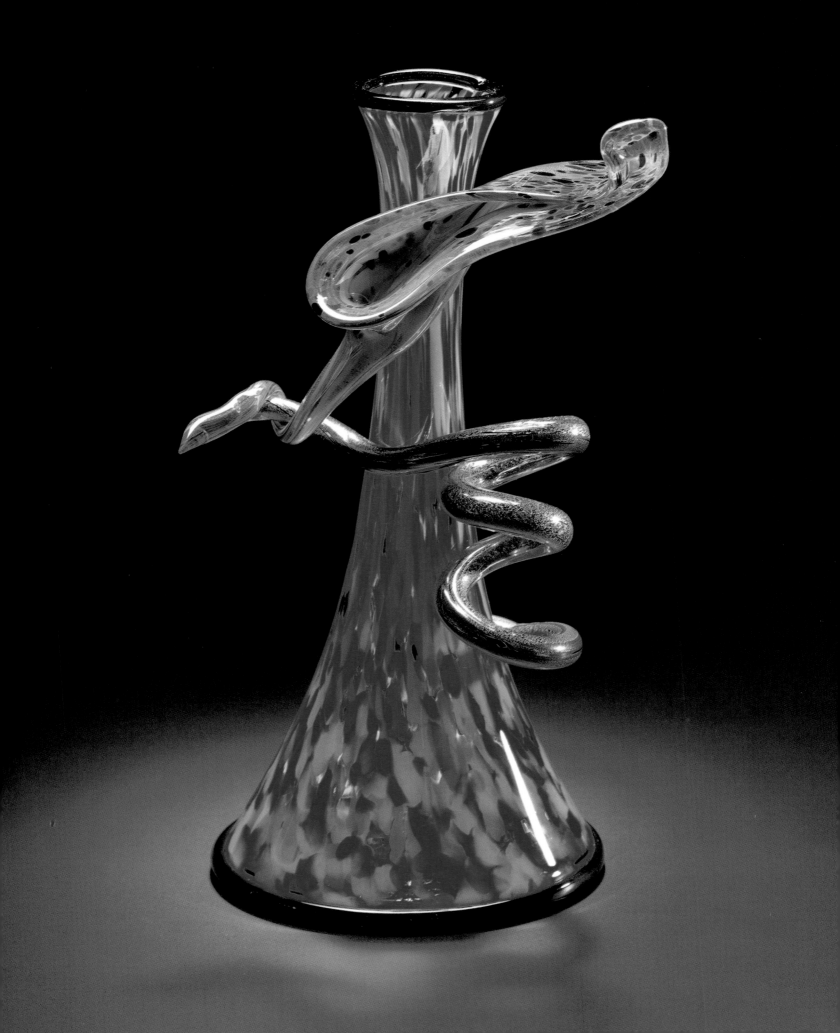

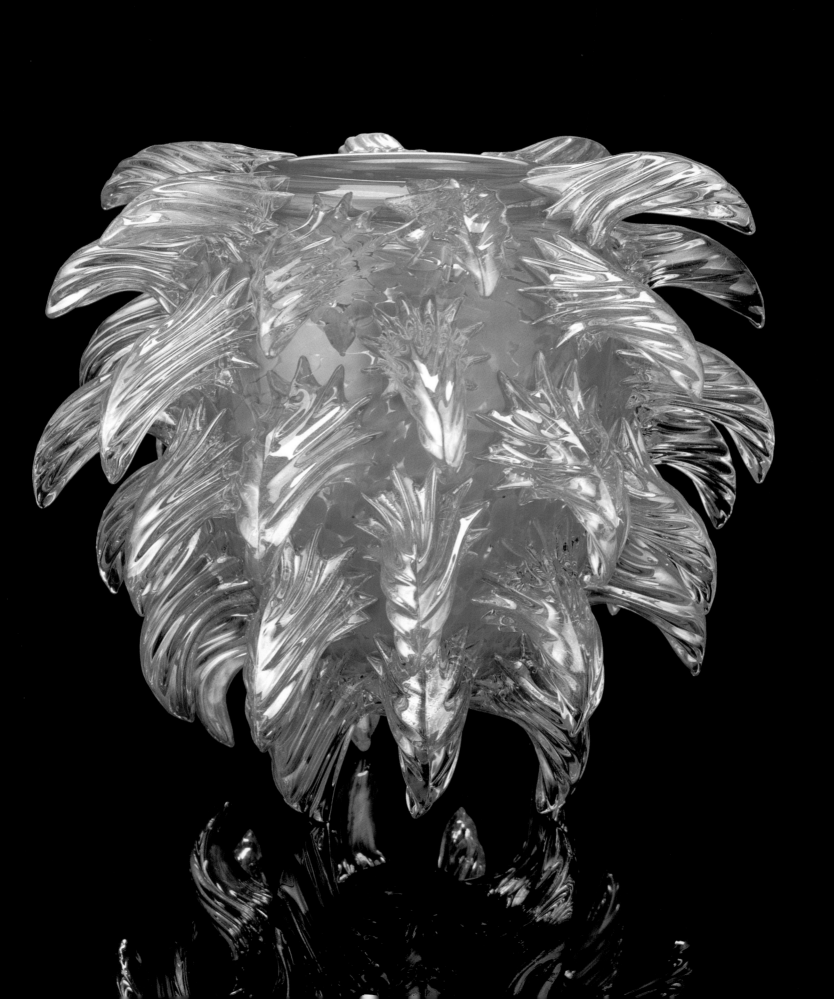

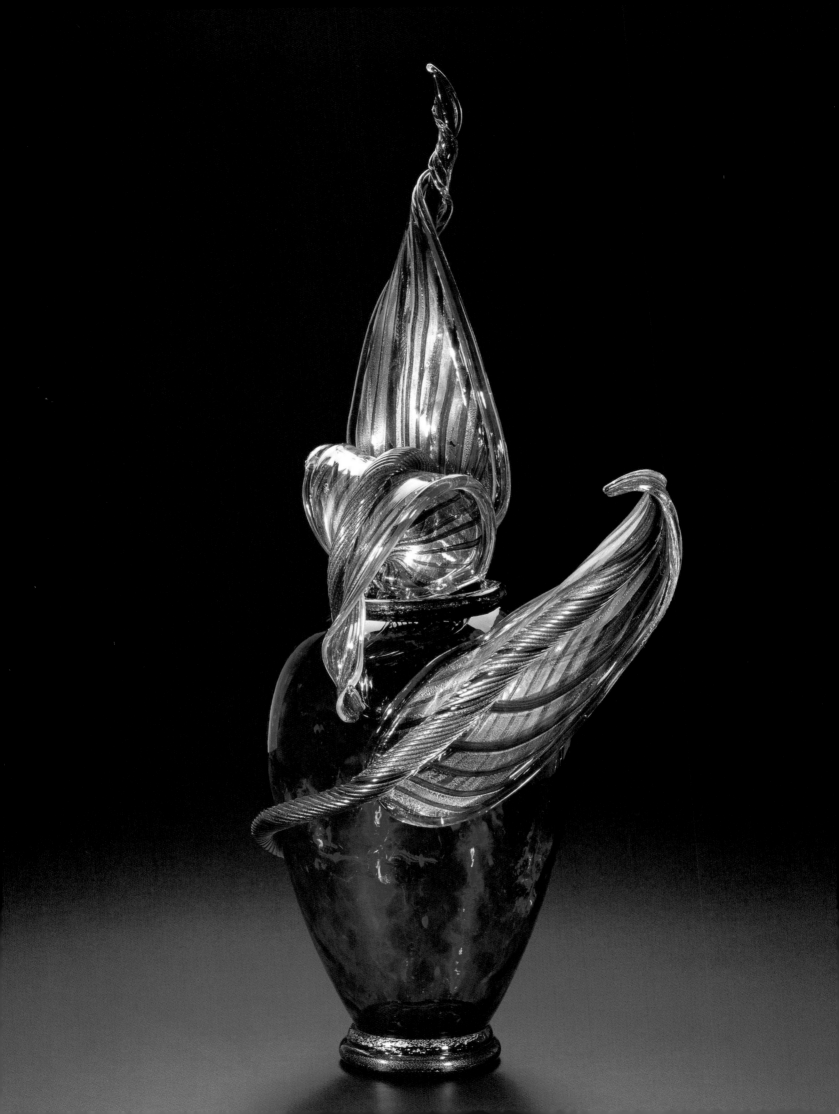

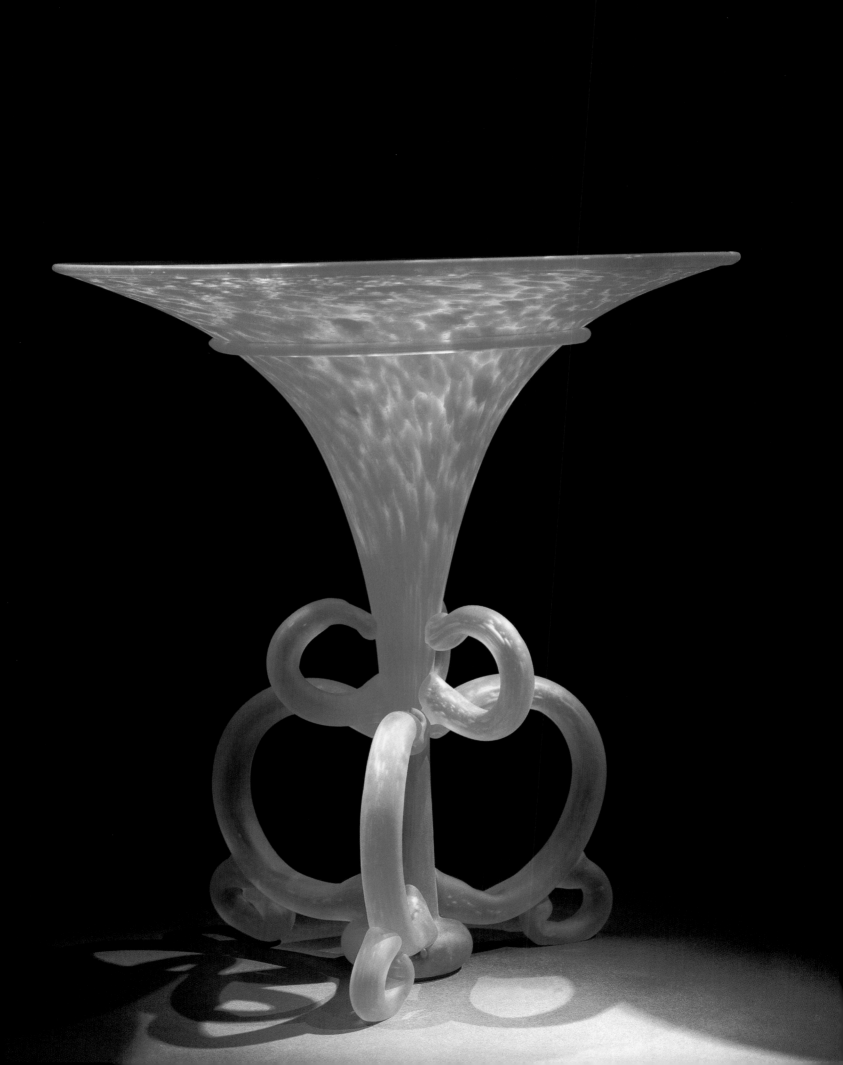

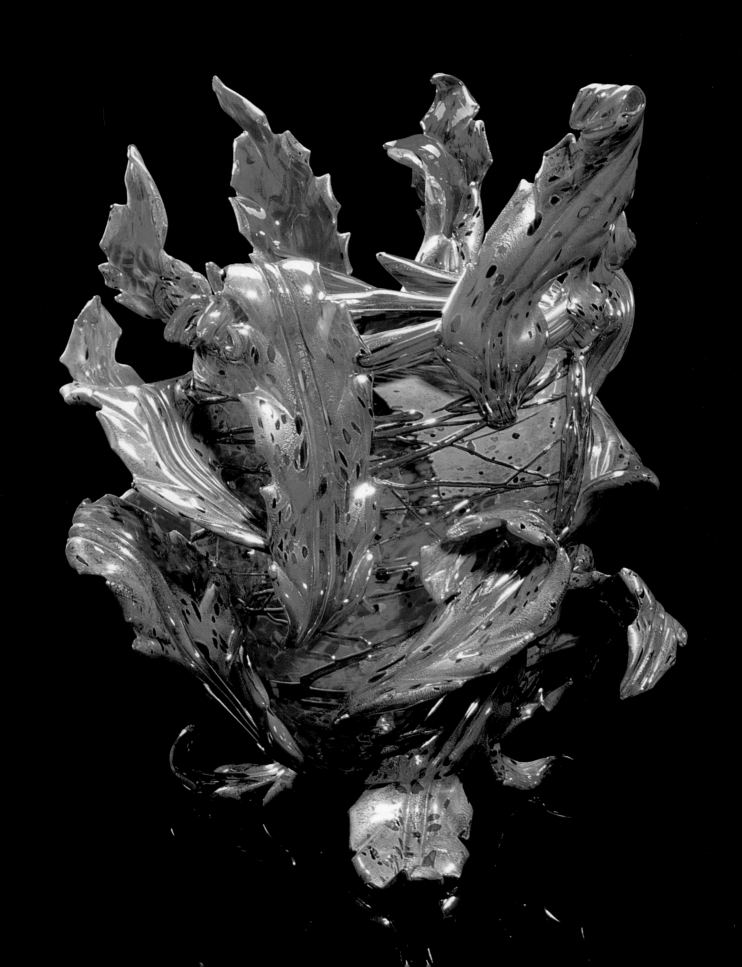

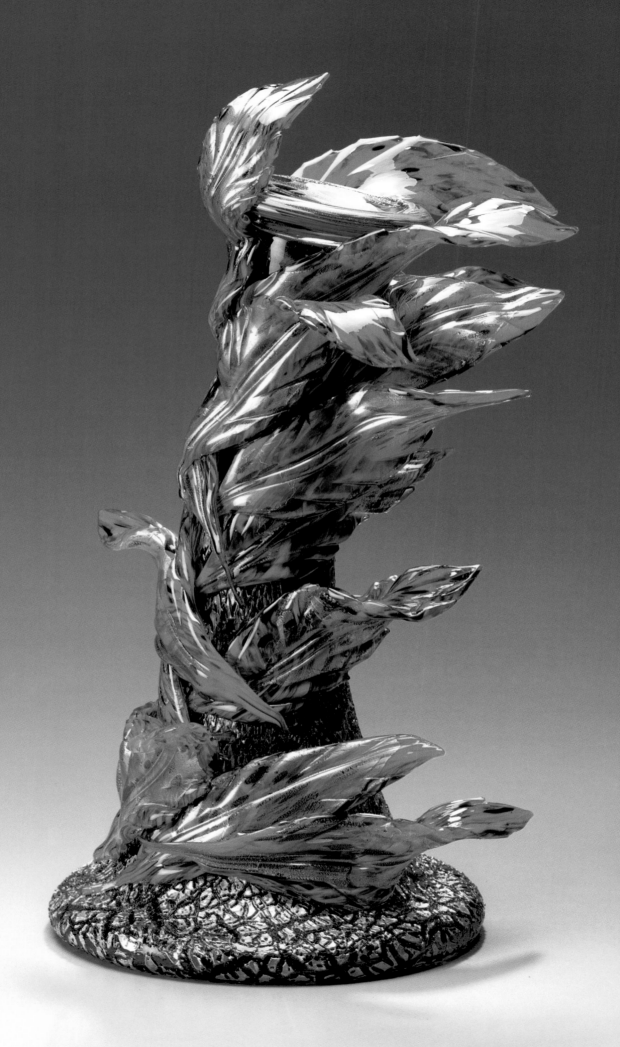

# Ikebana

Mr. Chihuly uses the word ikebana in most of his titles, and many of these works emulate the Japanese art of subtle but intensely stylized flower arranging . . . All of the work reflects the painterly chromatic complexity of Venetian glass and the sensuous curves of Art Nouveau, whose sometimes outlandish use of floral forms Mr. Chihuly is perfectly willing to match.

Holland Cotter, The New York Times, 1993

Chihuly grew up surrounded by flowers, his mother has a passion for gardening . . . It is not too surprising that Chihuly has periodically turned to floral motifs . . . To embellish his *Venetians* and complement and emphasize their larger scale, Chihuly created a series of elongated stems and blossoms, called *Ikebana*, after the stylized beauty of Japanese floral arrangements and reminiscent of the carved woods, gilt lotus blossoms that he admired on visits to Buddhist temples in Japan.

Patterson Sims, "Scuola di Chihuly: Venezia and Seattle," Dale Chihuly Installations 1964–1992, Seattle Art Museum, 1992

I was lucky to have not only Lino Tagliapietra, one of the really extraordinary glass masters in the world, but also Ben Moore, who is almost a son to Lino. Benny organized the teams for the *Venetian* series, with Lino as the maestro. We would bring together anywhere from twelve to eighteen glassblowers, primarily from Seattle, to try to do the most extreme pieces that I imagined they would be willing to do. Each session would get more elaborate. The teams kept getting bigger and wilder, and the pieces became more extreme. I would make a drawing, and Lino would look at it and shout out a few orders to Benny in Italian—even though Lino does speak English. One thing led to another.

Dale Chihuly, 1992

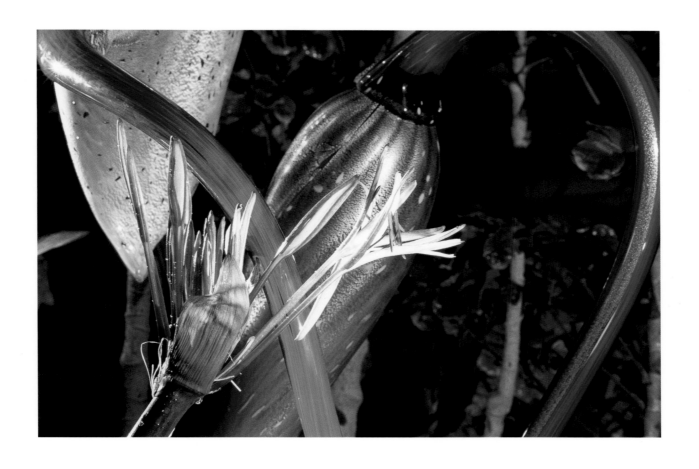

Pages 91 to 97

**Blue and Green Ikebana Stems,** Garfield Park Conservatory, Chicago, IL, 2001

**Gilded Ikebana with Ochre Flower and Red Leaf,** 1992, 30 x 40 x 16"

**Misty Chartreuse Ikebana with Yellow and Emerald Stems,** Atlanta Botanical Garden, Atlanta, GA, 2004

**Speckled Red Orange Ikebana with Moss Green and Golden Stems,** Garfield Park Conservatory, Chicago, IL, 2001

Ikebana grouping, Tacoma, WA, 2001

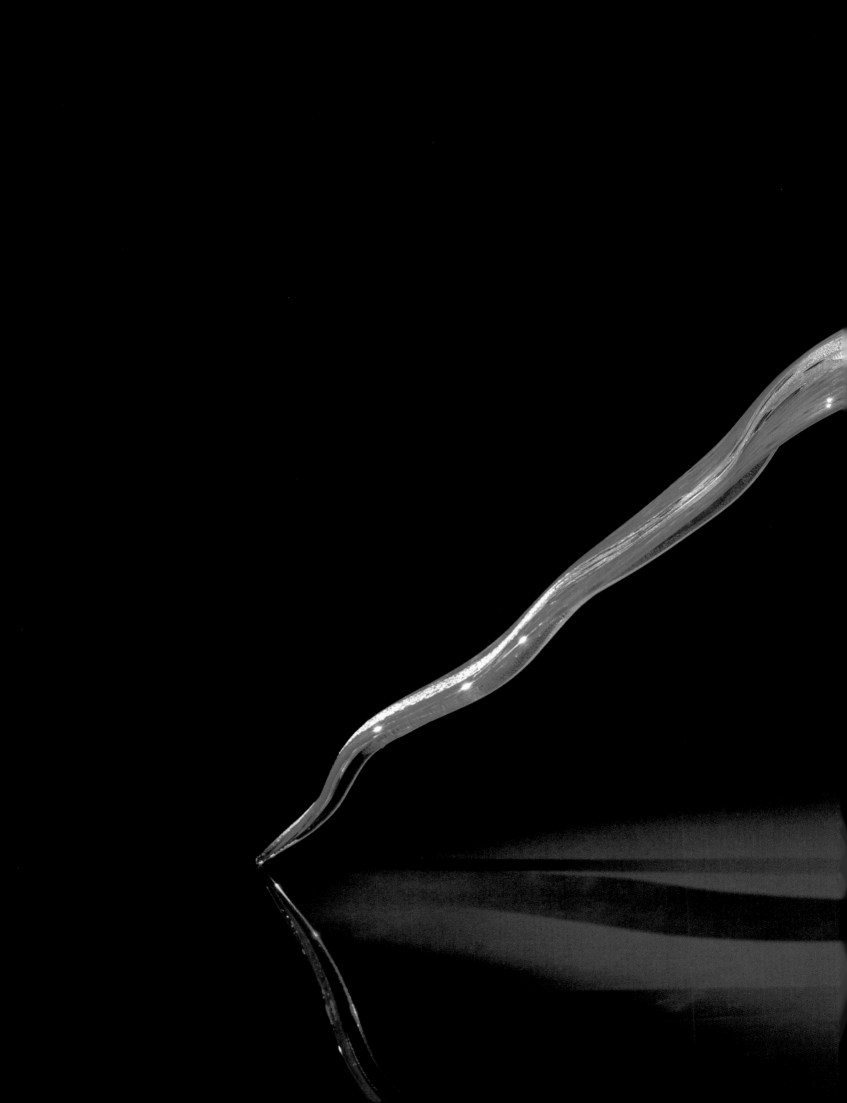

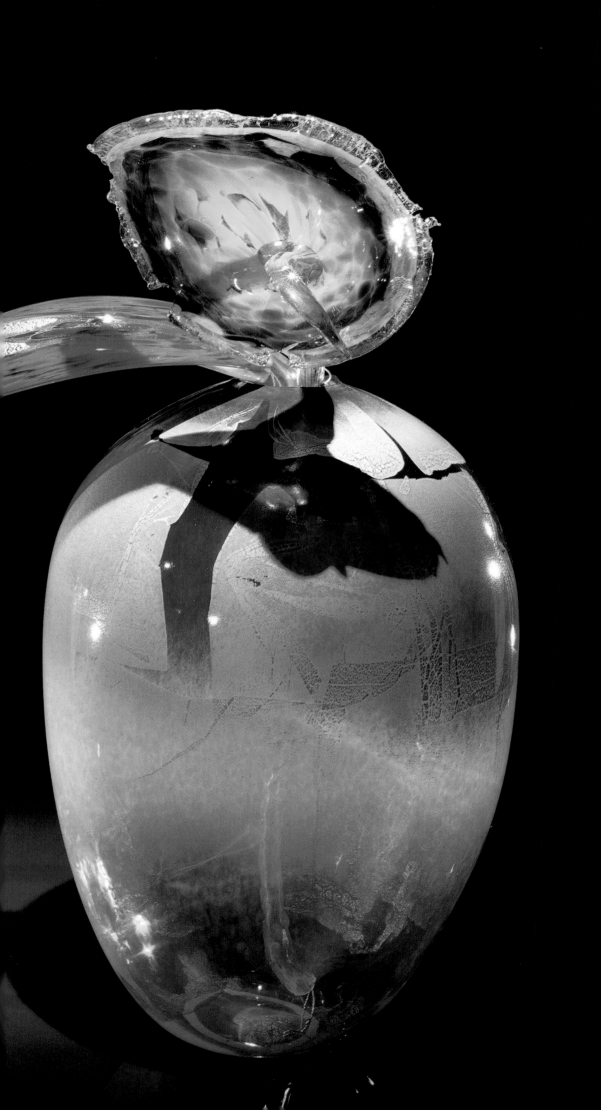

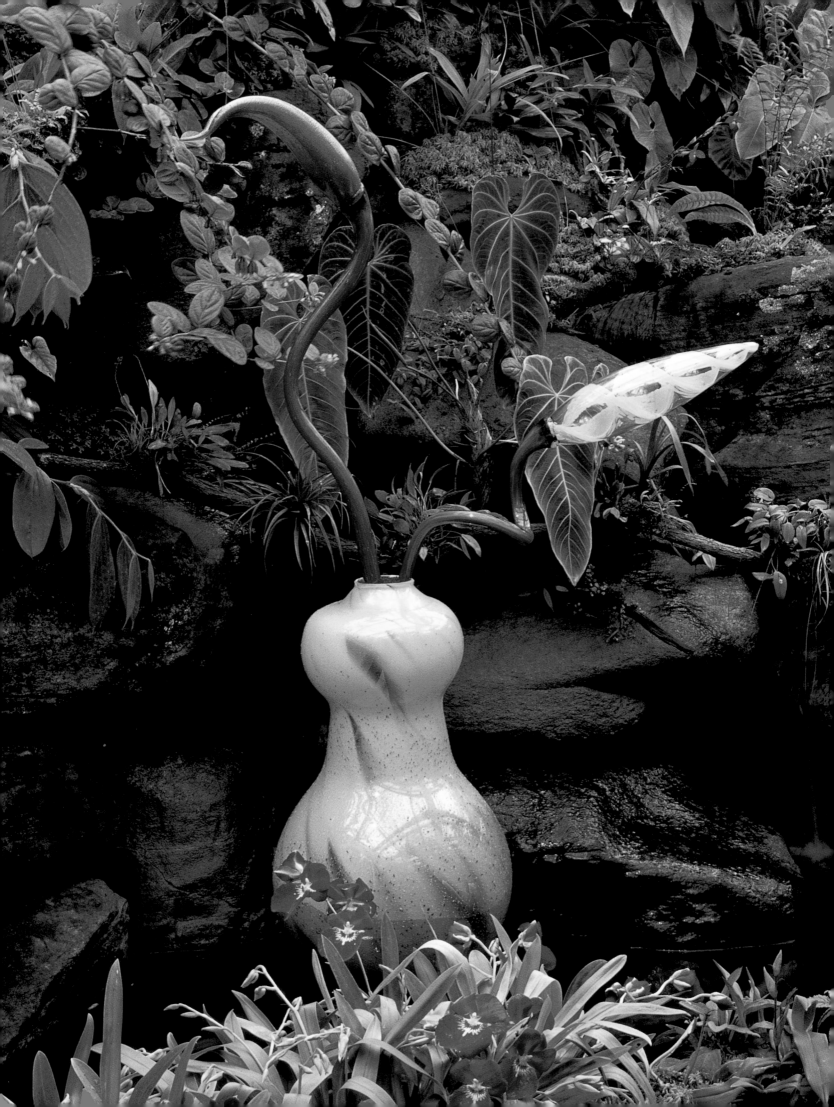

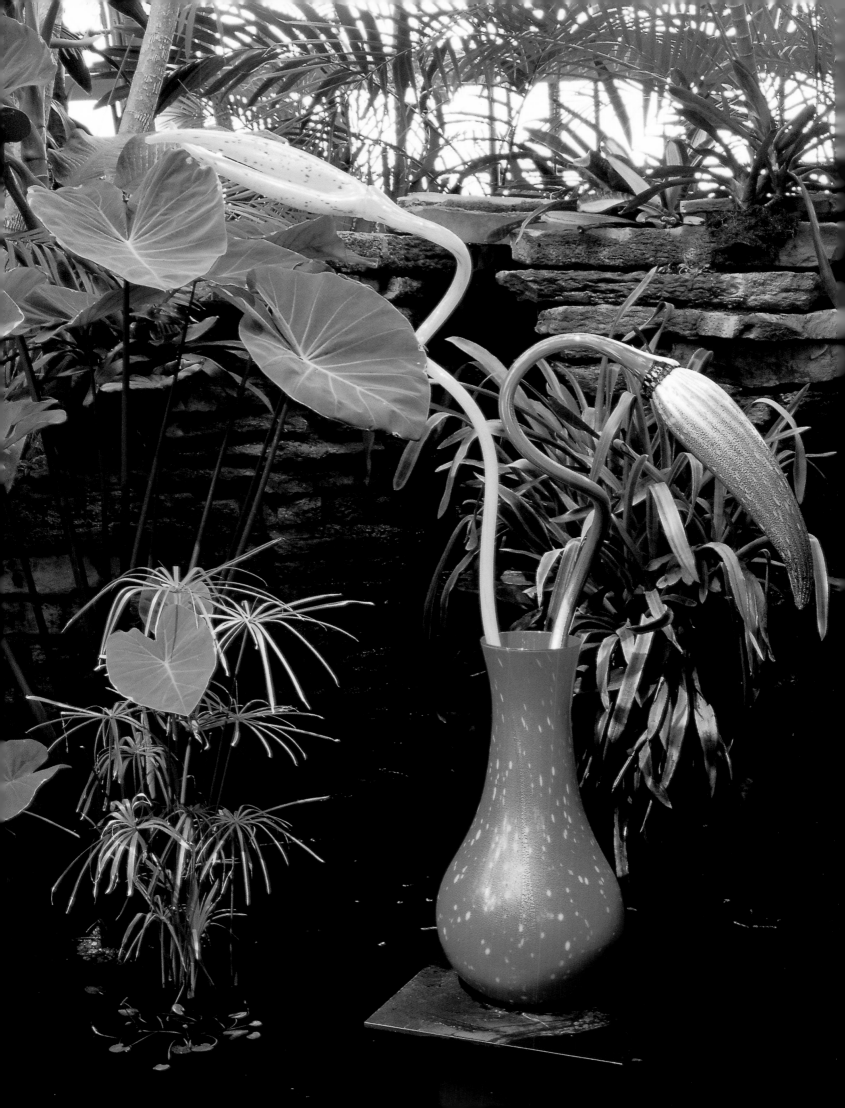

# Niijima Floats

The [*Niijima*] *Floats* . . . are really quite daring: they sit directly on the floor, spotlit, like benthic organisms under a diver's spotlight or jellyfish washed up on a beach or (as Chihuly suggests through their names) glass fishing-net floats. Their surfaces—several of the *Floats* feature gold-leaf technique developed during the *Venetian* series as well as streams of tiny air bubbles—suggest swirling current, pebbly streambeds, and biological organisms. Their coloring is as richly layered as Japanese lacquer or an undersea reef. It's this tension—between the fantasy world of high artifice and the natural world in its infinite mystery and variety—that gives these most recent works a greater significance.

Justin Spring, Artforum, 1992

It is fitting that Chihuly's elaborate exploration of form has ended by circling back to the most simple: that of the globe of glass. Oddly, the *Niijima Floats* are among the most difficult of all of Chihuly's forms to produce . . . Much of what makes the *Floats* so astonishing is their sheer size, which disrupts any conventional notion of their purpose.

Henry Adams, "Dale Chihuly: Thirty Years of Glass," UMB Financial Corporation, 1996

I've never done anything like the *Niijima Floats*. They are probably the most monumental-looking since there's no reminiscence of a container shape. Just because they are so goddamn big, the *Floats* are technically or, say, physically the most difficult things that we have ever done. Even though a sphere or a ball is about the easiest form you can make in glass, when you get to this scale, up to forty inches in diameter, it becomes extremely difficult.

Dale Chihuly, 1992

**Pages 99 to 105**

Acrylic on paper, 2000, 42 x 30"

**Niijima Floats,** Jerusalem, Israel, 1999

**Niijima Floats,** Seattle, WA, 1991

**Niijima Floats,** Fairchild Tropical Botanic Garden, Coral Gables, FL, 2005

**Niijima Floats,** Honolulu Academy of Arts, Honolulu, HI, 1992

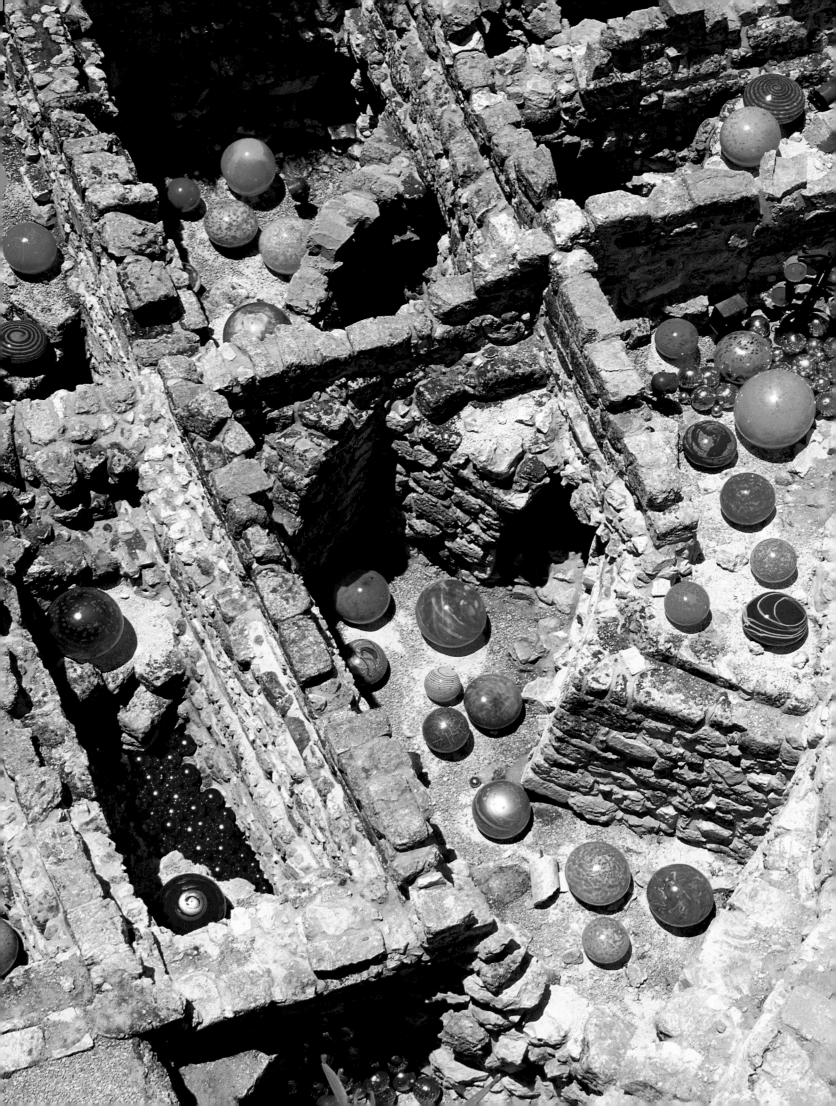

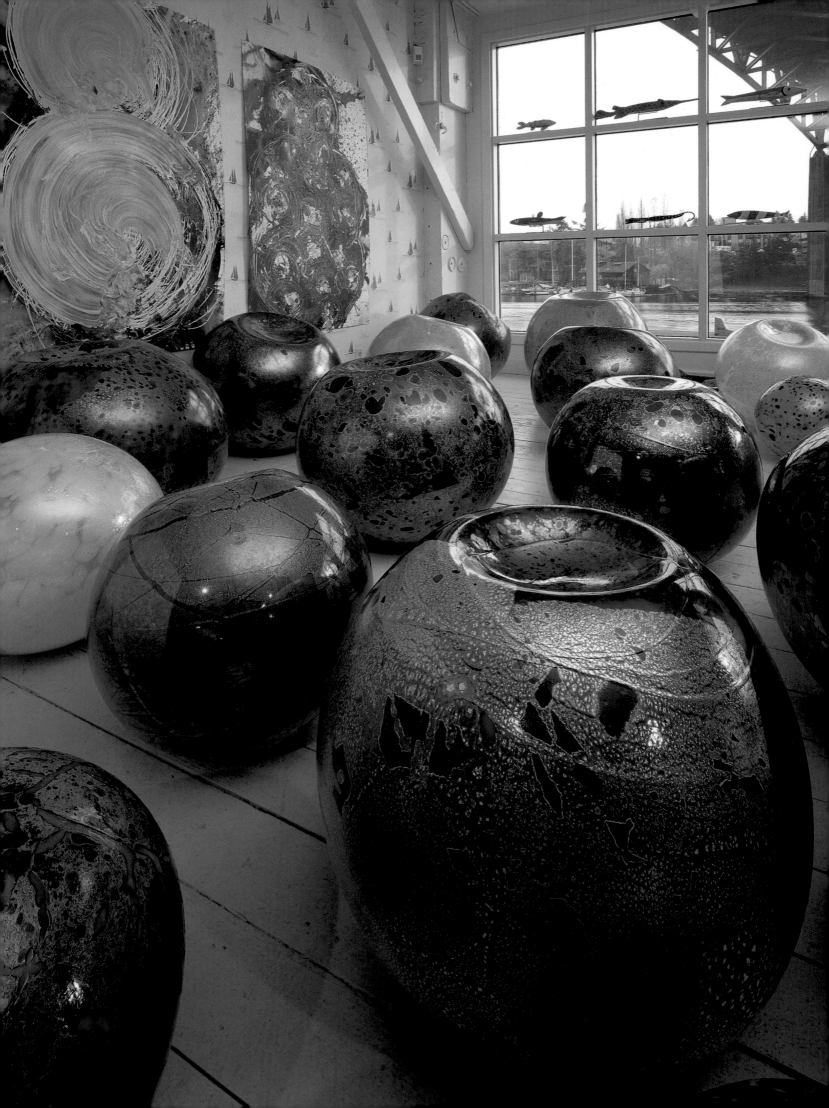

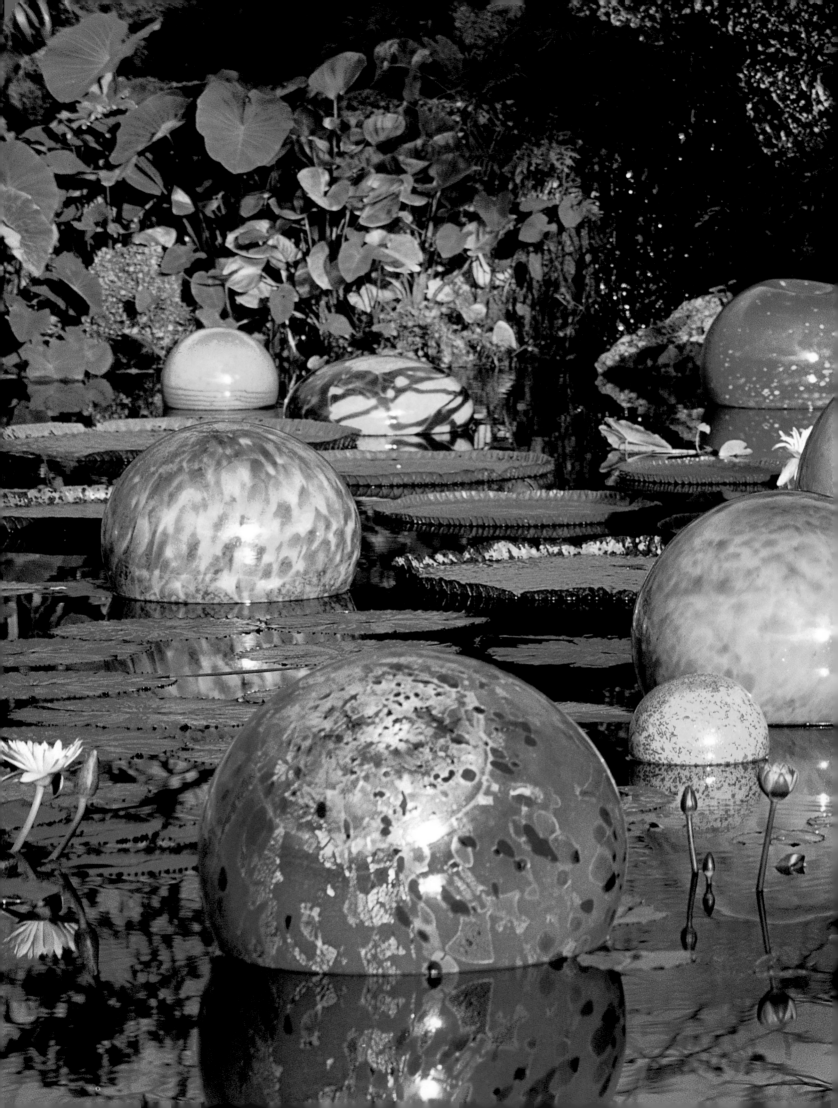

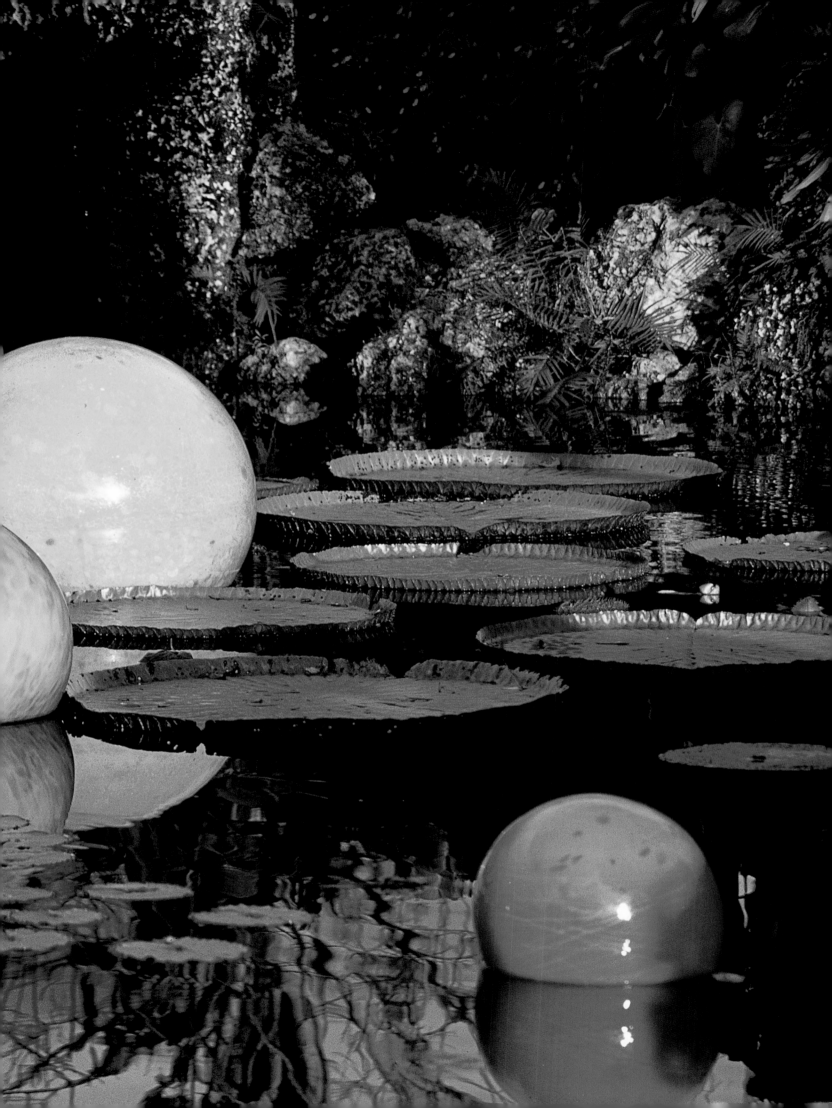

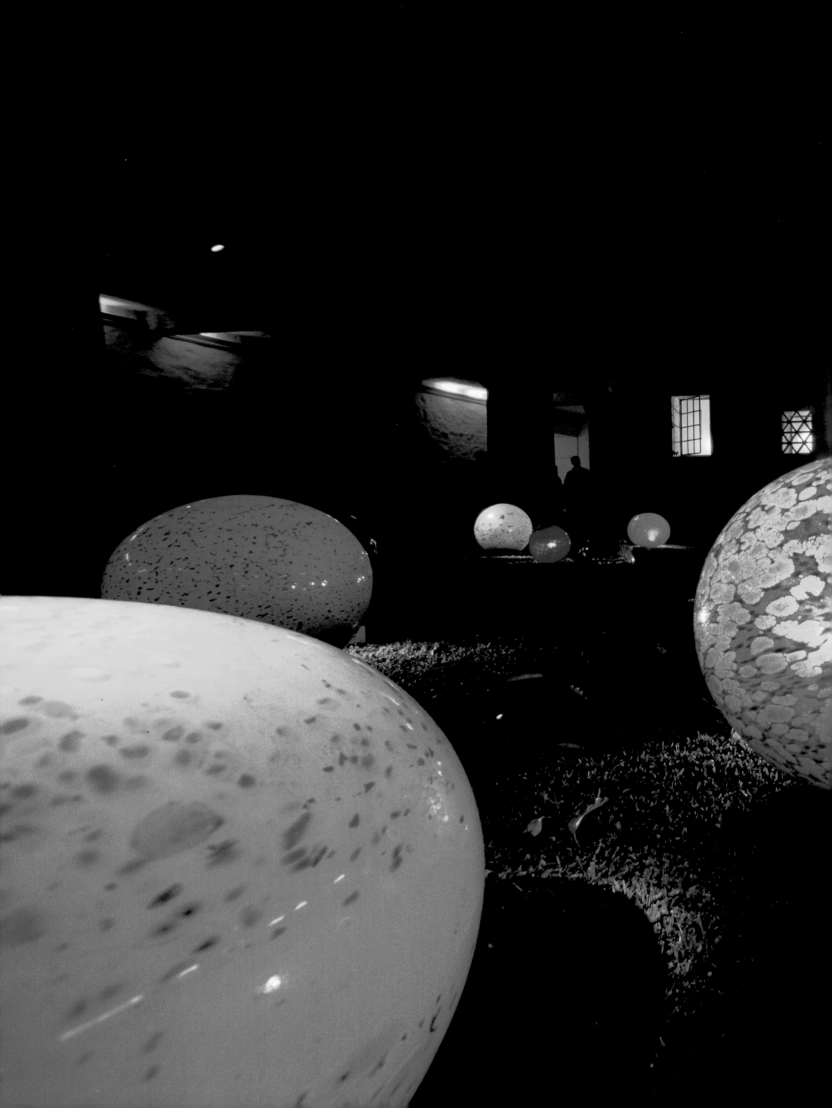

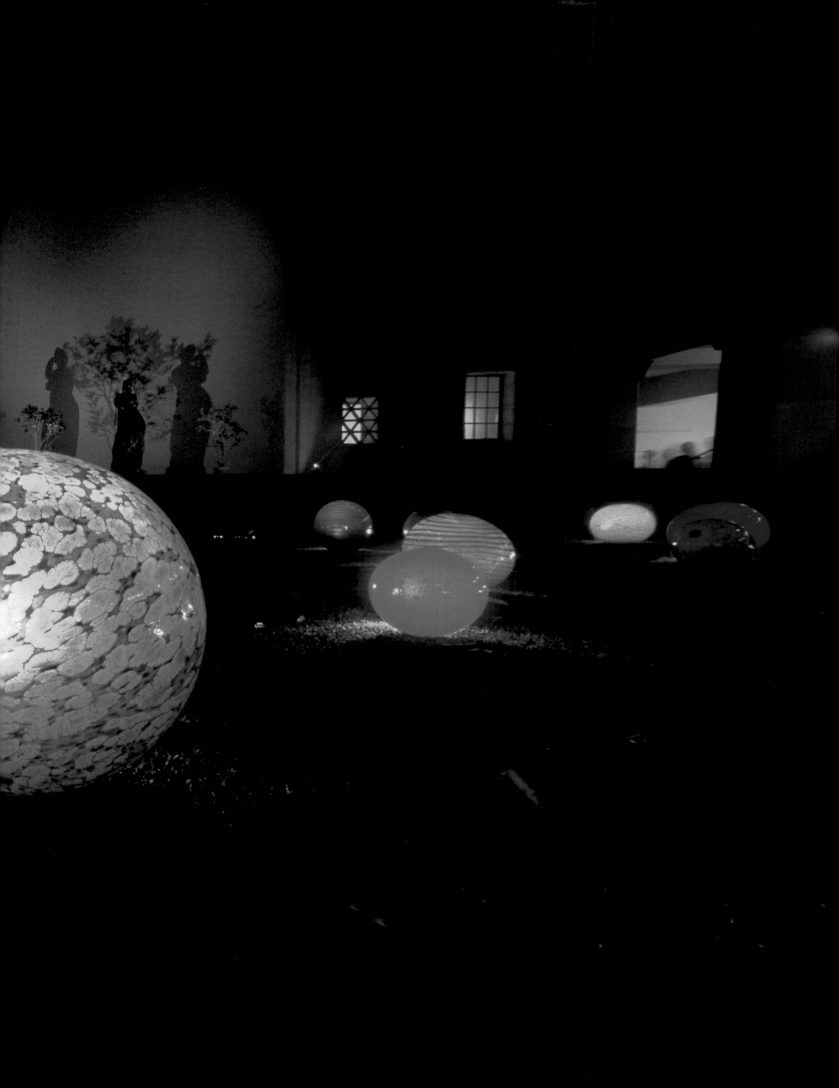

# Chandeliers

"I made the first *Chandelier* in 1992 for my show at the Seattle Art Museum. It was a big show, the entire second floor, and there was an area that wasn't working. At the last minute, I had the glassblowers start making a very simple shape—one of the easiest forms one can blow. It is also strong and simple, and I knew it would hang well. I put ten or fifteen blowers on the project, and we made it in a few days and then hung it in the museum before mocking it up completely. It was a little risky, but I was very confident. I put a large black granite table, eight by eight feet, under the piece to keep viewers back and to have a reflection."

Dale Chihuly, 1996

Beauty is beguiling, of course, and Chihuly simply seems incapable of creating much that's not beautiful. One of the most successful installations at Lismore Castle was a delicate-looking wasp nest of amethyst glass tendrils suspended between magnificent rows of ancient yew trees. When the brilliant late-afternoon light shone through the canopy of boughs, the *Chandelier* was stunning, glittering like a giant jewel. It was impossible not to be at least momentarily mesmerized.

Robin Updike, "Man of Glass," Seattle Times, 1995

The light's going to be changing all the time, so [Chihuly] decided not to put any color in the glass—because the color is going to come from nature . . . It looks kind of alive.

Quote by Harriet Bullitt, "Chandelier Arrives at Sleeping Lady," by Jeff Gauger, The Leavenworth Echo

Light, of course, affects everything, and pieces take on different characteristics as atmospheric conditions change and as the sun moves in its daily cycle. Most dazzling are his *Chandeliers*, which resemble underwater sea creatures with giant twisted tentacles. Blown in eye-popping iridescent colors like rain-slicker yellow and lime green, they exude a cartoonish exuberance.

Barbara B. Buchhols, "Glass Master," Chicago Tribune

Pages 107 to 117

Acrylic on paper, 1997, 60 x 40"

**Seattle Art Museum Chandelier,** Seattle Art Museum, Seattle, WA, 1992

**Gourd Chandelier,** Nuutajärvi, Finland, 1995

**Ruby Red Chandelier,** Vianne, France, 1997

**Turquoise Forest Chandelier,** Lismore Castle, Ireland, 1995

**Icicle Creek Chandelier,** Leavenworth, WA, 1996

**V&A Chandelier,** V&A Museum, London, United Kingdom, 2001

**Persian Chandelier,** Royal Botanic Gardens, Kew, Richmond, Surrey, United Kingdom, 2005

**Cobalt Blue Chandelier** and **Monarch Window,** Union Station, Tacoma, WA, 1994

**Palazzo Ducale Chandelier,** Venice, Italy, 1996

**Star,** Jerusalem, Israel, 1999

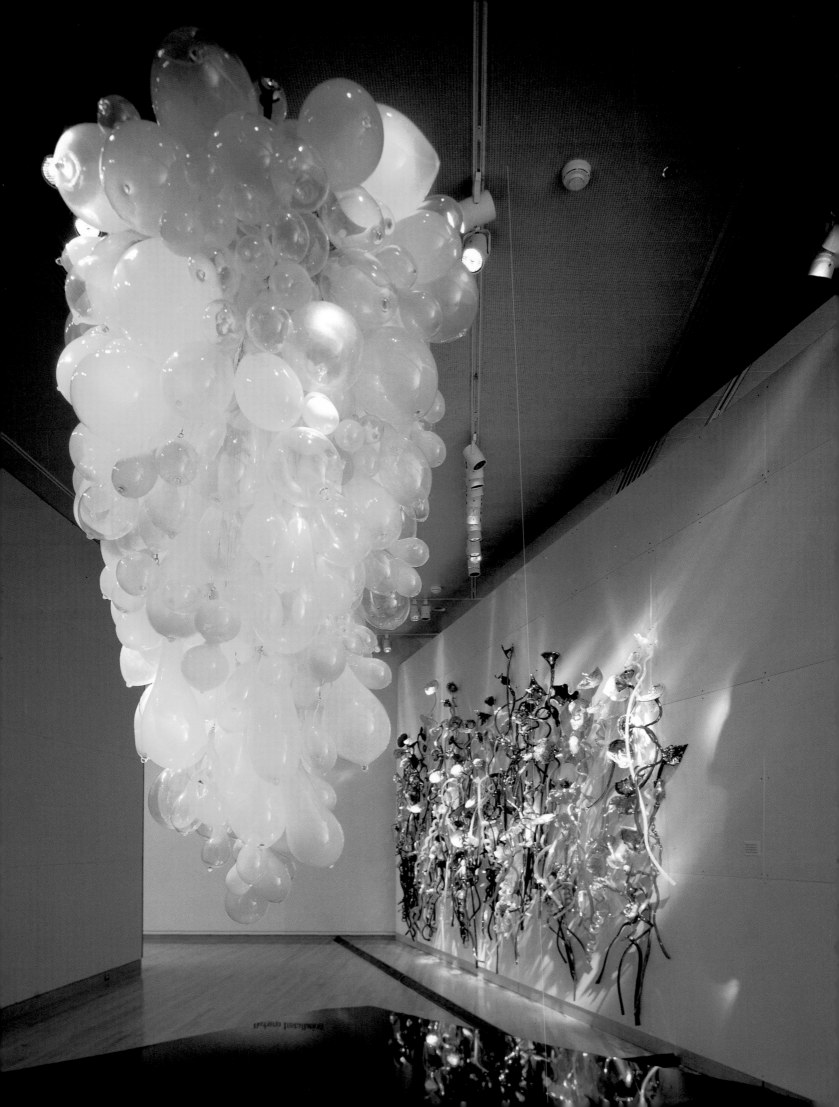

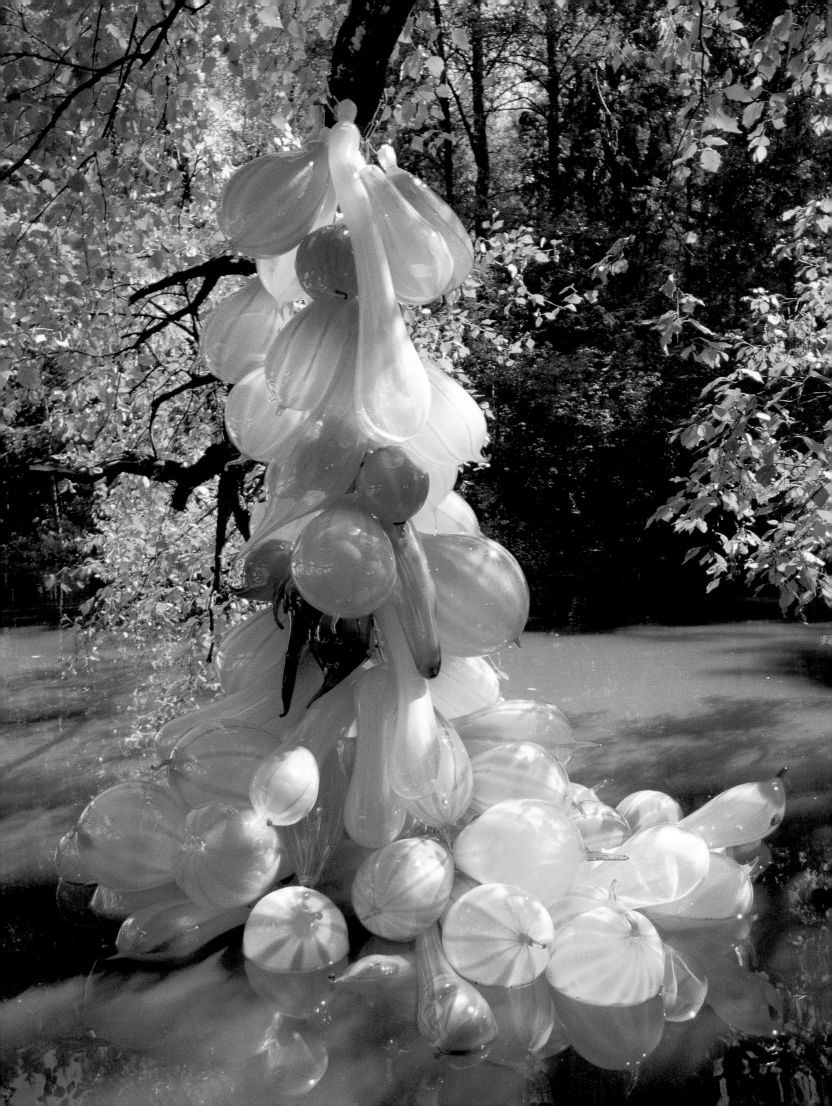

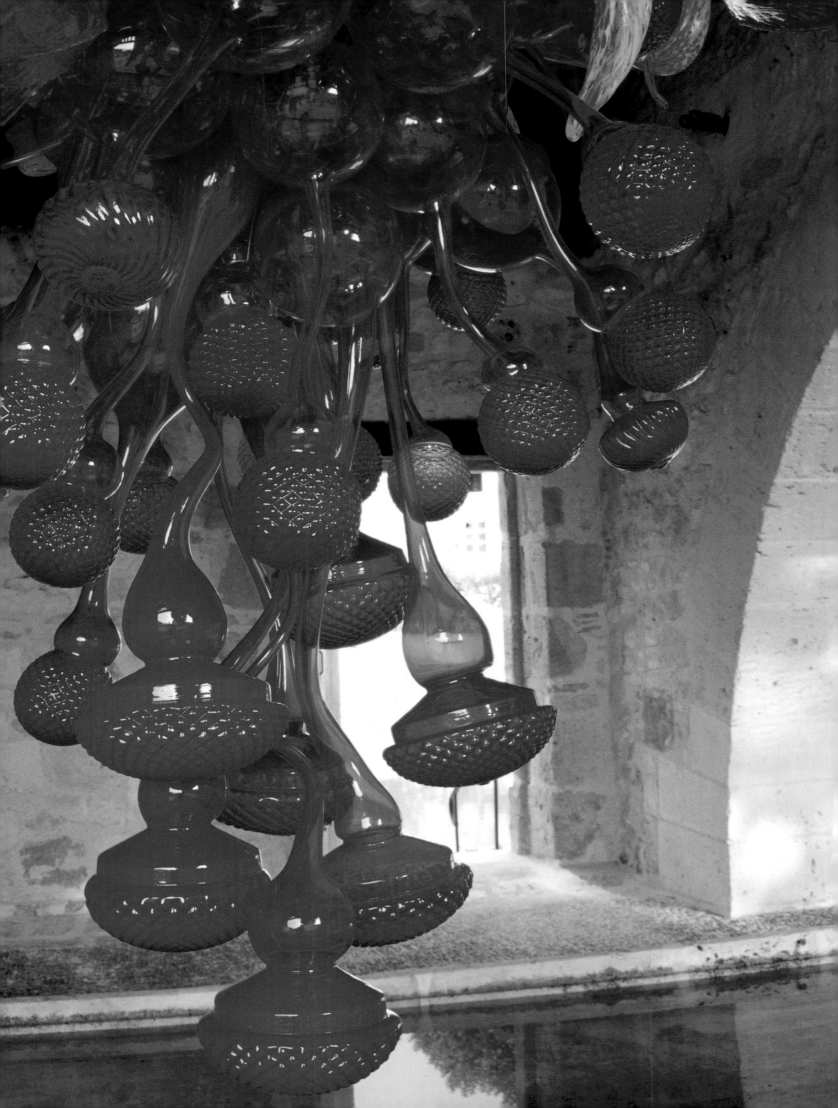

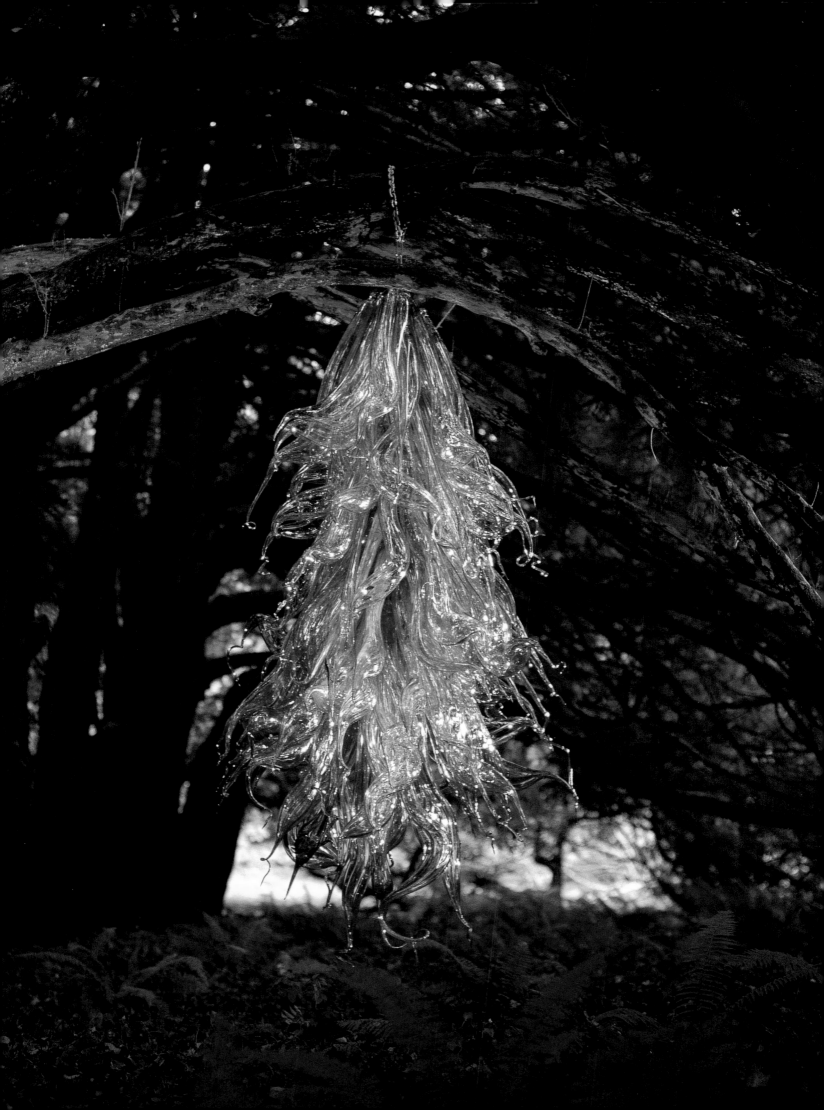

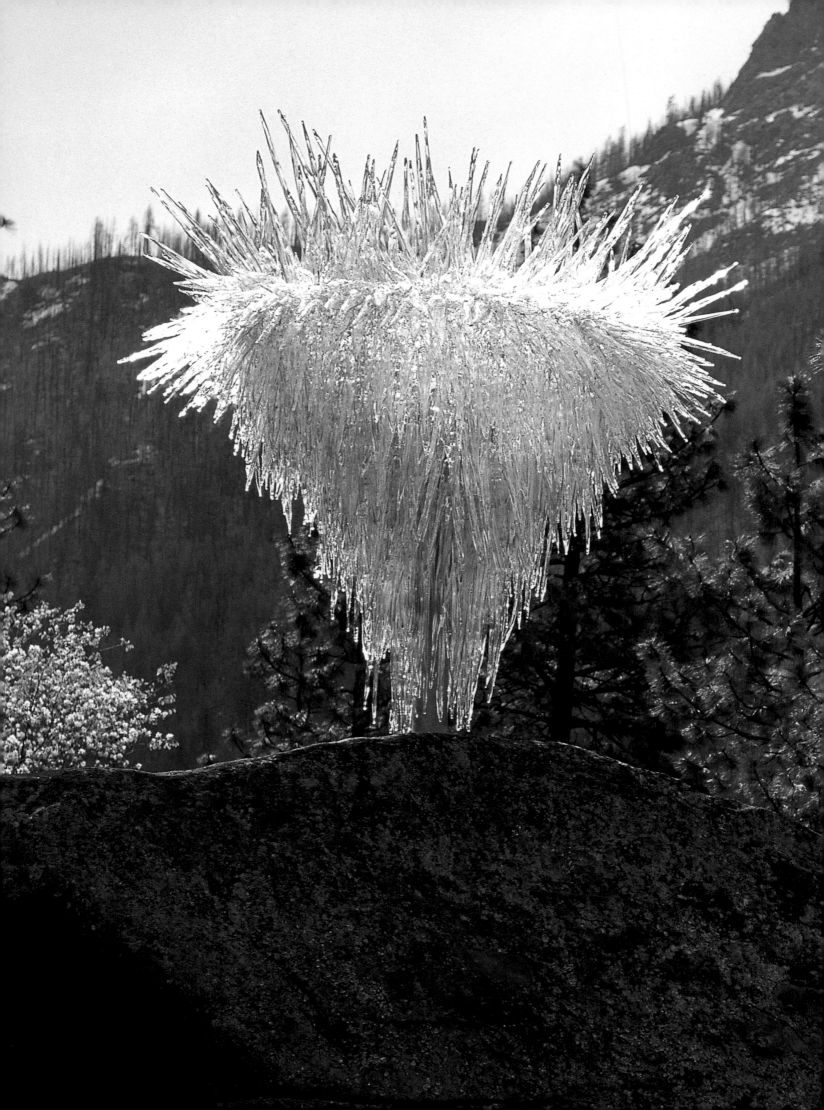

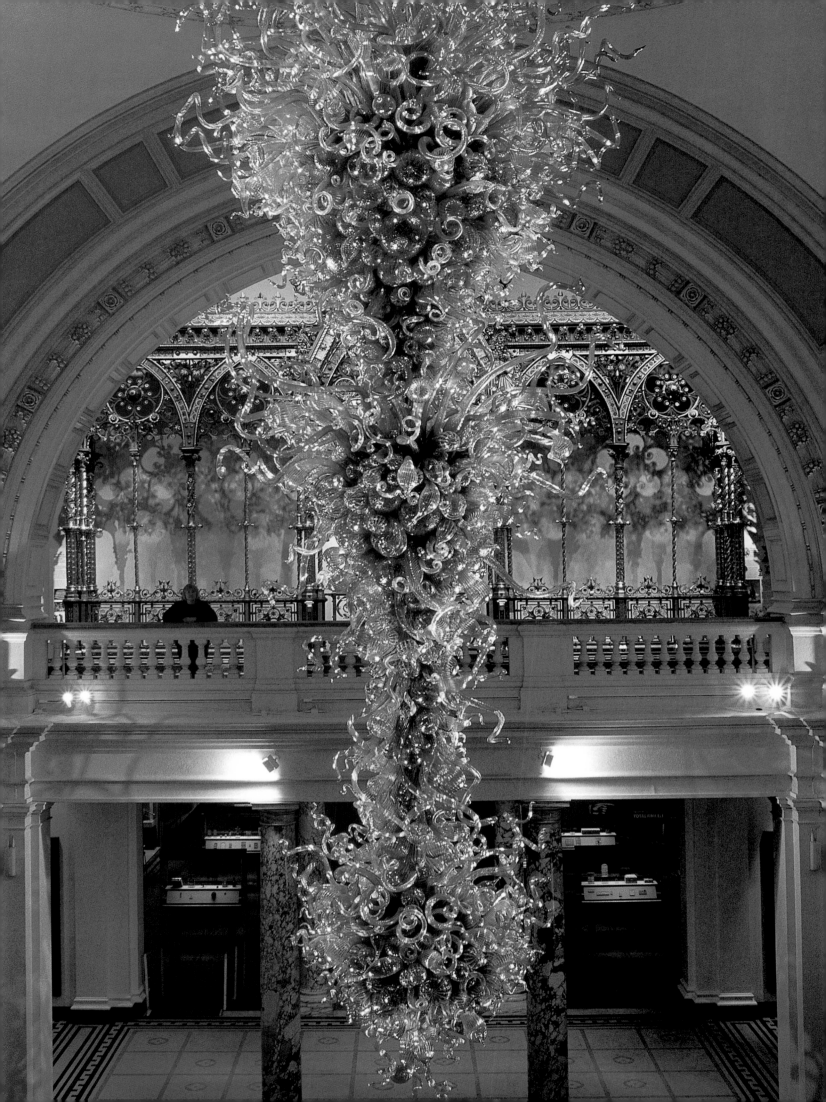

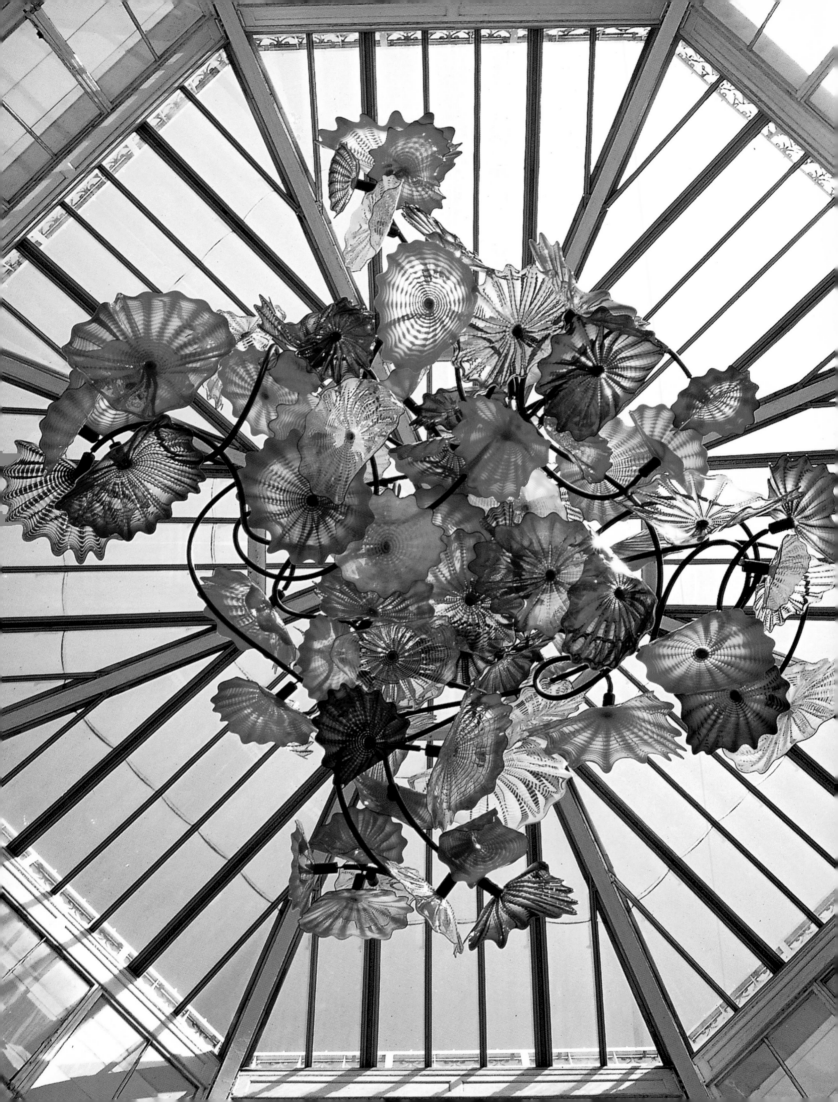

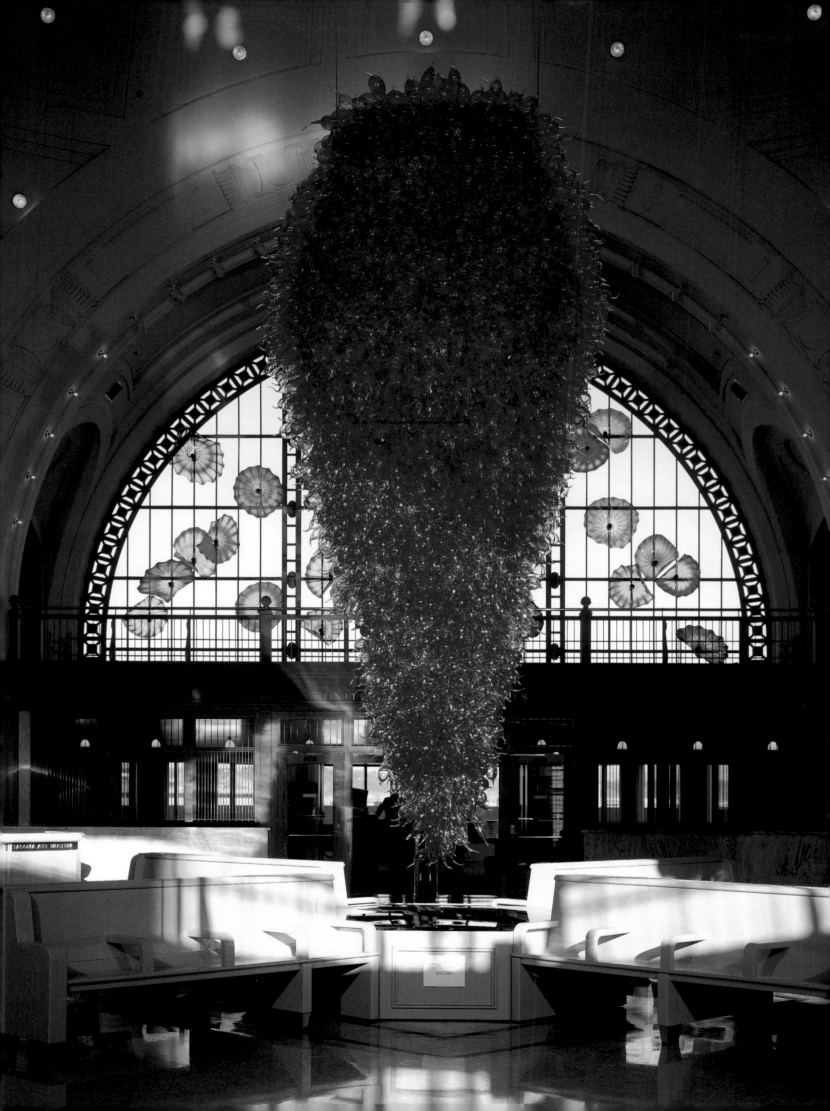

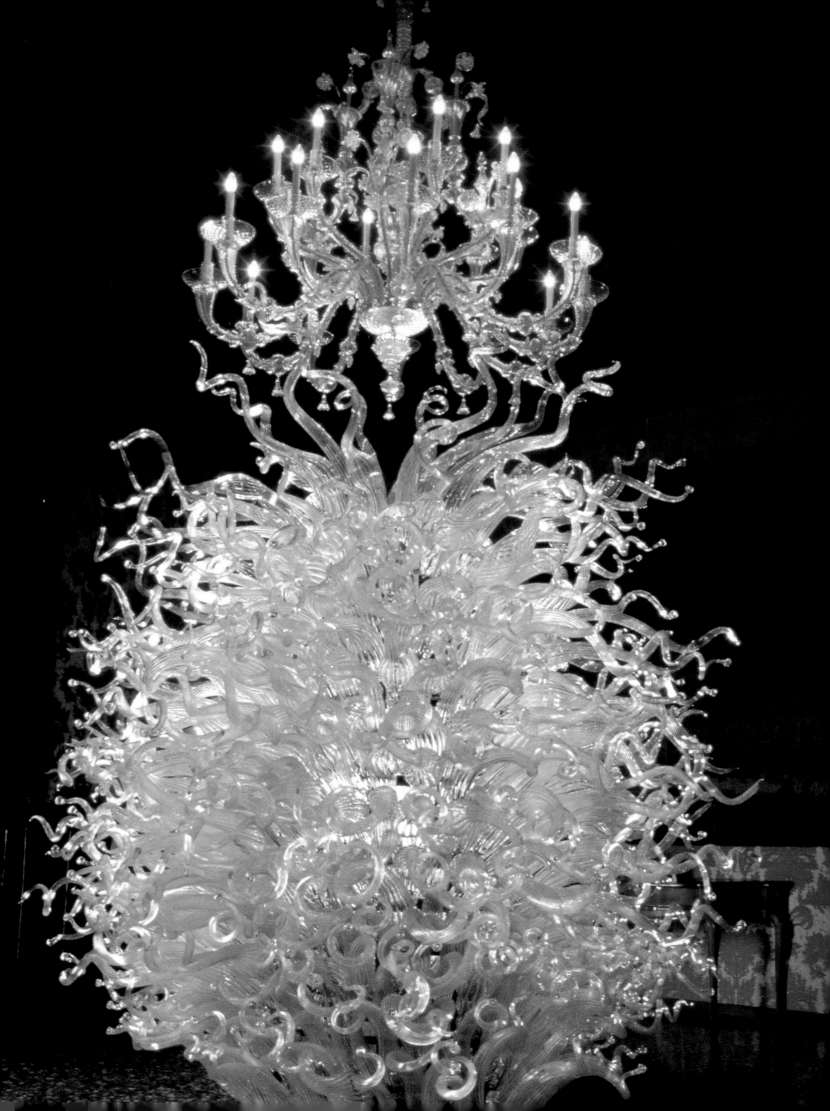

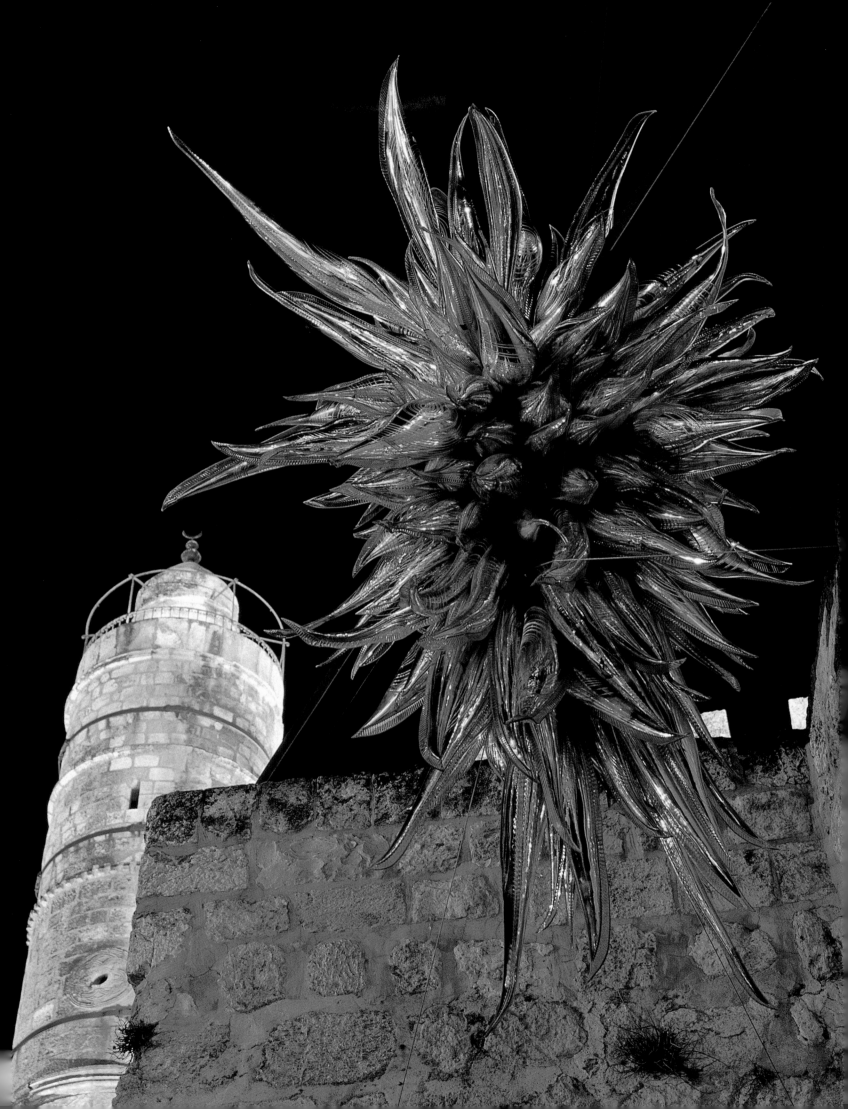

# Reeds

The *Spear Installation* can really be taken anywhere . . . and they can go outside. They're very strong pieces. They're very dramatic. We sometimes call them *Water Reeds*. Sometimes I call them *Water Reeds*, sometimes I call them *Spears* . . . I've yet to find a color that I like better than the red, but they'd probably be very nice in clear as well.

<div align="right">Dale Chihuly, 1998</div>

Why would I make the *Spears* in the river in Nuutajärvi? Well, I don't know why I made the *Spears* in the river at Nuutajärvi, except that I know by the time the ten days were over with and the *Spears* were up in the river . . . that they happened, I wanted them to happen. Don't ask me why they happened; I don't know where these ideas come from. They come from down deep inside you, below your stomach probably.

<div align="right">Dale Chihuly, 1998</div>

We were making these elongated shapes for the river already, and we just started making them longer and longer and longer, and, I don't know, they got up to be about fifteen feet long. We later extended the series, so they got up to about twenty feet long.

<div align="right">Dale Chihuly, 1998</div>

We later extended the series [*Spears*] even further by making them down at Bullseye, Oregon, because we need a factory situation at the moment that has a long enough oven to make these in. But we made these *Spears*, red *Spears* with clear on top, and the tops were really beautiful with this clear coming out of the red. And I just simply put them in the river on a steel . . . we put a steel stake in the mud and then put the *Spears* over them. It's a very simple installation. And they look terrific in red. We've done them in other colors since—green, yellow, orange, neodymium—but the red is my favorite. And I really like those installations. We also put them in trees. In Nuutajärvi, we did a *Red Spear Installation* where they went right over the tree branches. They also did sort of a turquoise blue.

<div align="right">Dale Chihuly, 1998</div>

Pages 119 to 123

Acrylic on paper, 1999, 42 x 60"

**Purple Reeds,** Palm Springs, CA, 2000

**Tepees,** Nuutajärvi, Finland, 1995

**Red Spears,** Vianne, France, 1997

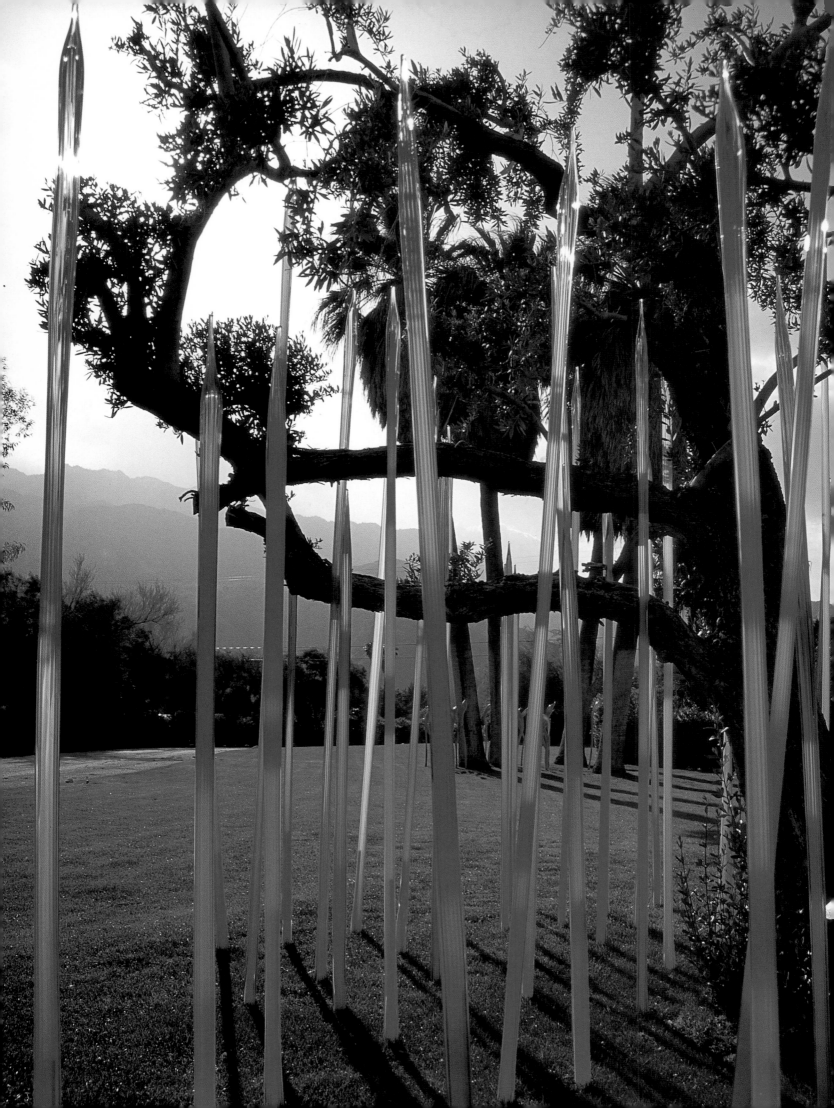

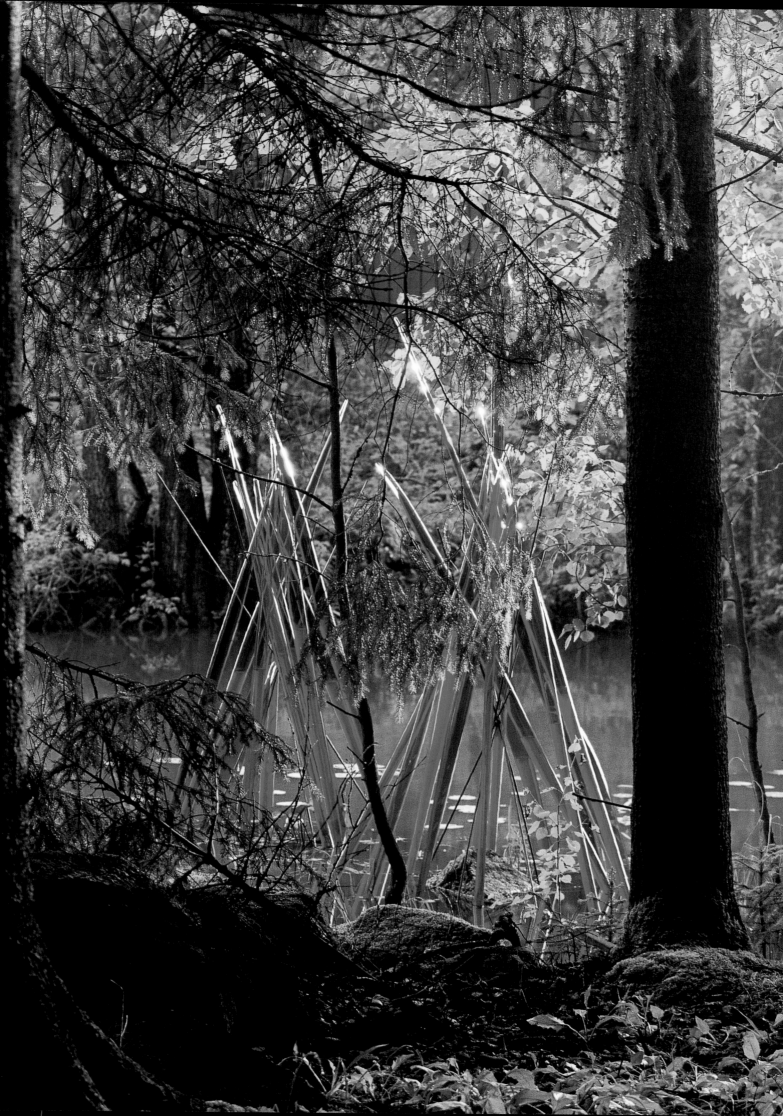

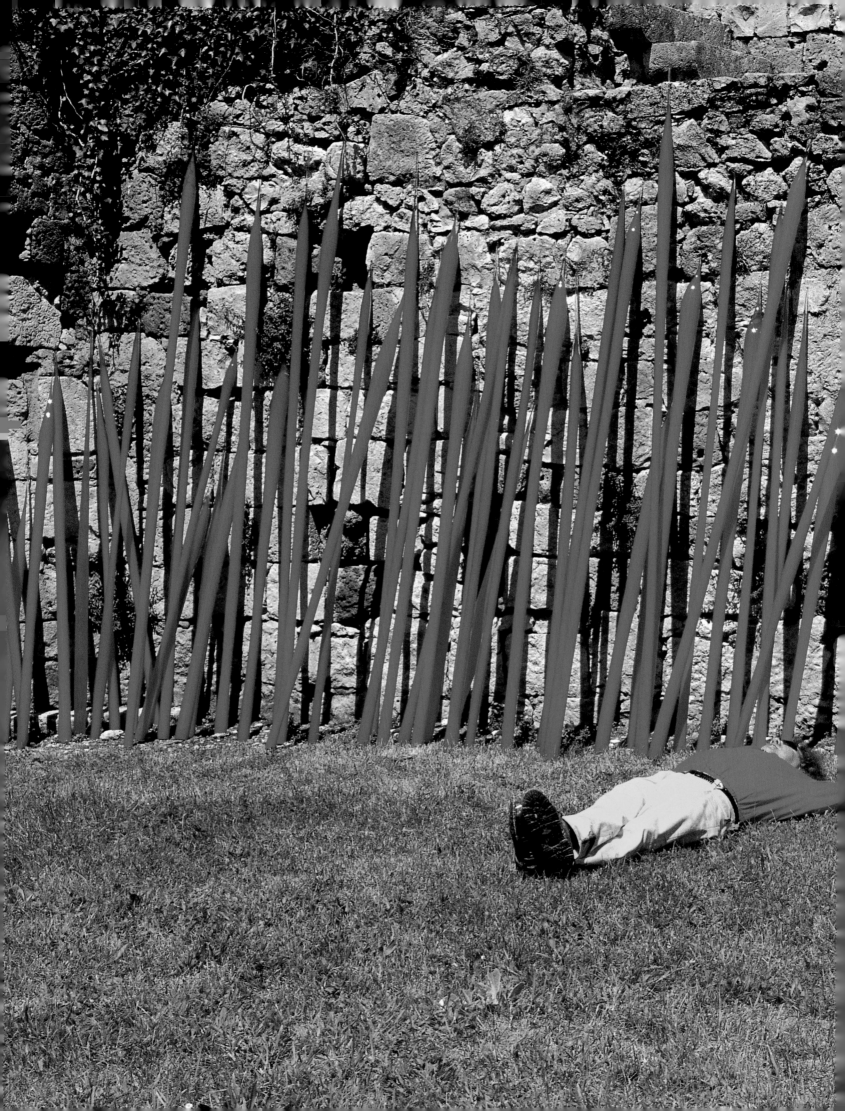

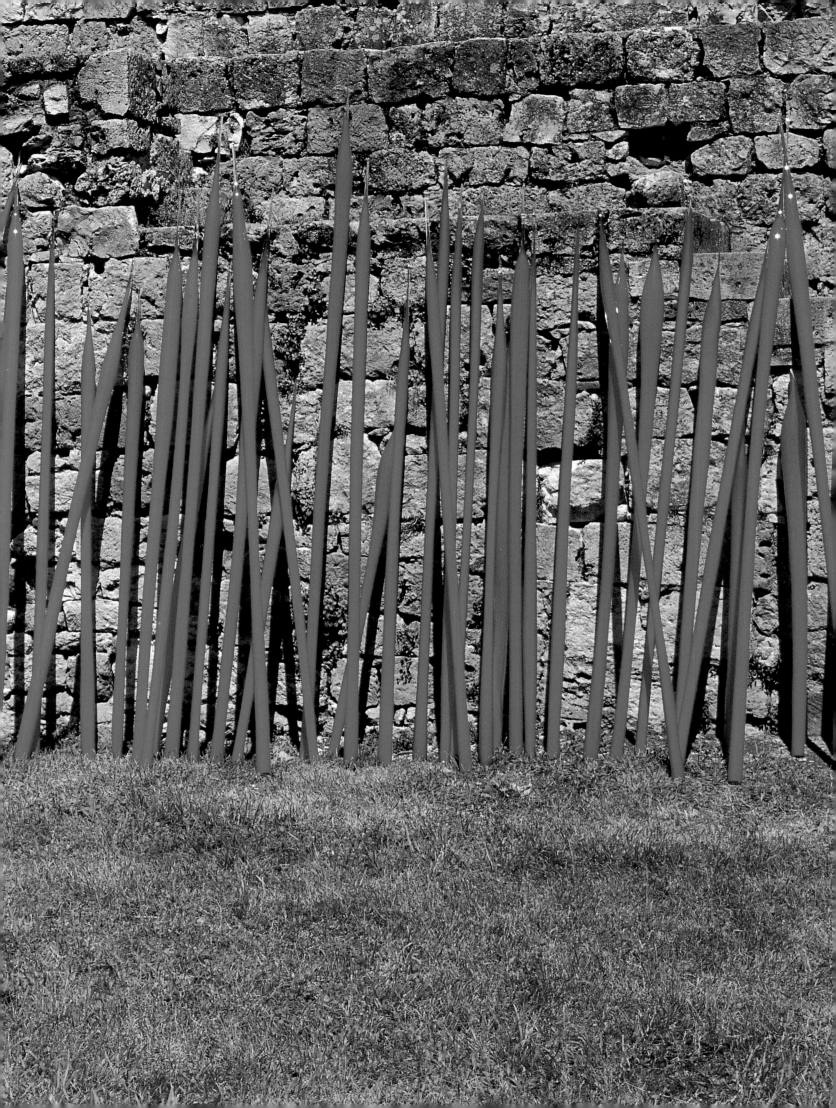

# Towers

The idea of a *Tower* just came from looking at one of my *Chandeliers* and imagining what it would look like upside down.

Dale Chihuly, 2000

Chihuly's *Towers* evolved from his *Chandeliers*. In 1992, he began massing blown-glass forms on steel armatures to create large, hanging sculptures. During the *Chihuly Over Venice* project (1995–96), he experimented extensively with the *Chandeliers*, varying both the shapes of the glass parts and the shapes of the *Chandeliers*. Subsequent projects challenged Chihuly to create large sculptures in spaces where the ceilings could not bear the weight of his *Chandeliers*, giving life to the development of Chihuly's *Towers*. His largest *Tower* is over fifty feet tall.

Jennifer Lewis, 2003

The most challenging *Tower* we ever made is at The Children's Museum of Indianapolis. It contains 3,278 pieces of glass.

Dale Chihuly, 2006

The *Towers* are an engineering feat for the studio.

Dale Chihuly, 2005

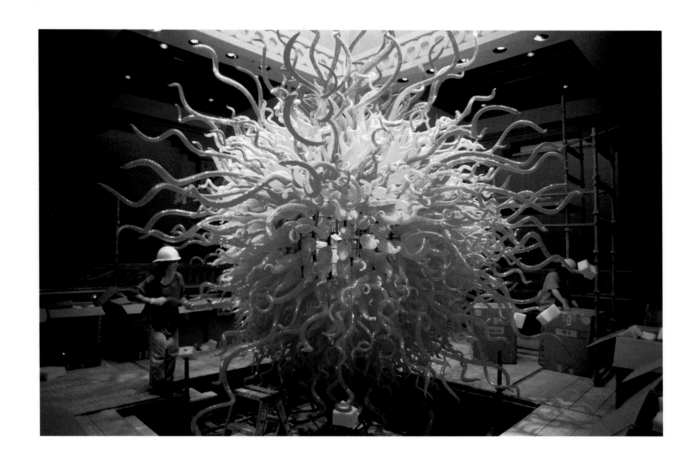

Pages 125 to 131

**Temple of the Sun,** Atlantis, Paradise Island, Bahamas, 1998

**Blue Tower,** Jerusalem, Israel, 1999

**Polyvitro Crystal Tower,** Missouri Botanical Garden, St. Louis, MO, 2006

**Crystal Gate,** Atlantis, Paradise Island, Bahamas, 1998

**Eleanor Blake Kirkpatrick Memorial Tower,** Oklahoma City Museum of Art, Oklahoma City, OK, 2002

**La Tour de Lumière,** Monte Carlo, Monaco, 2000

**Fireworks of Glass,** The Children's Museum of Indianapolis, Indianapolis, IN, 2006

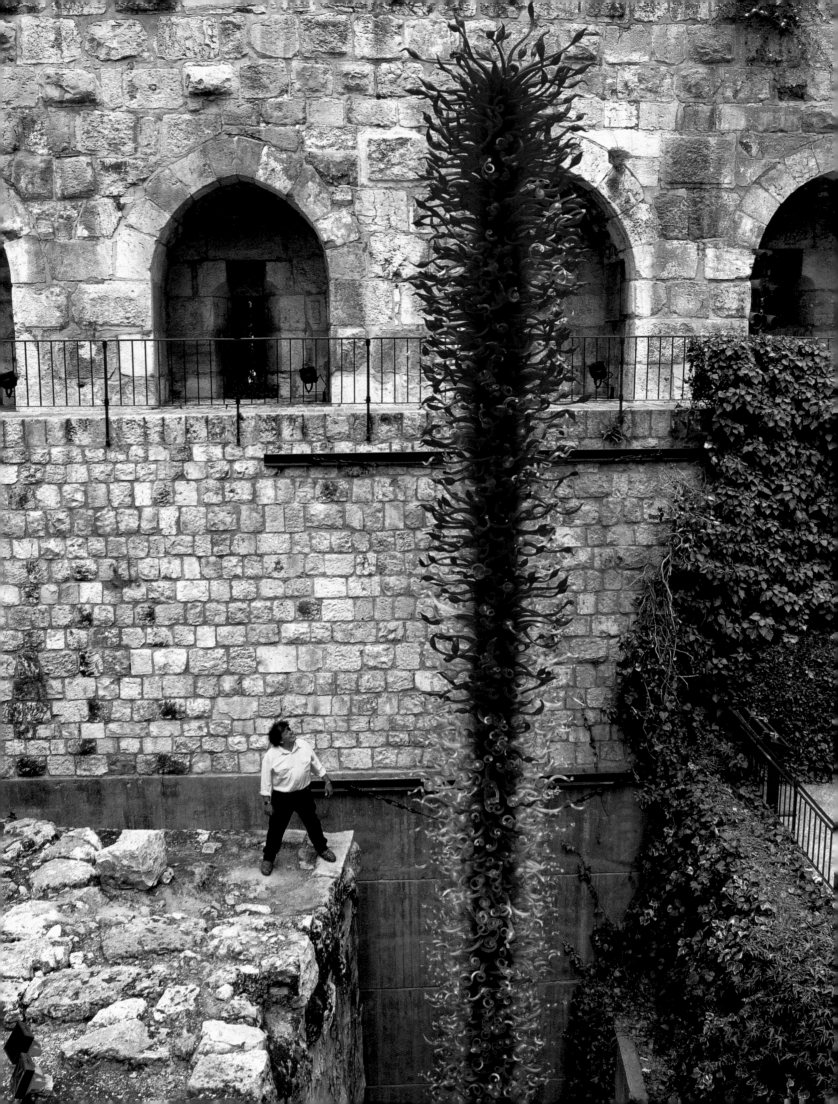

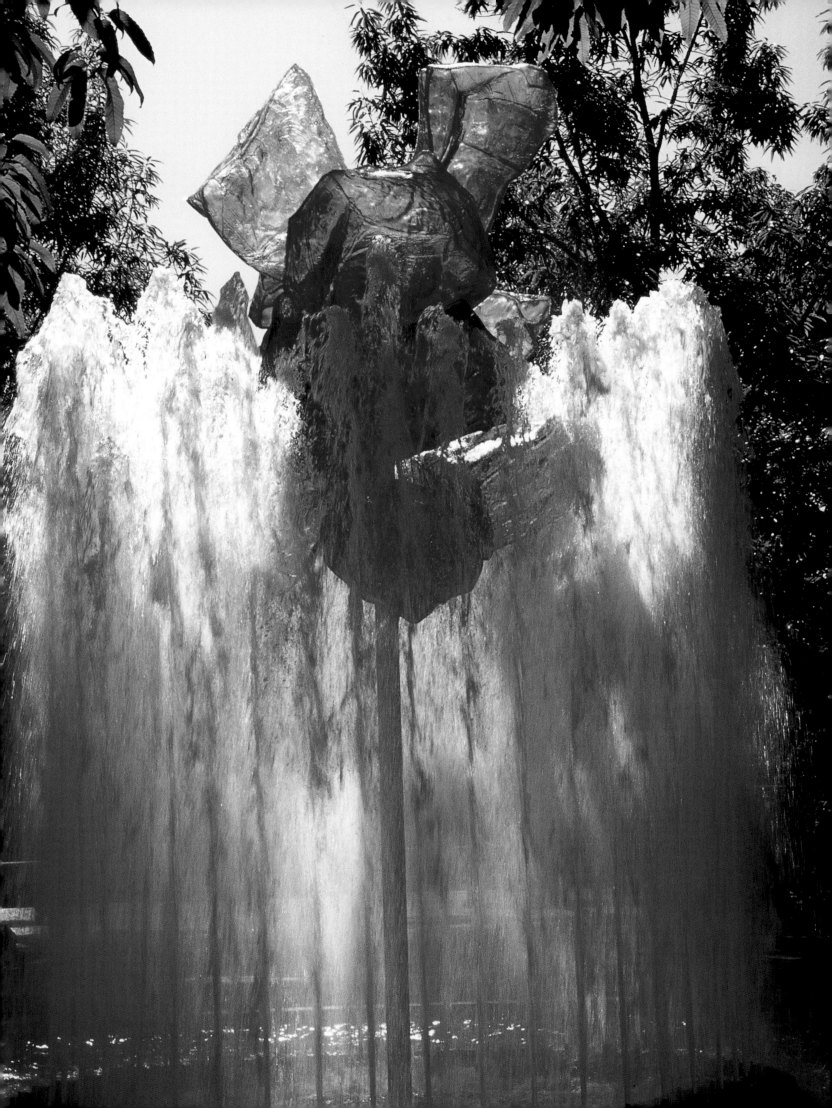

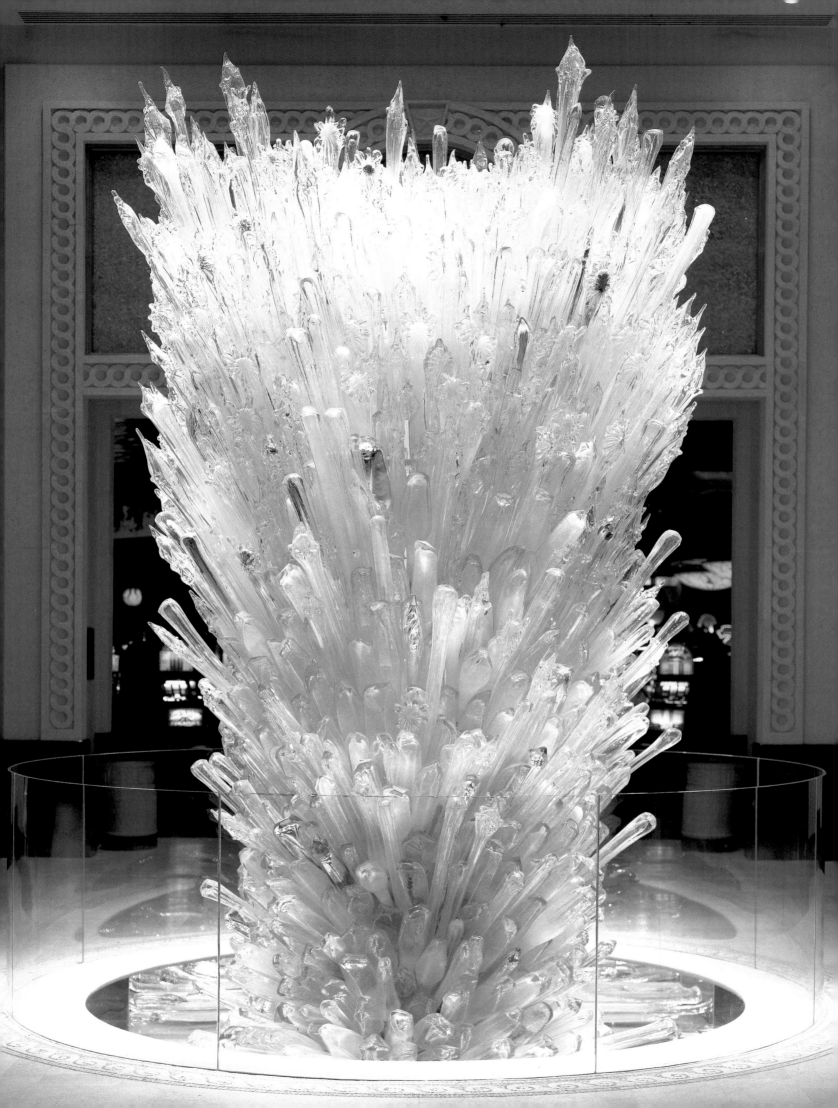

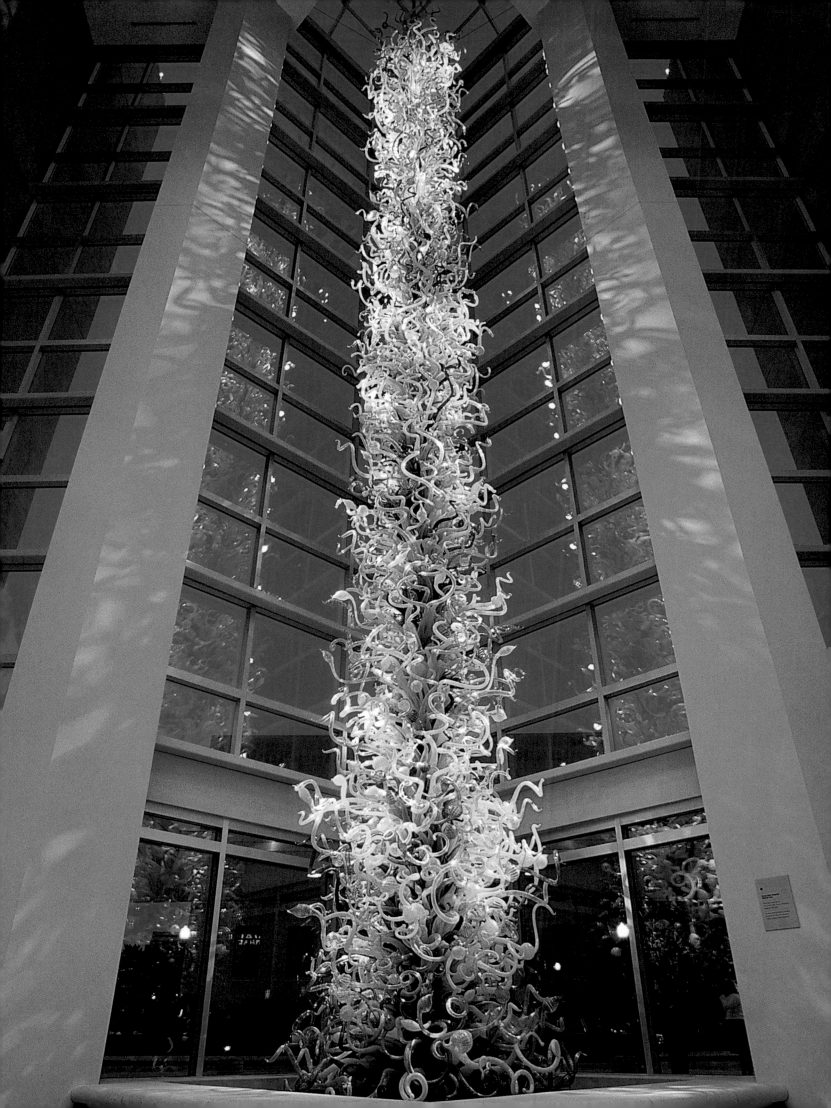

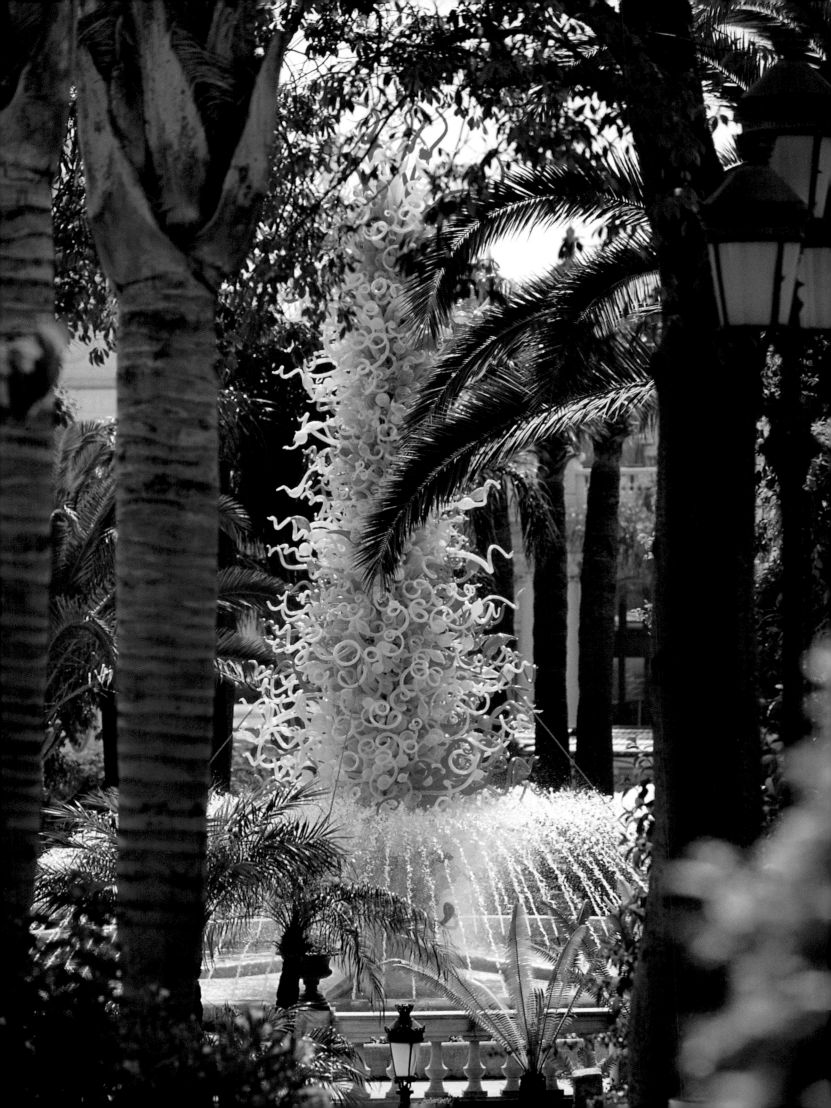

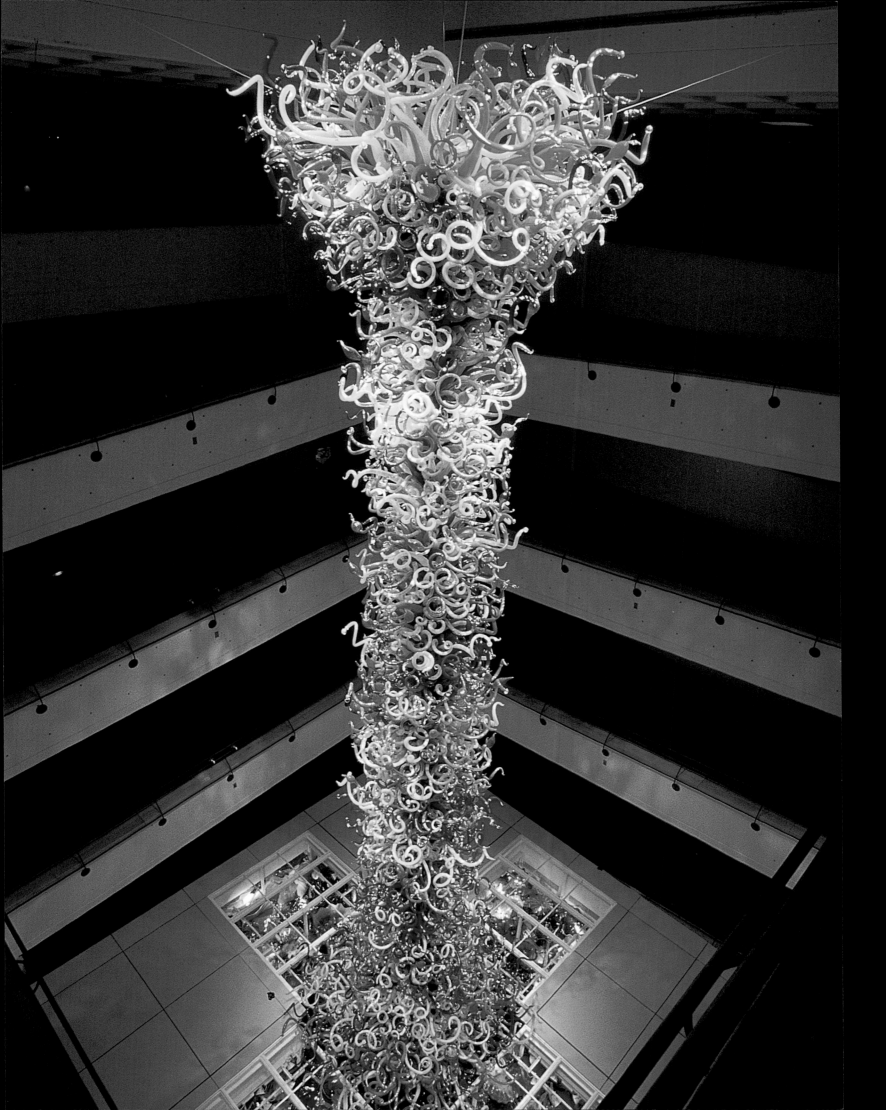

# Jerusalem Cylinders

Originally I went to Jerusalem in 1962 and worked on a *kibbutz*. And when I went back after thirty-five years, it made me want to do a series using stone as a symbol for the Jerusalem project.

You know, we have a great glassblowing team headed up by Jim Mongrain that make these. And they turned out so much better than I thought they would. I was so thrilled with how they came out.

So there is something new that comes from this project. We would never have done those *Cylinders* if we hadn't come over here to Israel and Jerusalem to do this project.

<div align="right">Dale Chihuly, 2000</div>

I've always wanted to do a series of blown objects with chunks of crystals on them—I love the look of glass crystals. The challenge was how to make the crystals and then how to apply them to the *Cylinders* and be able to reheat them without the crystals losing their beautiful sharp edges. I could have easily glued them onto the *Cylinders* but they wouldn't have had the right look and gluing is not my style and I don't trust glue in the end. So it's been a major technical challenge, perhaps the most difficult and complicated pieces I've ever made along with the large *Venetians*. And like the *Venetians*, it took a large, very experienced team—twelve to fifteen glassblowers.

<div align="right">Dale Chihuly, 1999</div>

I am amazed that we pulled off the *Jerusalem Cylinders*.

<div align="right">Dale Chihuly, 2006</div>

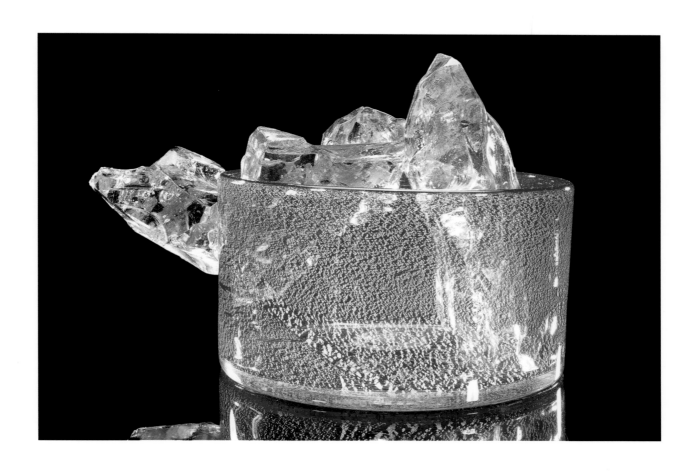

Pages 133 to 137

Jerusalem 2000 Cylinder #90, 1999, 14 x 15 x 15"

Jerusalem 2000 Cylinder #87, 1999, 26 x 12 x 11"

Jerusalem 2000 Cylinder #81, 1999, 32 x 22 x 11"

Jerusalem 2000 Cylinder #103, 1999, 23 x 21 x 15"

Jerusalem 2000 Cylinder #60, 1999, 19 x 17 x 11"

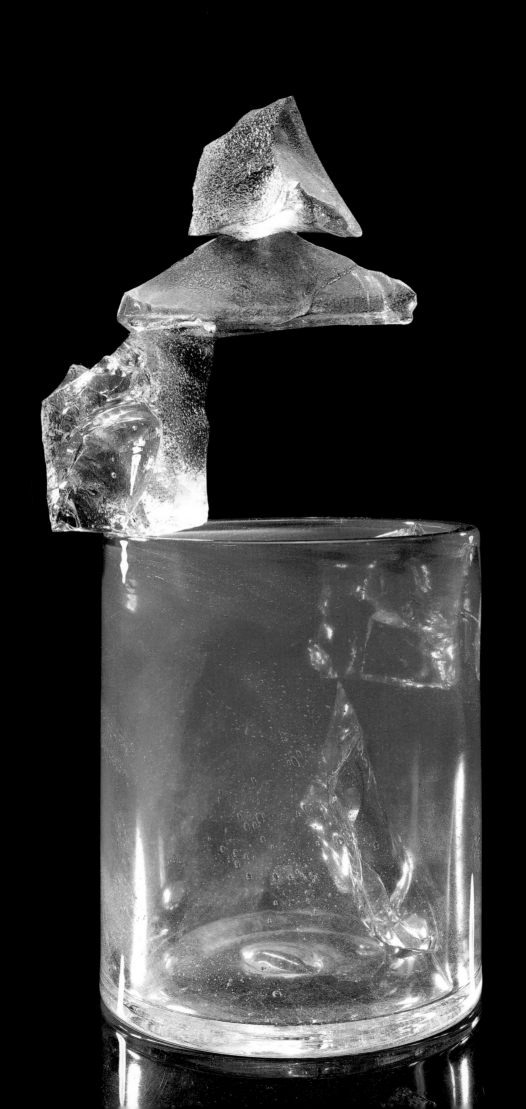

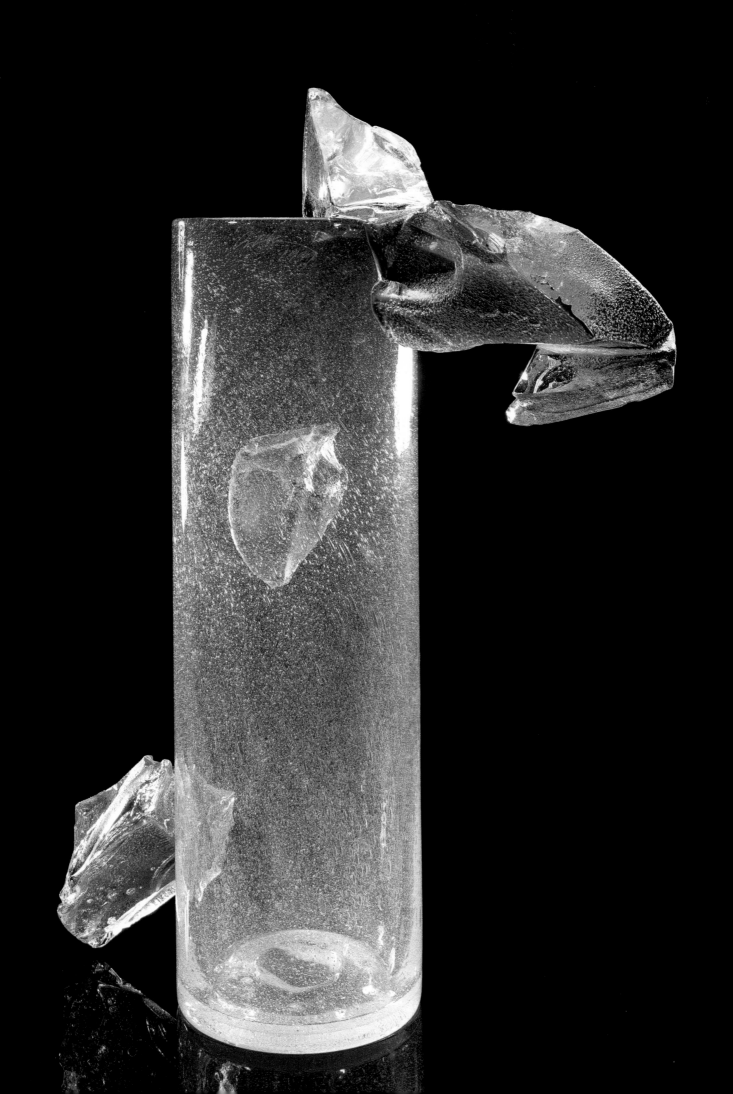

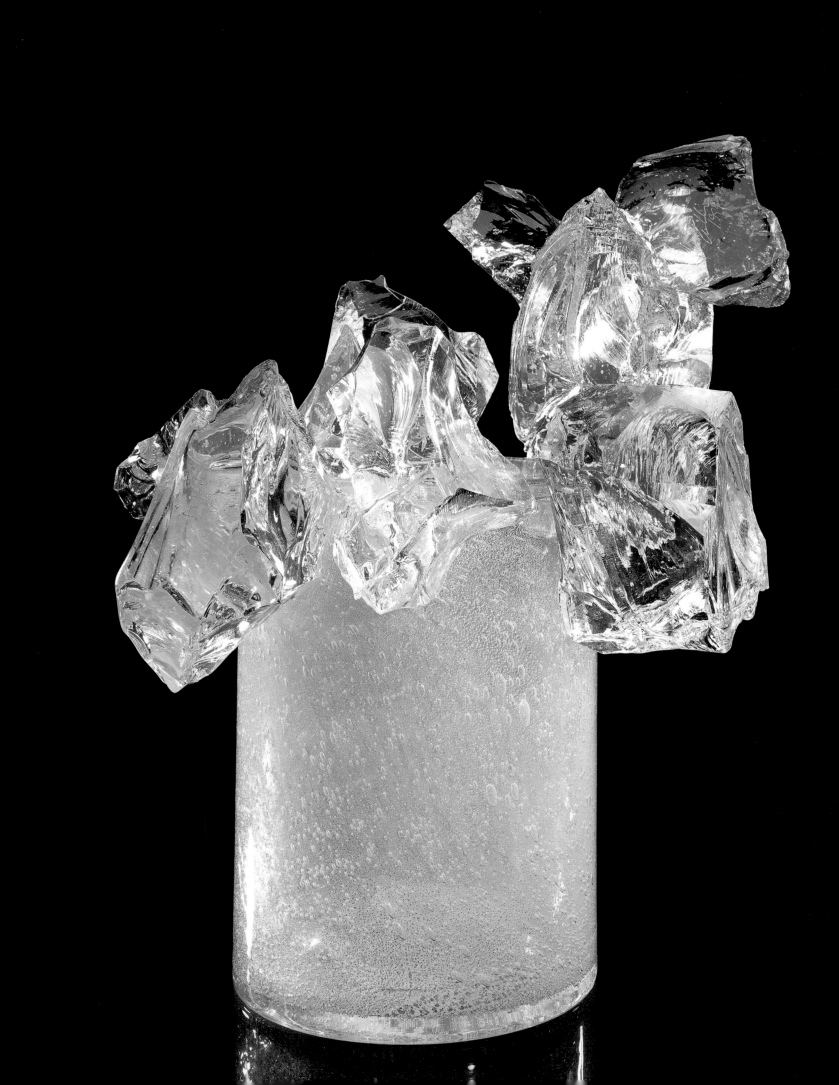

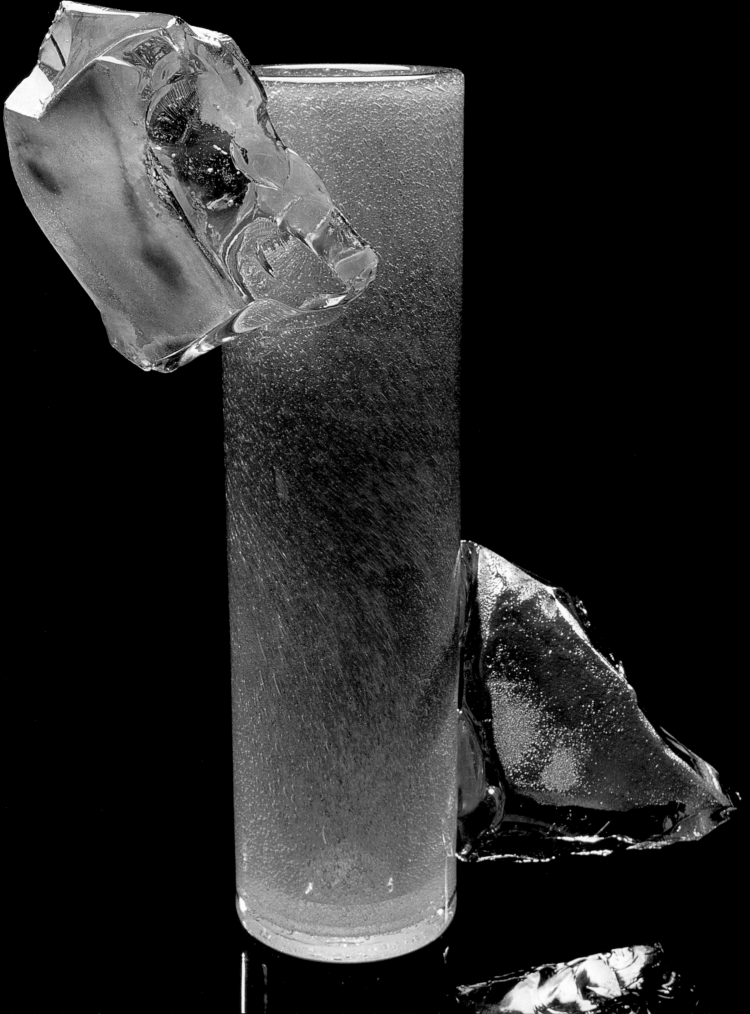

# Fiori

I like the fact that lots of people see it and they like it. Glass makes them feel good. The color is very emotional. The forms are very organic. I like it to feel like—was it made by man, or was it made by nature?

Dale Chihuly, 2001

I'm a little less particular about the placement of things. One of the reasons being that I like things to feel that they sort of happened by nature and not been put there by man. If it gets too organized, then it's too uptight for me. I get a kick out of having other people do things, because they might do them differently—even if they're a little awkward, I like it. I strive for, as if the wave from the ocean scattered it out and obviously it would happen differently every time the wave came in, but in a way that was natural and felt right.

Dale Chihuly, from video Chihuly in Charlotte, WTVI Charlotte Public Television, written, produced, and directed by Stuart Grasberg, 2000

There's something about the fluidity of glass that makes it want to make forms from nature . . . My forms are made in a very natural way, using fire, gravity, and centrifugal force, so they look like they come from nature. But I don't look at pictures of plants and say now I'm going to make one that looks like that.

Dale Chihuly, 2004

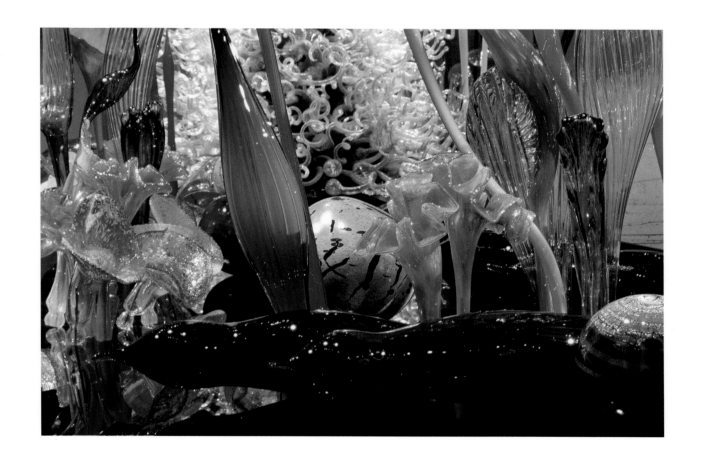

Pages 139 to 147

**Mille Fiori,** Tacoma Art Museum, Tacoma, WA, 2003

**Autumn Tendril Fiori,** 2005, 57 x 37 x 26"

**Ruby and Orange Sunset Fiori,** 2005, 72 x 22 x 22"

**Paintbrushes,** Medina, WA, 2006

**Mille Fiori,** Seattle, WA, 2004

**Mille Fiori,** Venice, CA, 2004

**Mille Fiori,** Venice, CA, 2004

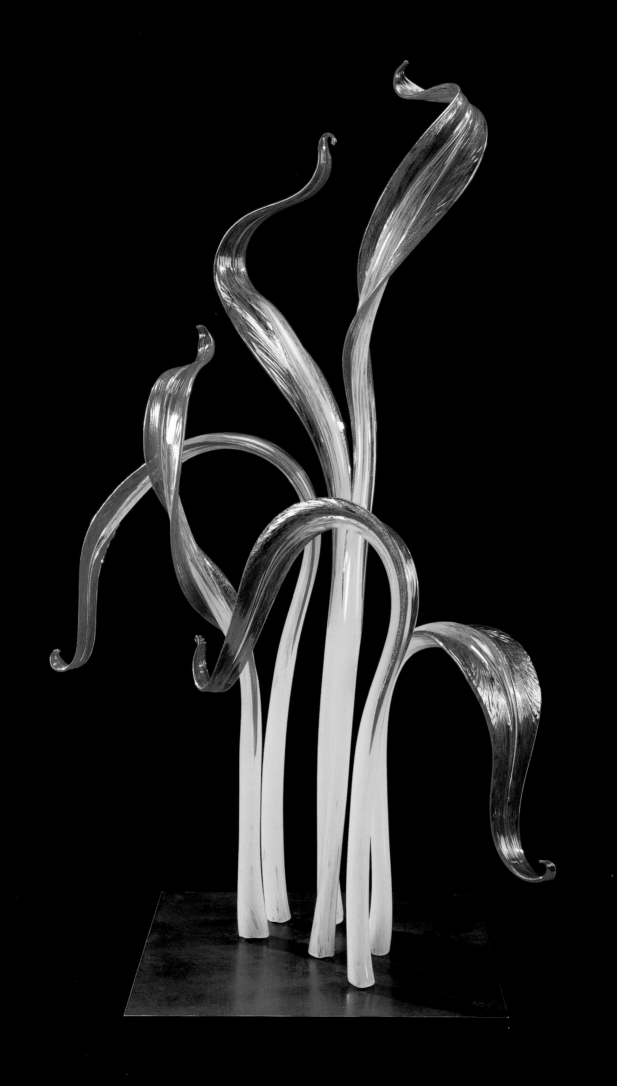

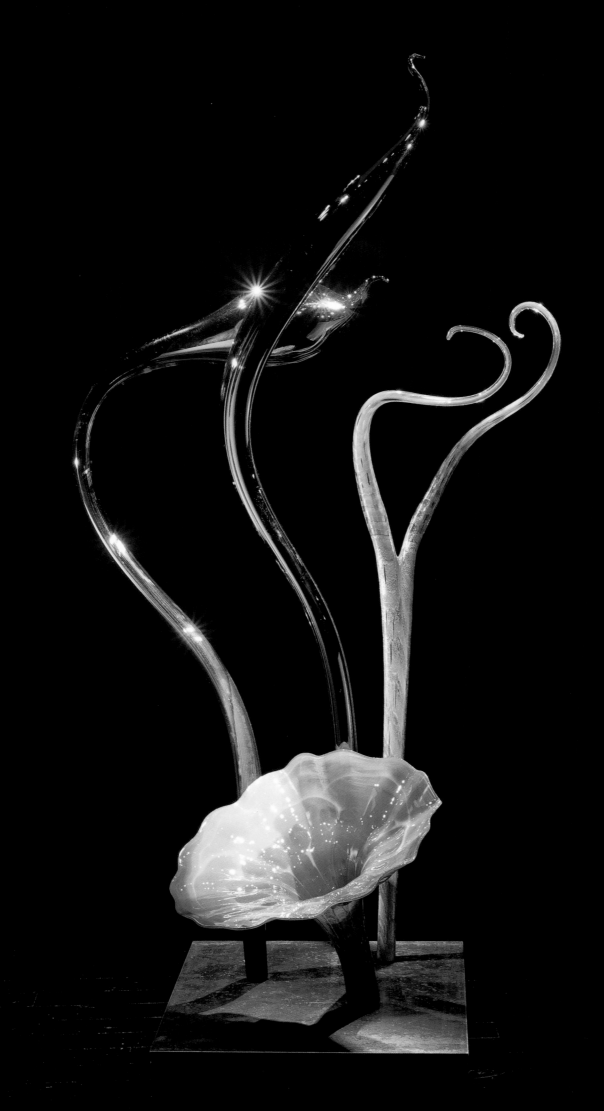

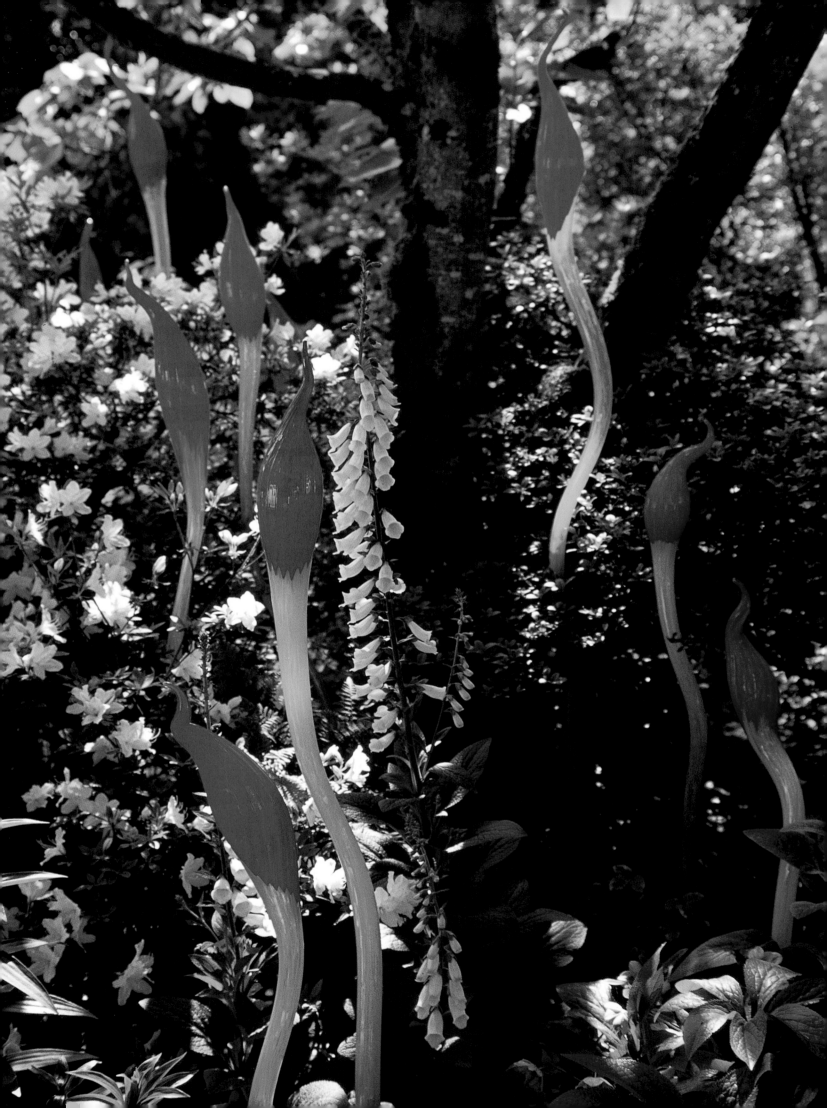

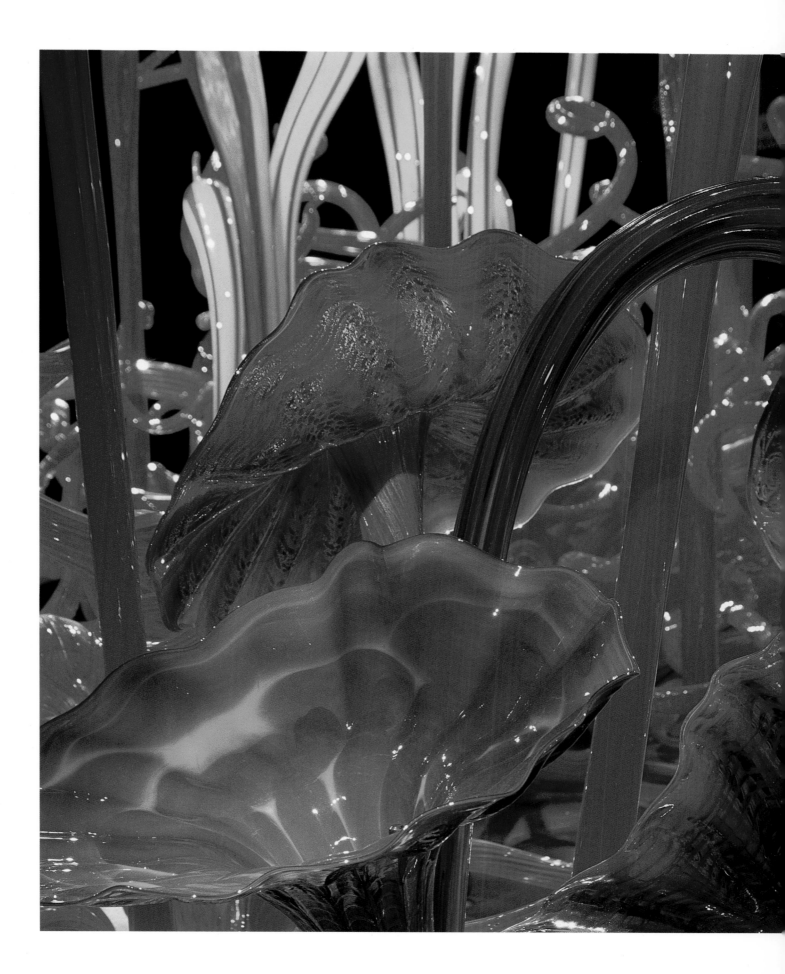

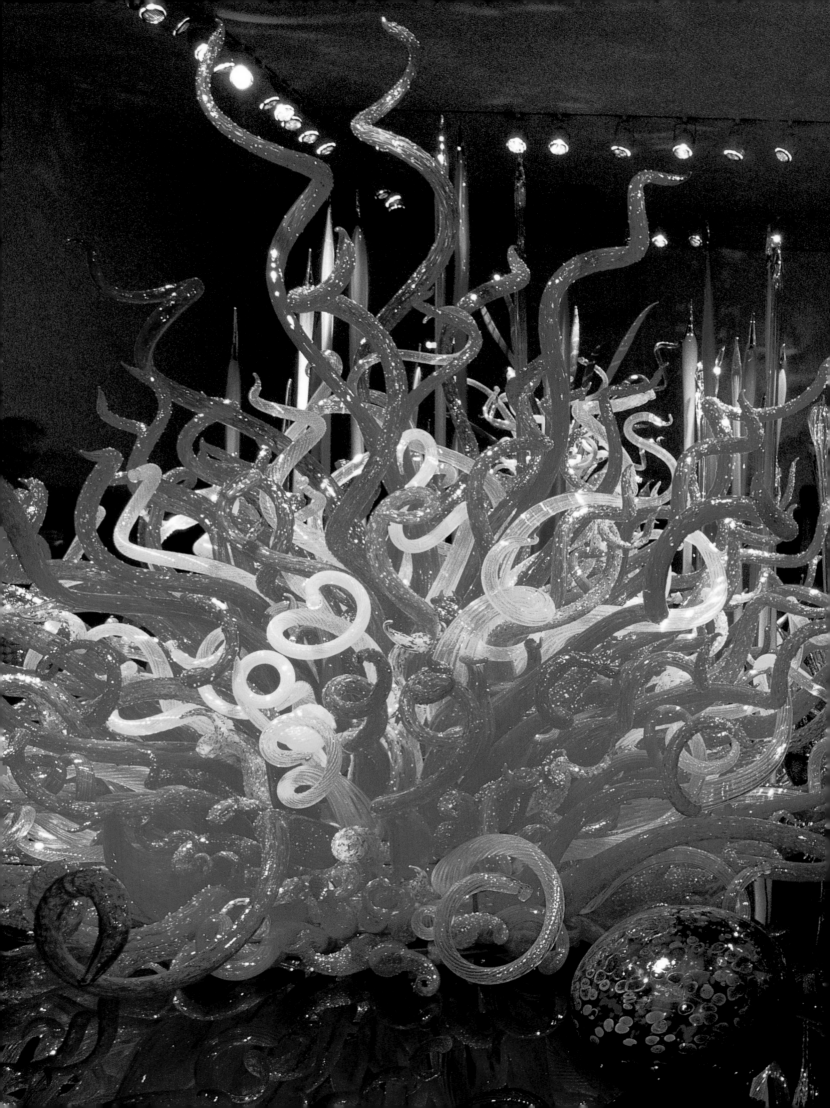

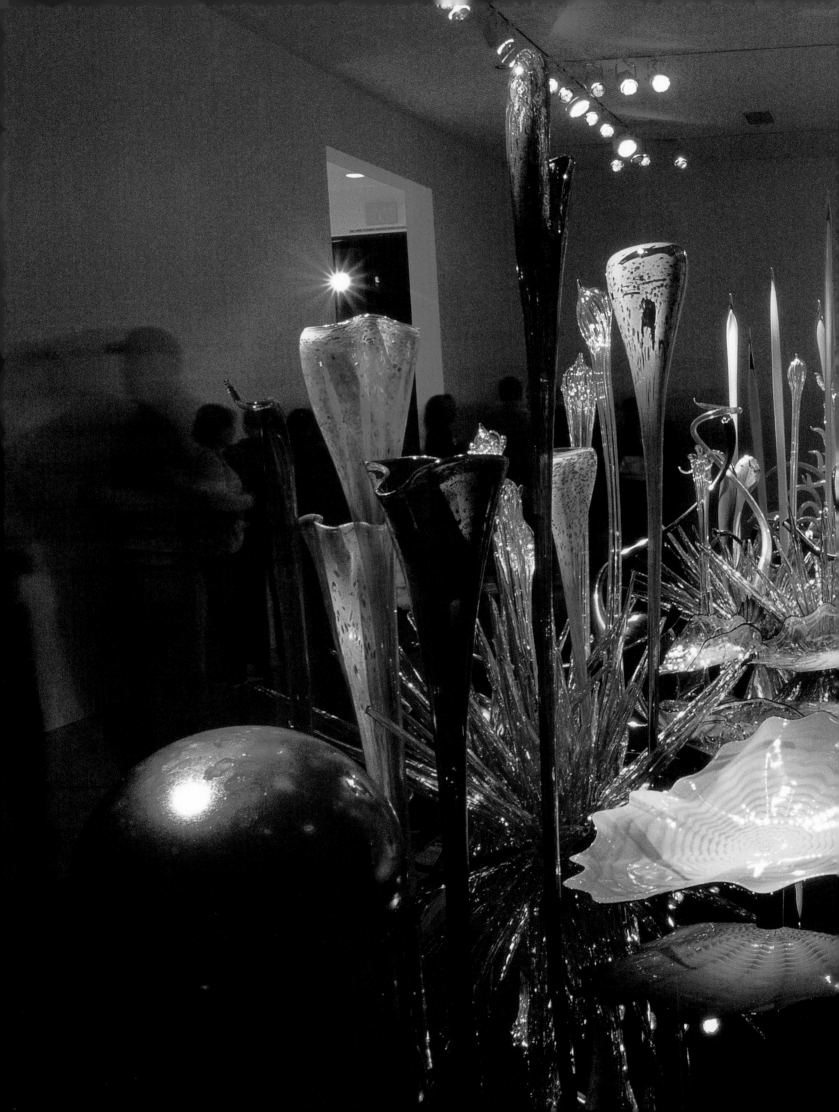

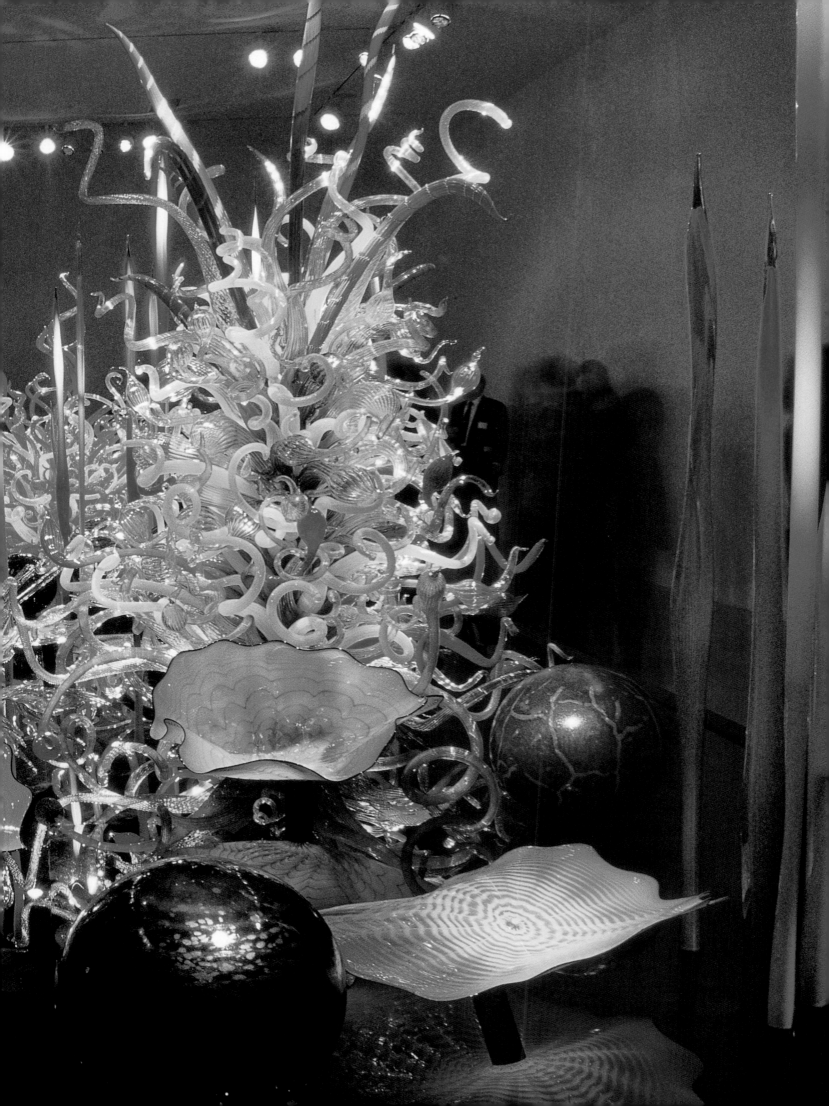

# Installations

There are four materials I work with: I work with glass, plastic, water, and ice. Those are the four materials that I work with; those are the four great transparent materials—really, the only transparent materials of any scale.

And so when you're working with transparent materials, when you're looking at glass, plastic, ice, or water, you're looking at light itself. The light is coming through and you see that color—that cobalt blue, that ruby red, whatever the color might be—you're looking at the light and the color mix together. Something magical and mystical, something we don't understand, nor do we care to understand. Sort of like trying to understand the moon. It has magical powers—water. And glass has magical powers. And so does plastic. And so does ice.

<div align="right">Dale Chihuly, 1999</div>

One of the attractions to being in the Northwest is the rain. I find the rain very creative. Water is the one thing that I can assure you is a major influence on my work and my life and everything I do. When I'm not here, I take more baths. I got to get into a bathtub frequently or take a shower. If I don't feel good or I don't feel creative, if I can get near the water something will start to happen.

<div align="right">Dale Chihuly, from video Inspirations, directed by Michael Apted,<br>produced by Clear Blue Sky Productions, 1997</div>

I think ideas come a great deal from being alone. Even though I work with a big team of people all day long, I happen to be an early riser, so I'm often up at four or five in the morning, and that's several hours to be on my own and think about things. The water is really important to me. I love to be on the ocean, I love baths, I love showers, I love swimming, and I think a lot when I'm in the water.

<div align="right">Dale Chihuly, 2001</div>

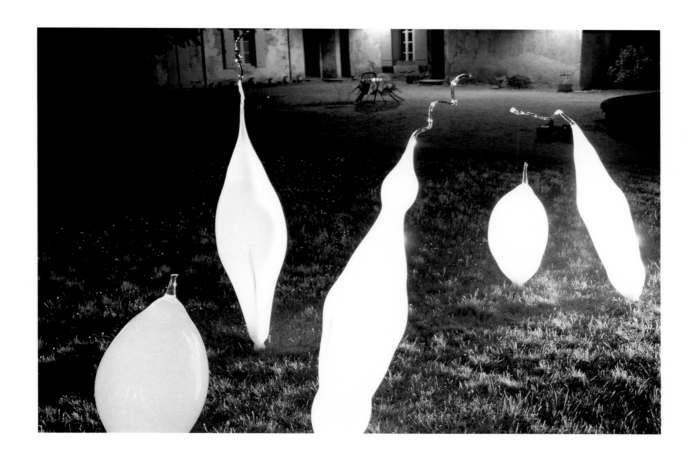

Pages 149 to 157

**White Seal Pups,** Vianne, France, 1997

**Blue Herons,** Palm Springs, CA, 2000

**Tiger Lilies,** Atlanta Botanical Garden, Atlanta, GA, 2004

**Blue Polyvitro Crystals,** Seattle, WA, 2005

**Boat,** Nuutajärvi, Finland, 1995

**Float Boat,** Oklahoma City Museum of Art, Oklahoma City, OK, 2002

**Thames Skiff,** Royal Botanic Gardens, Kew, Richmond, Surrey, United Kingdom, 2005

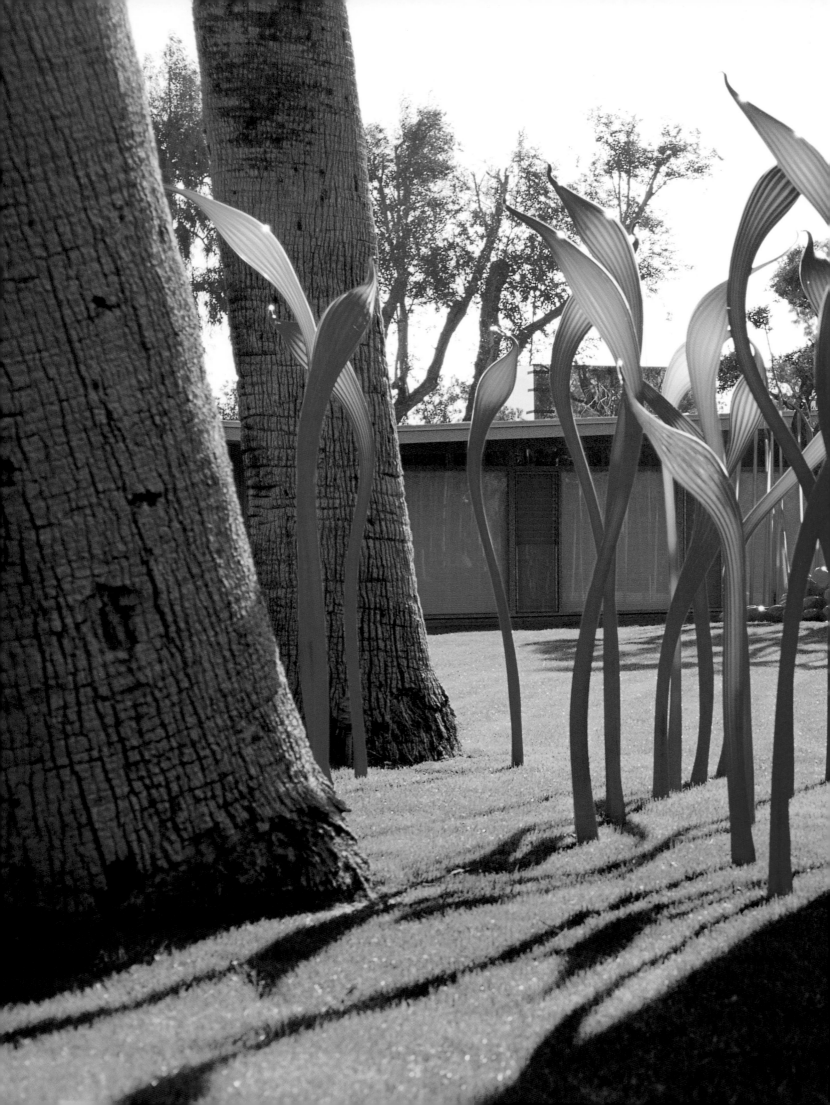

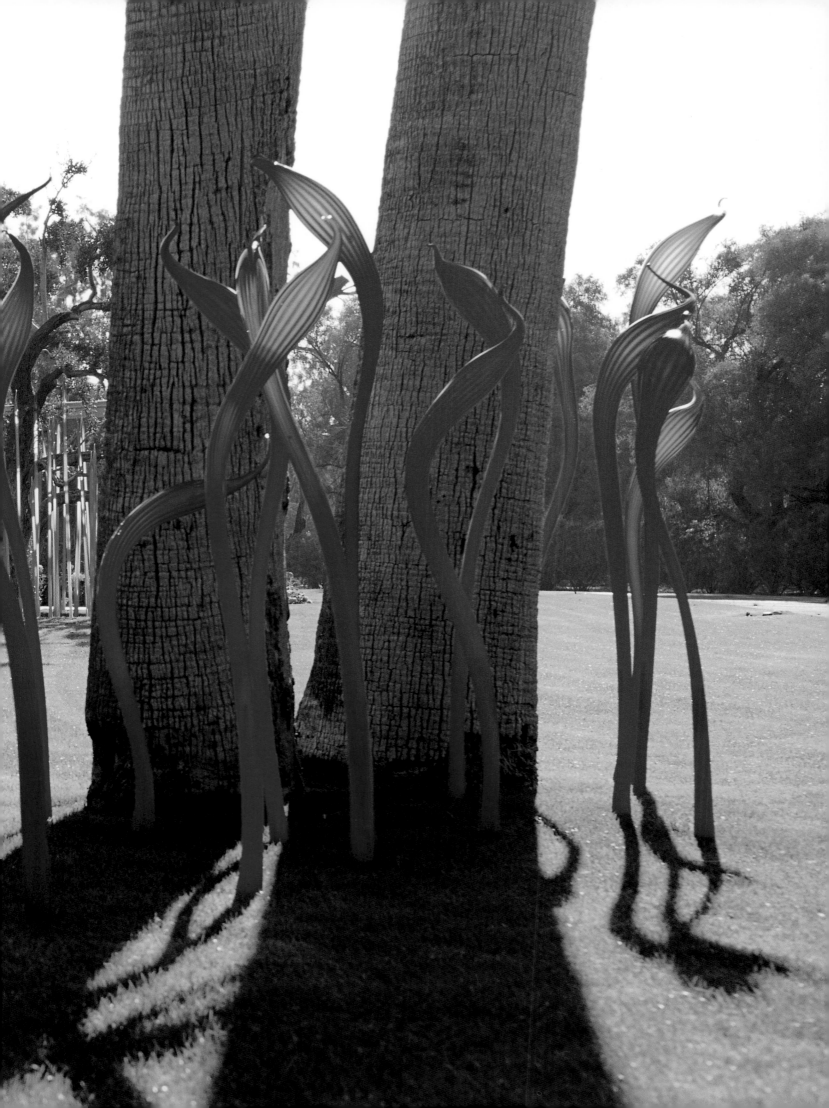

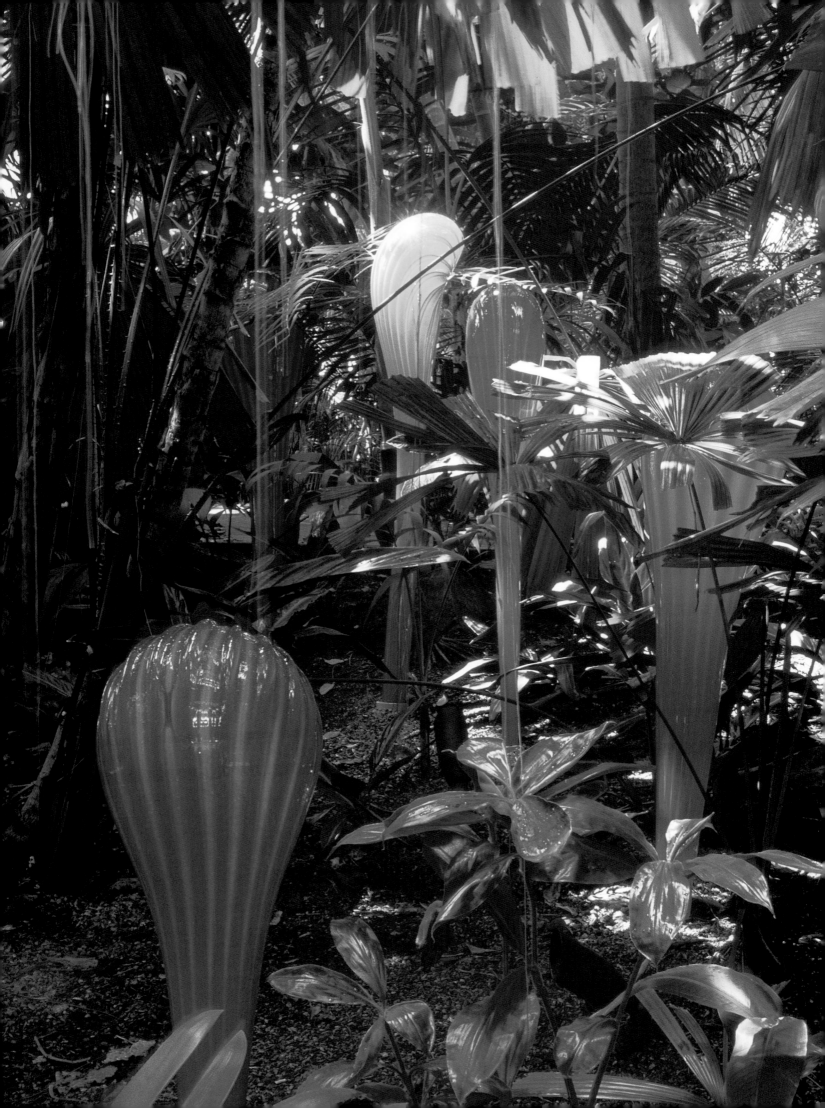

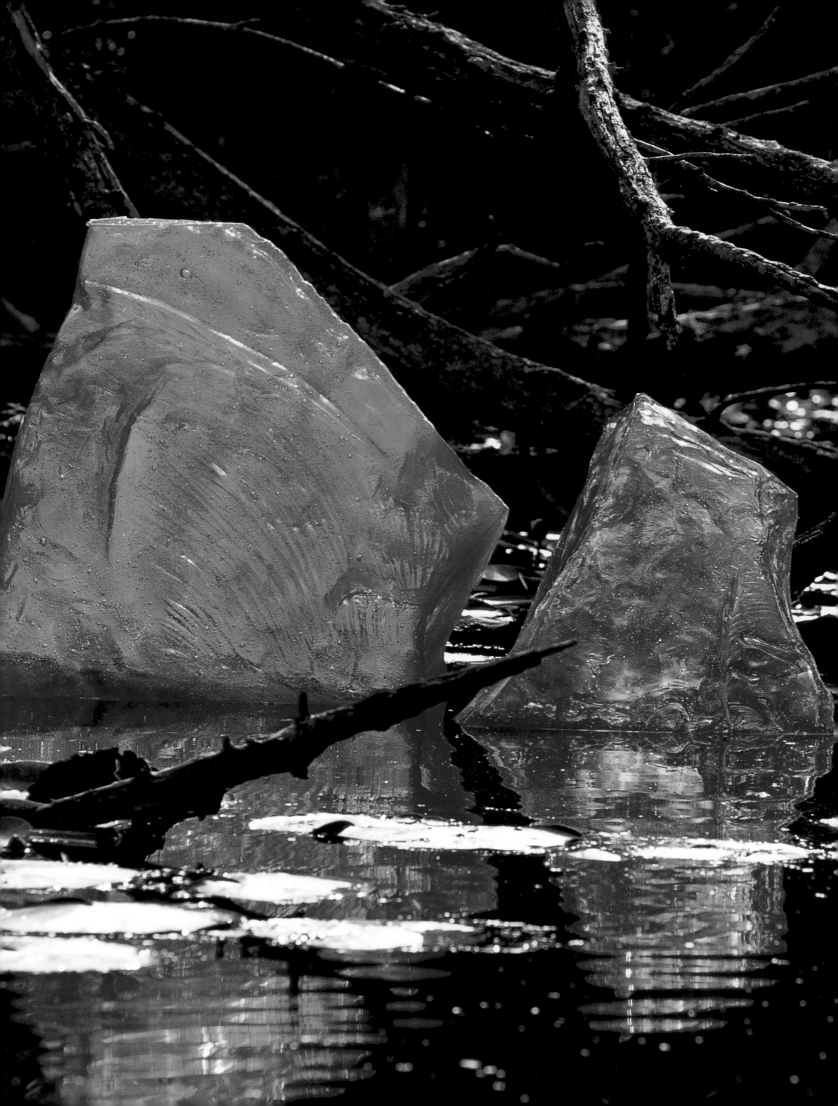

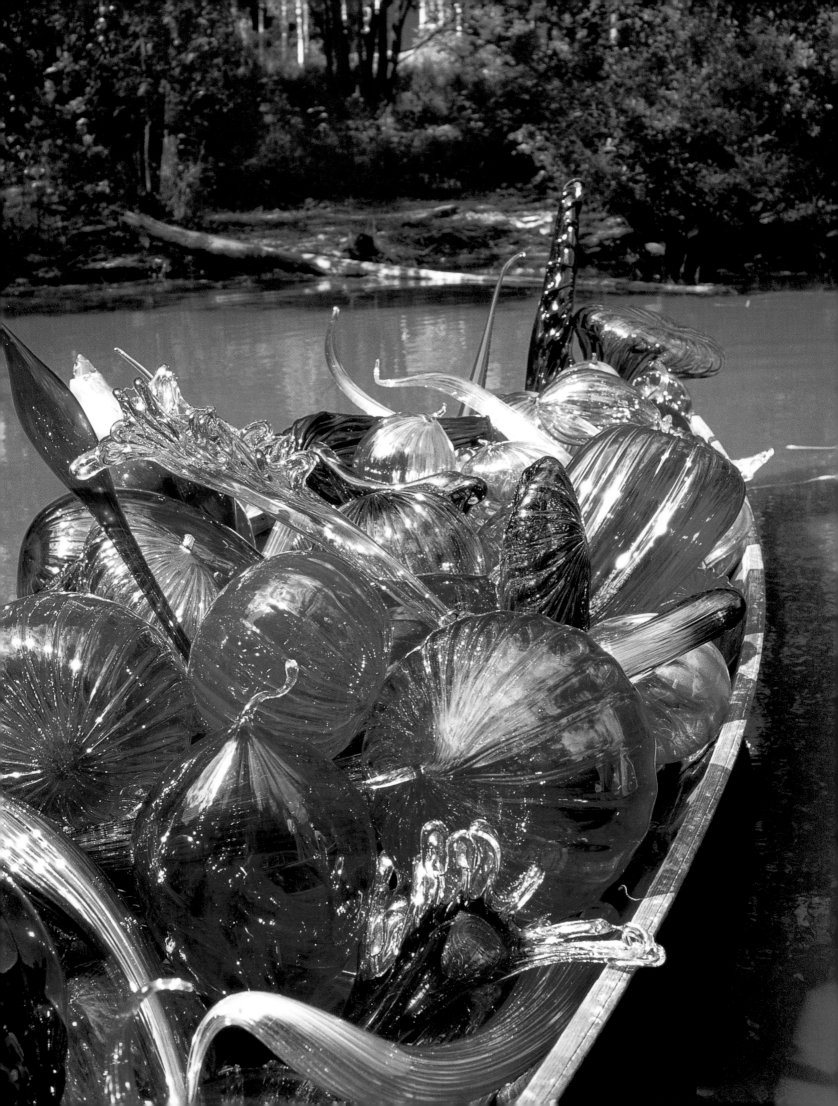

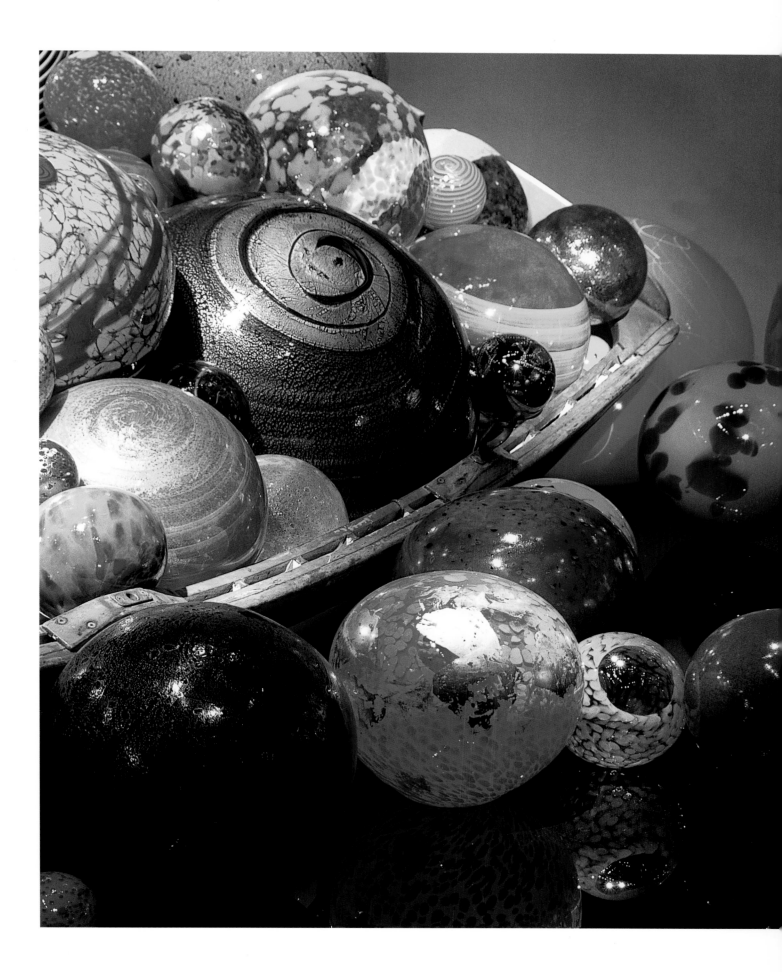

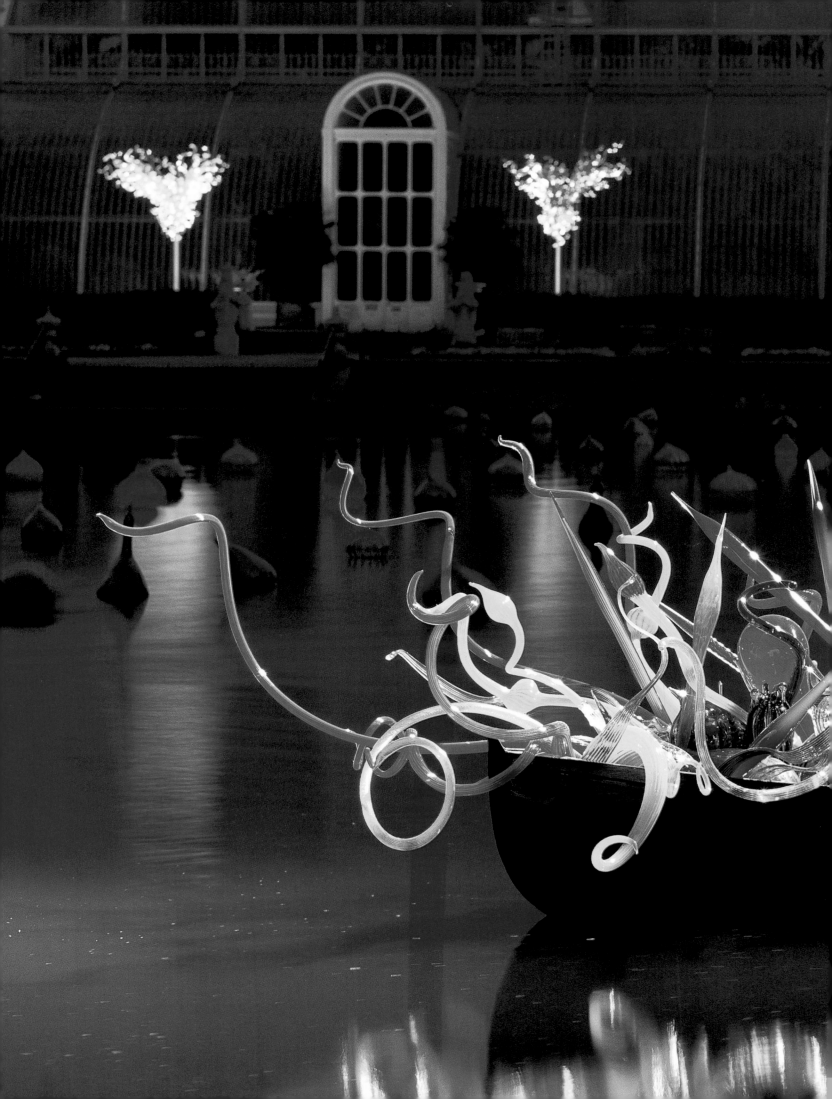

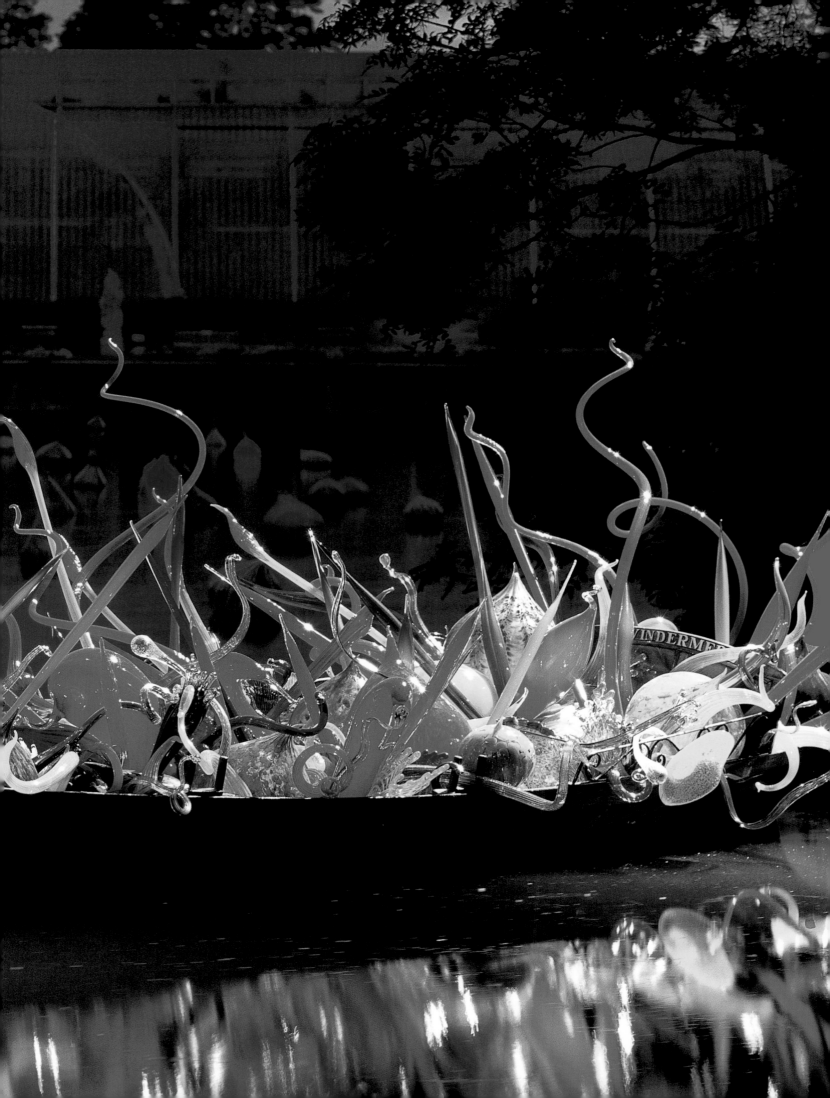

Tacoma, 1942

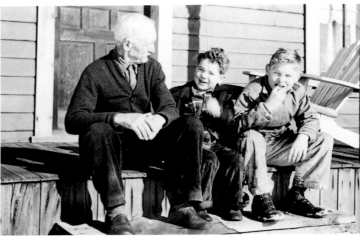

Grandfather Chihuly, Dale, and his brother, George, 1948

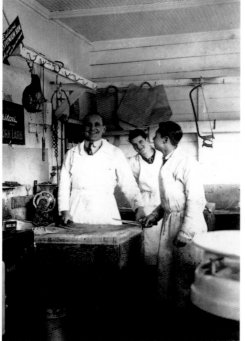

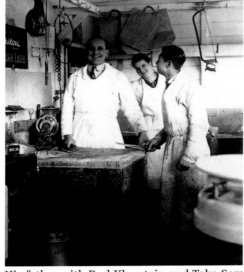

With his father, George, and his brother, George (right), circa 1943

His father with Bud Klepstein and Toke Semba, 1941

# Chronology

1941   Born September 20 in Tacoma, Washington, to George Chihuly and Viola Magnuson Chihuly.

1957   Older brother and only sibling, George, is killed in a Naval Air Force training accident in Pensacola, Florida.

1958   His father suffers a fatal heart attack at age 51. His mother goes to work to support herself and Dale.

1959   Graduates from high school in Tacoma. Enrolls in the College of Puget Sound (now the University of Puget Sound) in his hometown. Transfers to the University of Washington in Seattle to study interior design and architecture.

1961   Joins Delta Kappa Epsilon fraternity and becomes rush chairman. Learns to melt and fuse glass.

1962   Disillusioned with his studies, he leaves school and travels to Florence to study art. Discouraged by not being able to speak Italian, he leaves and travels to the Middle East.

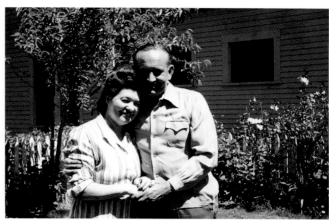

Viola and George Chihuly, circa 1949

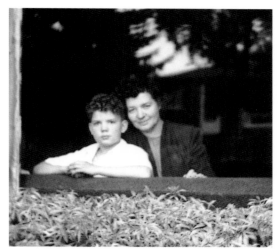

With his mother, Viola, circa 1951

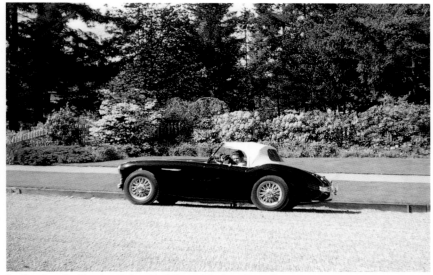

In the Austin Healey inherited from his brother, George, 1957

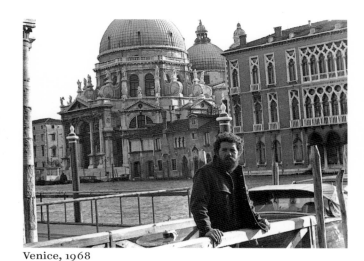

Venice, 1968

1963 Works on a *kibbutz* in the Negev Desert. Returns to the University of Washington in the College of Arts and Sciences and studies under Hope Foote and Warren Hill. In a weaving class with Doris Brockway, he incorporates glass shards into woven tapestries.

1964 Returns to Europe, visits Leningrad, and makes the first of many trips to Ireland.

1965 Receives B.A. in Interior Design from the University of Washington. Experimenting on his own in his basement studio, Chihuly blows his first glass bubble by melting stained glass and using a metal pipe.

1966 Works as a commercial fisherman in Alaska to earn money for graduate school. Enters the University of Wisconsin at Madison, where he studies glassblowing under Harvey Littleton.

1967 Receives M.S. in Sculpture from the University of Wisconsin. Enrolls at the Rhode Island School of Design (RISD) in Providence, where he begins his exploration of environmental works using neon, argon, and blown glass. Awarded a Louis Comfort Tiffany Foundation Grant for work in glass. Italo Scanga, then on the faculty at

At the Venini factory on the island of Murano, 1969

Teaching Art Wood's son glassblowing at RISD, 1970

At a shooting range with Frannie Hamilton, Italy, 1969

With James Carpenter, Venice, 1972

Pennsylvania State University's Art Department, lectures at RISD, and the two begin a lifelong friendship.

1968  Receives M.F.A. in Ceramics from RISD. Awarded a Fulbright Fellowship, which enables him to travel and work in Europe. Becomes the first American glassblower to work in the Venini factory on the island of Murano. Returns to the United States and spends four consecutive summers teaching at Haystack Mountain School of Crafts in Deer Isle, Maine.

1969  Travels again throughout Europe and meets glass masters Erwin Eisch in Germany and Jaroslava Brychtová and Stanislav Libenský in Czechoslovakia. Returning to the United States, Chihuly establishes the glass program at RISD, where he teaches for the next fifteen years.

1970  Meets James Carpenter, a student in the RISD Illustration Department, and they begin a four-year collaboration.

1971  On the site of a tree farm donated by Seattle art patrons Anne Gould Hauberg and

With Erwin Eisch, Pilchuck Glass School, 1972

With Buster Simpson and Italo Scanga, 1971

Barbara Vaessen and James Carpenter, Venice, 1972

With Dennis Oppenheim and his son, 1974

John Hauberg, the Pilchuck Glass School is founded. Chihuly's first environmental installation at Pilchuck is created that summer. He resumes teaching at RISD and creates *20,000 Pounds of Ice and Neon*, *Glass Forest #1*, and *Glass Forest #2* with James Carpenter, installations that prefigure later environmental works by Chihuly.

1972 Continues to collaborate with Carpenter on large-scale architectural projects. They create *Rondel Door* and *Cast Glass Door* at Pilchuck. Back in Providence, they create *Dry Ice, Bent Glass and Neon*, a conceptual breakthrough.

1974 Supported by a National Endowment for the Arts grant at Pilchuck, James Carpenter, a group of students, and he develop a technique for picking up glass thread drawings. In December at RISD, he completes his last collaborative project with Carpenter, *Corning Wall*.

1975 At RISD, begins series of *Navajo Blanket Cylinders*. Kate Elliott and, later, Flora Mace fabricate the complex thread drawings. He receives the first of two National Endowment for the Arts Individual Artist grants. Artist-in-residence with Seaver Leslie at Artpark,

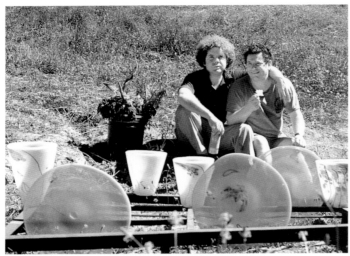

With Italo Scanga, Pilchuck Glass School, 1974

*La Donna Perfecta*, purchased in 1974

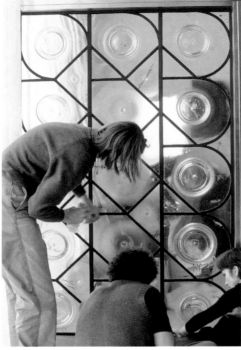

*Corning Wall*, 1974

Seattle, circa 1973

on the Niagara Gorge, in New York State. Begins *Irish Cylinders* and *Ulysses Cylinders* with Leslie and Mace.

1976   An automobile accident in England leaves him, after weeks in the hospital and 256 stitches in his face, without sight in his left eye and with permanent damage to his right ankle and foot. After recuperating he returns to Providence to serve as head of the Department of Sculpture and the Program in Glass at RISD. Henry Geldzahler, curator of contemporary art at the Metropolitan Museum of Art in New York, acquires three *Navajo Blanket Cylinders* for the museum's collection. This is a turning point in Chihuly's career, and a friendship between artist and curator commences.

1977   Inspired by Northwest Coast Indian baskets he sees at the Washington State Historical Society in Tacoma, begins the *Basket* series at Pilchuck over the summer, with Benjamin Moore as his assistant gaffer. Continues his bicoastal teaching assignments, dividing his time between Rhode Island and the Pacific Northwest.

1978   Meets William Morris, a student at Pilchuck Glass School, and the two begin a close,

162

Michael Murphy, Ireland, 1976

An automobile accident leaves him without sight in his left eye, 1976

Recovering at the home of Peter Blake, 1976

With Fairfield Porter, Providence, 1976

eight-year working relationship. A solo show, *Baskets and Cylinders*, curated by Michael W. Monroe at the Renwick Gallery, Smithsonian Institution, in Washington, D.C., is another career milestone.

1979 Dislocates his shoulder in a bodysurfing accident and relinquishes the gaffer position for good. William Morris becomes his chief gaffer for the next several years. Chihuly begins to make drawings as a way to communicate his designs.

1980 Resigns his teaching position at RISD. He returns there periodically during the 1980s as artist-in-residence. Begins *Seaform* series at Pilchuck in the summer and later, back in Providence, returns to architectural installations with the creation of windows for the Shaare Emeth Synagogue in St. Louis, Missouri.

1981 Begins *Macchia* series.

1982 First major catalog is published: *Chihuly Glass*, designed by RISD colleague and friend Malcolm Grear.

1983 Returns to the Pacific Northwest after sixteen years on the East Coast. Works at

Viola Chihuly and Italo Scanga, circa 1976

Toots Zynsky, Flora Mace, Joey Kirkpatrick, and Claydine Eugenia, Malta, 1985

Dan Dailey, Alan Seret, Italo Scanga, Seaver Leslie, Dale Chihuly, Viola Chihuly, and James Carpenter, Tacoma, 1976

With Thomas Buechner and Stanislav Libenský, Corning, 1980

Pilchuck in the fall and winter, further developing the *Macchia* series with William Morris as chief gaffer.

1984 Begins work on the *Soft Cylinder* series, with Flora Mace and Joey Kirkpatrick executing the glass drawings.

1985 Begins working hot glass on a larger scale and creates several site-specific installations.

1986 Begins *Persian* series with Martin Blank as gaffer, assisted by Robbie Miller. With the opening of *Dale Chihuly objets de verre* at the Musée des Arts Décoratifs, Palais du Louvre, in Paris, he becomes one of only four American artists to have had a one-person exhibition at the Louvre.

1987 Establishes his first hotshop in the Van de Kamp Building near Lake Union. Begins association with artist Parks Anderson. Marries playwright Sylvia Peto.

1988 Inspired by a private collection of Italian Art Deco glass, Chihuly begins *Venetian* series. Working from Chihuly's drawings, Lino Tagliapietra serves as gaffer.

1989 With Italian glass masters Lino Tagliapietra, Pino Signoretto, and a team of

In his first Aston Martin, Volunteer Park, Seattle, 1986

With David Hockney, circa 1989

With Viola Chihuly, Sylvia Peto, and Aunt Naomi, circa 1989

With Henry Geldzahler, Southampton, New York, 1988

glassblowers at Pilchuck Glass School, begins *Putti* series. Working with Tagliapietra, Chihuly creates *Ikebana* series, inspired by his travels to Japan and exposure to ikebana masters.

1990  Purchases the historic Pocock Building located on Lake Union, realizing his dream of being on the water in Seattle. Renovates the building and names it The Boathouse, for use as a studio, hotshop, and archives. Travels to Japan.

1991  Begins *Niijima Float* series with Richard Royal as gaffer, creating some of the largest pieces of glass ever blown by hand. Completes a number of architectural installations. He and Sylvia Peto divorce.

1992  Begins *Chandelier* series with a hanging sculpture at the Seattle Art Museum. Designs sets for Seattle Opera production of Debussy's *Pelléas et Mélisande*.

1993  Begins *Piccolo Venetian* series with Lino Tagliapietra. Creates *100,000 Pounds of Ice and Neon*, a temporary installation in the Tacoma Dome, Tacoma, Washington.

1994  Creates five installations for Tacoma's Union Station Federal Courthouse. Hilltop

With Viola Chihuly, The Boathouse, Seattle, 1991

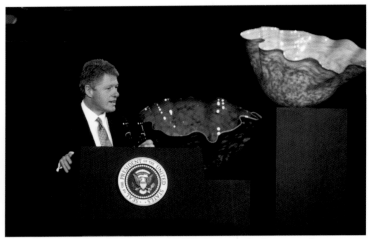

President Clinton at the Asia Pacific Economic Cooperation (APEC) Summit, Seattle, 1993

With Robin Williams in Malibu, California, at the American Academy of Achievement Awards, where both were honored in 1994

With Paul Parkman and George Stroemple, Venice, 1996

Artists-in-Residence, a glassblowing program for at-risk youths in Tacoma, Washington, is created by friend Kathy Kaperick. Within two years the program partners with Tacoma Public Schools, and Chihuly remains a strong role model and adviser.

1995 *Chihuly Over Venice* begins with a glassblowing session in Nuutajärvi, Finland, and a subsequent blow at the Waterford Crystal factory, Ireland.

1996 *Chihuly Over Venice* continues with a blow in Monterrey, Mexico, and culminates with the installation of fourteen *Chandeliers* at various sites in Venice. Creates his first permanent outdoor installation, *Icicle Creek Chandelier*.

1997 Continues and expands series of experimental plastics he calls Polyvitro. *Chihuly* is designed by Massimo Vignelli and copublished by Harry N. Abrams, Inc., New York, and Portland Press, Seattle. A permanent installation of Chihuly's work opens at the Hakone Glass Forest, Ukai Museum, in Hakone, Japan.

1998 Chihuly is invited to Sydney, Australia, with his team to participate in the Sydney Arts Festival. A son, Jackson Viola Chihuly, is born February 12 to Dale Chihuly and Leslie

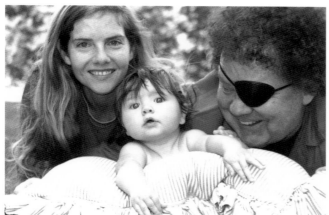

With Leslie Jackson and Jackson Viola Chihuly, 1998

Jackson, Christmas Day, Sun Valley, 1999

With Teddy Kollek, Jerusalem, 1999

With Leslie and Jackson Viola Chihuly, 1999

Jackson. Creates architectural installations for Benaroya Hall, Seattle; Bellagio, Las Vegas; and Atlantis, the Bahamas.

1999  Begins *Jerusalem Cylinder* series with gaffer James Mongrain, in concert with Flora Mace and Joey Kirkpatrick. Mounts his most ambitious exhibition to date: *Chihuly in the Light of Jerusalem 2000*, at the Tower of David Museum of the History of Jerusalem. Outside the museum he creates a sixty-foot wall from twenty-four massive blocks of ice shipped from Alaska.

2000  Creates *La Tour de Lumière* sculpture as part of the exhibition *Contemporary American Sculpture* in Monte Carlo. Marlborough Gallery represents Chihuly. More than a million visitors enter the Tower of David Museum to see *Chihuly in the Light of Jerusalem 2000*, breaking the world attendance record for a temporary exhibition during 1999–2000.

2001  The Victoria and Albert Museum, in London, curates the exhibition *Chihuly at the V&A*. Exhibits at Marlborough Gallery, New York and London. Groups a series of

With Jackson, Seattle, 2000

With Jane Goodall, Seattle, 2000

With Colin Powell in the Boathouse hotshop, Seattle, 2000

With Leslie and Jackson at the Bridge of Glass, 2002

*Chandeliers* for the first time to create an installation for the Mayo Clinic in Rochester, Minnesota. Artist Italo Scanga dies, friend and mentor for over three decades. Presents his first major glasshouse exhibition, *Chihuly in the Park: A Garden of Glass*, at the Garfield Park Conservatory, Chicago.

2002  Creates installations for the Salt Lake 2002 Olympic Winter Games. The Chihuly Bridge of Glass, conceived by Chihuly and designed in collaboration with Arthur Andersson of Andersson·Wise Architects, is dedicated in Tacoma, Washington.

2003  Begins the *Fiori* series for the opening exhibition at the Tacoma Art Museum's new building. TAM designs a permanent installation for its collection of his works. *Chihuly at the Conservatory* opens at the Franklin Park Conservatory, Columbus, Ohio.

2004  Creates new forms in his *Fiori* series for an exhibition at Marlborough Gallery, New York. The Orlando Museum of Art and the Museum of Fine Arts, St. Petersburg, Florida, become the first museums to collaborate and present simultaneous major exhibitions of his work. Presents a glasshouse exhibition at Atlanta Botanical Garden. Another

168

With Leslie, Christo, and Jean-Claude, 2004

With Queen Elizabeth at the V&A, 2001

Jackson with his dog, Coby, 2005

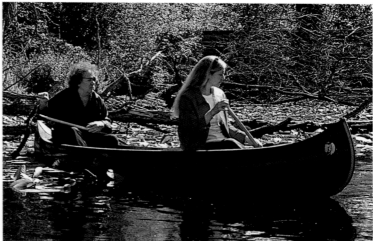

With Leslie at temporary installation on Union Bay, Seattle, 2005

collaborative exhibition opens in Los Angeles at the Frederick R. Weisman Museum of Art, L.A. Louver gallery, and Frank Lloyd Gallery.

2005 Marries Leslie Jackson. Mounts a major garden exhibition at the Royal Botanic Gardens, Kew, outside London. Shows at Marlborough Monaco and Marlborough London. Exhibits at the Fairchild Tropical Botanic Garden, Coral Gables, Florida.

2006 Mother, Viola, dies at the age of ninety-eight in Tacoma, Washington. Presents glasshouse exhibits at the Missouri Botanical Garden and the New York Botanical Garden. *Chihuly in Tacoma*, hotshop sessions at the Museum of Glass, reunites Chihuly and glassblowers from important periods in his development.

Akita Senshu Museum of Art, Akita, Japan
Akron Art Museum, Akron, Ohio
Albany Museum of Art, Albany, Georgia
Albright-Knox Art Gallery, Buffalo, New York
Allied Arts Association, Richland, Washington
Arizona State University Art Museum, Tempe, Arizona
Arkansas Arts Center, Little Rock, Arkansas
Art Gallery of Greater Victoria, Victoria, British Columbia, Canada
Art Gallery of Western Australia, Perth, Australia
Art Museum of Missoula, Missoula, Montana
Art Museum of South Texas, Corpus Christi, Texas
Art Museum of Southeast Texas, Beaumont, Texas
Asheville Art Museum, Asheville, North Carolina
Auckland Museum, Auckland, New Zealand
Austin Museum of Art, Austin, Texas
Azabu Museum of Arts and Crafts, Tokyo, Japan
Ball State University Museum of Art, Muncie, Indiana
Beach Museum of Art, Kansas State University, Manhattan, Kansas
Berkeley Art Museum, University of California, Berkeley, California
Birmingham Museum of Art, Birmingham, Alabama
Boarman Arts Center, Martinsburg, West Virginia
Boca Raton Museum of Art, Boca Raton, Florida
Brauer Museum of Art, Valparaiso University, Valparaiso, Indiana
Brooklyn Museum, Brooklyn, New York
Canadian Clay & Glass Gallery, Waterloo, Ontario, Canada
Canadian Craft Museum, Vancouver, British Columbia, Canada
Carnegie Museum of Art, Pittsburgh, Pennsylvania
Center for the Arts, Vero Beach, Florida
Charles A. Wustum Museum of Fine Arts, Racine, Wisconsin
Charles H. MacNider Art Museum, Mason City, Iowa
Chrysler Museum of Art, Norfolk, Virginia
Cincinnati Art Museum, Cincinnati, Ohio
Cleveland Museum of Art, Cleveland, Ohio
Clinton Library and Archives, Little Rock, Arkansas
Colorado Springs Fine Arts Center, Colorado Springs, Colorado
Columbus Museum, Columbus, Georgia
Columbus Museum of Art, Columbus, Ohio
Contemporary Art Center of Virginia, Virginia Beach, Virginia
Contemporary Arts Center, Cincinnati, Ohio

Contemporary Crafts Association and Gallery, Portland, Oregon
Contemporary Museum, Honolulu, Hawaii
Cooper-Hewitt, National Design Museum, Smithsonian Institution, New York, New York
Corcoran Gallery of Art, Washington, D.C.
Corning Museum of Glass, Corning, New York
Crocker Art Museum, Sacramento, California
Currier Gallery of Art, Manchester, New Hampshire
Daiichi Museum, Nagoya, Japan
Dallas Museum of Art, Dallas, Texas
Danske Kunstindustrimuseum, Copenhagen, Denmark
Daum Museum of Contemporary Art, Sedalia, Missouri
David Winton Bell Gallery, Brown University, Providence, Rhode Island
Dayton Art Institute, Dayton, Ohio
DeCordova Museum and Sculpture Park, Lincoln, Massachusetts
Delaware Art Museum, Wilmington, Delaware
Denver Art Museum, Denver, Colorado
Design museum Gent, Ghent, Belgium
Detroit Institute of Arts, Detroit, Michigan
Dowse Art Museum, Lower Hutt, New Zealand
Eretz Israel Museum, Tel Aviv, Israel
Everson Museum of Art, Syracuse, New York
Experience Music Project, Seattle, Washington
Fine Arts Institute, Edmond, Oklahoma
Flint Institute of Arts, Flint, Michigan
Fonds Régional d'Art Contemporain de Haute-Normandie, Sotteville-lès-Rouen, France
Frederik Meijer Gardens & Sculpture Park, Grand Rapids, Michigan
Galéria mesta Bratislavy, Bratislava, Slovakia
Glasmuseet Ebeltoft, Ebeltoft, Denmark
Glasmuseum, Frauenau, Germany
Glasmuseum alter Hof Herding, Glascollection, Ernsting, Germany
Glasmuseum Wertheim, Wertheim, Germany
Haggerty Museum of Art, Marquette University, Milwaukee, Wisconsin
Hakone Glass Forest, Ukai Museum, Hakone, Japan
Hawke's Bay Exhibition Centre, Hastings, New Zealand
Henry Art Gallery, Seattle, Washington
High Museum of Art, Atlanta, Georgia
Hiroshima City Museum of Contemporary Art, Hiroshima, Japan
Hokkaido Museum of Modern Art, Hokkaido, Japan
Honolulu Academy of Arts, Honolulu, Hawaii
Hunter Museum of American Art, Chattanooga, Tennessee
Huntington Museum of Art, Huntington, West Virginia

Indianapolis Museum of Art, Indianapolis, Indiana

Israel Museum, Jerusalem, Israel

Japan Institute of Arts and Crafts, Tokyo, Japan

Jesse Besser Museum, Alpena, Michigan

Jesuit Dallas Museum, Dallas, Texas

Joslyn Art Museum, Omaha, Nebraska

Jule Collins Smith Museum of Fine Art, Auburn University, Auburn, Alabama

Jundt Art Museum, Gonzaga University, Spokane, Washington

Kalamazoo Institute of Arts, Kalamazoo, Michigan

Kaohsiung Museum of Fine Arts, Kaohsiung, Taiwan

Kemper Museum of Contemporary Art, Kansas City, Missouri

Kestner-Gesellschaft, Hanover, Germany

Kobe City Museum, Kobe, Japan

Krannert Art Museum, University of Illinois, Champaign, Illinois

Krasl Art Center, St. Joseph, Michigan

Kunstmuseum Düsseldorf, Düsseldorf, Germany

Kunstsammlungen der Veste Coburg, Coburg, Germany

Kurita Museum, Tochigi, Japan

Leigh Yawkey Woodson Art Museum, Wausau, Wisconsin

Lobmeyr Museum, Vienna, Austria

LongHouse Reserve, East Hampton, New York

Los Angeles County Museum of Art, Los Angeles, California

Lowe Art Museum, University of Miami, Coral Gables, Florida

Lyman Allyn Art Museum, New London, Connecticut

M.H. de Young Memorial Museum, San Francisco, California

Manawatu Museum, Palmerston North, New Zealand

Matsushita Art Museum, Kagoshima, Japan

Meguro Museum of Art, Tokyo, Japan

Memorial Art Gallery, University of Rochester, Rochester, New York

Metropolitan Museum of Art, New York, New York

Milwaukee Art Museum, Milwaukee, Wisconsin

Mingei International Museum, San Diego, California

Minneapolis Institute of Arts, Minneapolis, Minnesota

Mint Museum of Craft + Design, Charlotte, North Carolina

Mobile Museum of Art, Mobile, Alabama

Montreal Museum of Fine Arts, Montreal, Quebec, Canada

Morris Museum, Morristown, New Jersey

Musée d'Art Moderne et d'Art Contemporain, Nice, France

Musée de design et d'arts Appliqués Contemporains, Lausanne, Switzerland

Musée des Arts Décoratifs, Palais du Louvre, Paris, France

Musée des Beaux-Arts et de la Céramique, Rouen, France

Museo del Vidrio, Monterrey, Mexico

Museo Vetrario, Murano, Italy

Museum Bellerive, Zurich, Switzerland

Museum Boijmans Van Beuningen, Rotterdam, The Netherlands

Museum für Kunst und Gewerbe Hamburg, Hamburg, Germany

Museum für Kunsthandwerk, Frankfurt am Main, Germany

Museum of American Glass at Wheaton Village, Millville, New Jersey

Museum of Art and Archaeology, Columbia, Missouri

Museum of Art Fort Lauderdale, Fort Lauderdale, Florida

Museum of Arts & Design, New York, New York

Museum of Arts and Sciences, Daytona Beach, Florida

Museum of Contemporary Art, Chicago, Illinois

Museum of Contemporary Art San Diego, La Jolla, California

Museum of Fine Arts, Boston, Massachusetts

Museum of Fine Arts, St. Petersburg, Florida

Museum of Fine Arts, Houston, Houston, Texas

Museum of Northwest Art, La Conner, Washington

Museum of Outdoor Arts, Englewood, Colorado

Muskegon Museum of Art, Muskegon, Michigan

Muzeum města Brna, Brno, Czech Republic

Muzeum skla a bižuterie, Jablonec nad Nisou, Czech Republic

Múzeum židovskej kultúry, Bratislava, Slovakia

Naples Museum of Art, Naples, Florida

National Gallery of Australia, Canberra, Australia

National Gallery of Victoria, Melbourne, Australia

National Liberty Museum, Philadelphia, Pennsylvania

National Museum Kyoto, Kyoto, Japan

National Museum of American History, Smithsonian Institution, Washington, D.C.

National Museum of Modern Art Kyoto, Kyoto, Japan

National Museum of Modern Art Tokyo, Tokyo, Japan

Nationalmuseum, Stockholm, Sweden

New Orleans Museum of Art, New Orleans, Louisiana

Newark Museum, Newark, New Jersey

Niijima Contemporary Art Museum, Niijima, Japan

North Central Washington Museum, Wenatchee, Washington

Norton Museum of Art, West Palm Beach, Florida

Notojima Glass Art Museum, Ishikawa, Japan

O Art Museum, Tokyo, Japan

Oklahoma City Museum of Art, Oklahoma City, Oklahoma

Orange County Museum of Art, Newport Beach, California

Otago Museum, Dunedin, New Zealand

Palm Beach Community College Museum of Art, Lake Worth, Florida
Palm Springs Desert Museum, Palm Springs, California
Palmer Museum of Art, Pennsylvania State University, University Park, Pennsylvania
Philadelphia Museum of Art, Philadelphia, Pennsylvania
Phoenix Art Museum, Phoenix, Arizona
Plains Art Museum, Fargo, North Dakota
Portland Art Museum, Portland, Oregon
Portland Museum of Art, Portland, Maine
Powerhouse Museum, Sydney, Australia
Princeton University Art Museum, Princeton, New Jersey
Queensland Art Gallery, South Brisbane, Australia
Reading Public Museum, Reading, Pennsylvania
Rhode Island School of Design Museum, Providence, Rhode Island
Royal Ontario Museum, Toronto, Ontario, Canada
Saint Louis Art Museum, St. Louis, Missouri
Saint Louis University Museum of Art, St. Louis, Missouri
Samuel P. Harn Museum of Art, University of Florida, Gainesville, Florida
San Antonio Museum of Art, San Antonio, Texas
San Jose Museum of Art, San Jose, California
Scottsdale Center for the Arts, Scottsdale, Arizona
Seattle Art Museum, Seattle, Washington
Shimonoseki City Art Museum, Shimonoseki, Japan
Singapore Art Museum, Singapore
Slovenská národná galéria, Bratislava, Slovakia
Smith College Museum of Art, Northampton, Massachusetts
Smithsonian American Art Museum, Washington, D.C.
Sogetsu Art Museum, Tokyo, Japan
South Texas Institute for the Arts, Corpus Christi, Texas
Speed Art Museum, Louisville, Kentucky
Spencer Museum of Art, University of Kansas, Lawrence, Kansas
Springfield Museum of Fine Arts, Springfield, Massachusetts
Štátna galéria Banská Bystrica, Banská Bystrica, Slovakia
Suntory Museum of Art, Tokyo, Japan
Suomen Lasimuseo, Riihimäki, Finland
Suwa Garasu no Sato Museum, Nagano, Japan
Tacoma Art Museum, Tacoma, Washington
Taipei Fine Arts Museum, Taipei, Taiwan
Tochigi Prefectural Museum of Fine Arts, Tochigi, Japan
Toledo Museum of Art, Toledo, Ohio
Tower of David Museum of the History of Jerusalem, Jerusalem, Israel
Uměleckoprůmyslové muzeum, Prague, Czech Republic

University Art Museum, University of California, Santa Barbara, California
Utah Museum of Fine Arts, University of Utah, Salt Lake City, Utah
Victoria and Albert Museum, London, England
Wadsworth Atheneum, Hartford, Connecticut
Waikato Museum of Art and History, Hamilton, New Zealand
Walker Hill Art Center, Seoul, South Korea
Whatcom Museum of History and Art, Bellingham, Washington
White House Collection of American Crafts, Washington, D.C.
Whitney Museum of American Art, New York, New York
Wichita Art Museum, Wichita, Kansas
World of Glass, St. Helens, England
Württembergisches Landesmuseum Stuttgart, Stuttgart, Germany
Yale University Art Gallery, New Haven, Connecticut
Yokohama Museum of Art, Yokohama, Japan

# Colophon

This third printing of Fire · Dale Chihuly is limited to 7,500 casebound copies.
The entire contents are copyright © 2006 Dale Chihuly unless otherwise stated.
All rights reserved.

Photograph of Dale, Leslie, and Jackson Chihuly courtesy of William Wegman

Photography
Philip Amdal, Parks Anderson, Theresa Batty, Dick Busher, Shaun Chappell, Jan Cook,
David Emery, Paul Fisher, John Gaines, Ira Garber, Claire Garoutte, Thomas Gray,
Russell Johnson, Ansgard Ute Kaliss, Scott M. Leen, John Marshall, Teresa Nouri Rishel,
Terry Rishel, Roger Schreiber, W. T. Schuck, L. Shabott, Robin Stark, and Robert Vinnedge

Design
Anna Katherine Curfman and Barry Rosen

Typefaces
Paperback and Frutiger

Paper
White A matt art 157 gsm

Printed and bound in
China by Global PSD

Portland Press
PO Box 70856, Seattle, Washington 98127
800 574 7272
www.portlandpress.net

ISBN: 978-1-57684-159-4